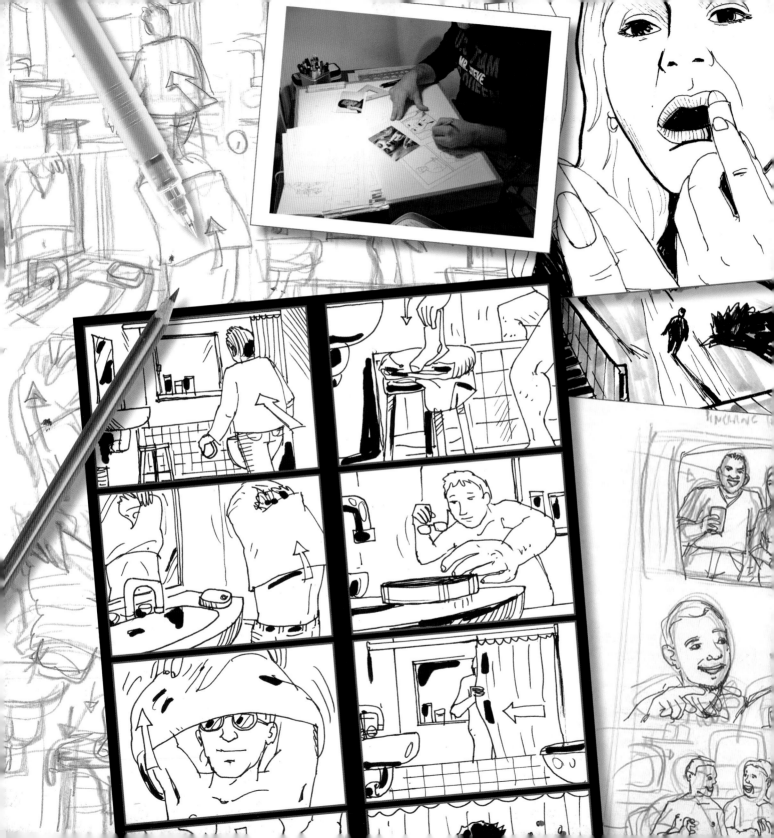

The Storyboard Design Course

The ultimate guide for artists, directors, producers and scriptwriters

Giuseppe Cristiano

Thames & Hudson

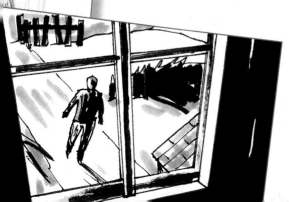

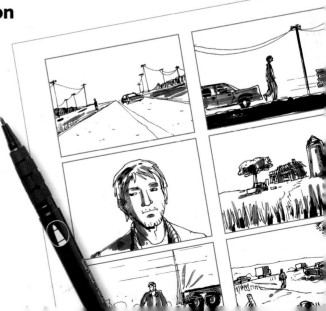

First published in the United Kingdom in 2008 by Thames & Hudson Ltd, 181A High Holborn, London WC1V 7QX

www.thamesandhudson.com

Copyright © 2007 Quarto Inc.

British Library Cataloguing-in-Publication Data A catalogue record for this book is available from the British Library

ISBN: 978-0-500-28690-6

Printed and bound in China

CONTENTS

INTRODUCTION

Storyboards are a well-known tool in the film industry and in the world of advertising; they have been used in varying formats for almost as long as cinema and animation have existed. Despite that, however, years ago, I was invited to give a lesson on storyboards for a university course and, when the students asked where they could buy books on the subject, I was at a loss to know what to suggest to them. I did some research and effectively found nothing – not one publication. Even today, I feel there is still not enough focus on storyboard design. This is where this book comes in.

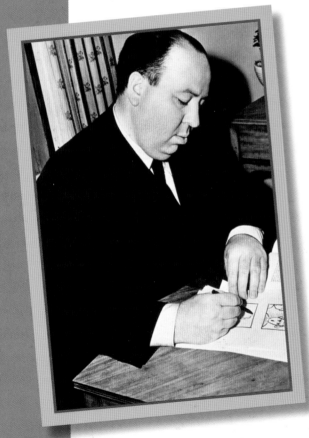

Alfred Hitchcock previsualized the frames in his films by carefully planning out shots on storyboards.

THE IMPORTANCE OF STORYBOARDS

The storyboard has often been described as "invisible art", something that is only known to industry insiders. So what exactly is it – and why is it so important? Although many people seem to think of it as a kind of "comic strip", it is nothing of the sort. A storyboard can be considered as pre-direction of the film. A good storyboard, in fact, should make you focus not on the style of the drawings but on the continuity of the scenes and on how cinematographic it is. It is also vital for a good storyboard artist to understand how a plot works, as very often you are asked to find solutions that are not written in the script. For example, how to make the cut from one scene to the next more interesting, or just simply how to visualize the inner feelings of a character.

The storyboard is also a way of defining the budget for a production. By using a storyboard to plan out the shots and sequences, it is possible to calculate production costs and times.

Storyboards also allow all members of the production team to understand the work they will have to undertake. Very often, films are not shot in chronological sequence: the end sequence, for example, may be shot first, so imagine the confusion that would arise if no structure had been set up.

MY BEGINNINGS AS A STORYBOARD ARTIST

As far as my own working life goes, I never attended a course relevant to storyboard design and never even had the chance to peruse a good textbook on the subject – although, as a child, I often became so enthusiastic about a book that I would start to illustrate it, maybe creating a small comic book based on the story. Perhaps this is how I learned to interpret a text and convert it into images.

To tell the truth, when I first started out, I didn't even know what a storyboard was. It all began when I was 15, and I found myself answering an ad by an agency looking for a storyboard artist. I went to the interview with my folder full of drawings – and everything I'd taken with me was useless. But I got the chance to do a test: they gave me a sketchy script for a possible advertising campaign. What I finally produced was completely off the mark and the agency told me to try again in the future.

At that point I thought that maybe this was not the field for me. But some years later I found myself in a similar position with another agency. The experience that I had gained as an artist and writer during the intervening years, added to the multitude of films I had seen, helped me to interpret the text. This time, my storyboard "worked". Since then I've worked on projects for Ridley Scott Associates, Saatchi & Saatchi, Fox, MTV, Nickelodeon, Aardman, Warner Bros., Universal and Playstation, among others.

Your role as a storyboard artist is not just to draw shots clearly. You are also employed to interpret and solve the visual flow of the story.

Storyboards were used by Disney
Studios to add substance to their
early animated films.

A.B. Frost pioneered the form of
comic strips with his illustrations.

A MEANS TO AN END

Unlike comic or book illustration, the storyboard is not a
stand-on-its-own art form. It is a means to an end – a tool
that uses sequential drawings to help take an idea to its
finished moving-image form. The majority of artwork
generated by storyboard artists, regardless of how beautifully
it is executed, rarely reaches an audience beyond the
production team. But this form of art has always been
"behind the scenes". Storyboards were introduced and
developed at the beginning of the 1930s by the writer Webb Smith
and, a decade later, were being increasingly used in film
production. The work produced by Disney Studios, for example,
is available in their publications, but most work created for
advertising has a short lifespan. Unfortunately, many examples
have been irredeemably lost and we do not even know the names
of these artists. All I can do is mention those artists who have
inspired me the most over the years – namely Norman Rockwell,
Harold Michelson, AB Frost and, more recently, Jean Giraud (also
known as Moebius), whom I was lucky enough to meet and whose
art and advice have probably led me to where I am now.

HOW THIS BOOK WILL HELP YOU

When most young artists finish their training, they are unaware of
just how many opportunities there are in the job market. Even
discounting the more obvious areas such as graphic design and
book illustration, there will always be openings for skilled – and,
perhaps even more importantly, fast – drawers as freelance
storyboard artists. Yet graphic art schools seldom offer storyboard
instruction – perhaps because it's an area that some teachers
would rather keep for themselves.

So what can you expect from this manual? It will show you how a working storyboard artist operates, what a storyboard really is, how to get going and keep motivated, what techniques you need to master, how to deal with the agencies, and even how to get paid. I hope it will provide aspiring storyboard artists with the essentials to enable them to realize their potential. Talent is important, but all the rest – intuition, creativity, problem solving, working fast – are traits that are gained through experience. A good storyboard artist needs to be constantly up to date with the changing market, do plenty of research, watch many films, know the work of different directors, and, above all, know the work of different storyboard artists, as nowadays (thanks to the Internet) their art is no longer so "invisible".

Beyond that, this book can benefit anyone involved in the production process, from art director, writer, or producer to director, whether they're working in film, television, advertising, CD-ROMs or web design. Not everyone will have to draw storyboards themselves, but most of these people will work with them in one form or another. This book will enable anyone working in production to get the most out of both the storyboard artist and the storyboard process.

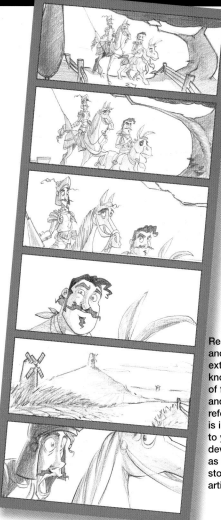

Research and an extensive knowledge of film and literary references is important to your development as a storyboard artist.

UNIT 1:
WHAT ARE STORYBOARDS?

WHAT ARE STORYBOARDS?

films

TV

advertisements

games

animation

Storyboards have been used in one form or other since the very beginning of moviemaking. Hitchcock, for example, was a notorious planner who wouldn't do anything if it had not been accurately previsualized. The same is true for many directors, from Orson Welles to Steven Spielberg, Martin Scorsese and Ridley Scott, just to name a few. Yet even after years of working as a professional storyboard artist, I still come across the occasional person who doesn't really understand the purpose of the storyboard they're hiring me to do. They're unsure of what they want me to draw or of how they can take advantage of the board.

Generally speaking, a storyboard is a means of describing and planning the continuity or shot-by-shot flow of a film using sequential illustrations. Most people think of a storyboard as a tool for the director, to enable him or her to plan shot sequences, camera angles, camera placement and other elements. Just as importantly, it is also a "visual budget" that aids the whole production team. A storyboard makes it possible to estimate the cost of production as everyone can see the number of shots, scenes, characters, equipment and set-up that are required. A storyboard can break down a scene or a whole script shot by shot, allowing a production manager to effectively calculate and plan shooting days. A production designer who has access to a storyboard knows what will be in frame, and can save time and money by not overbuilding a set.

The storyboard is usually mounted on black boards when presented to a client.

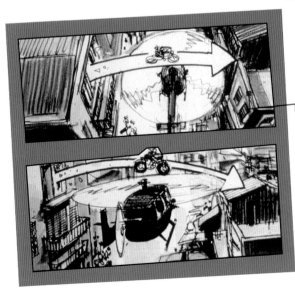

Action sequences
Preproduction planning of action scenes with a storyboard can save enormous amounts of time, money and hair pulling later on.

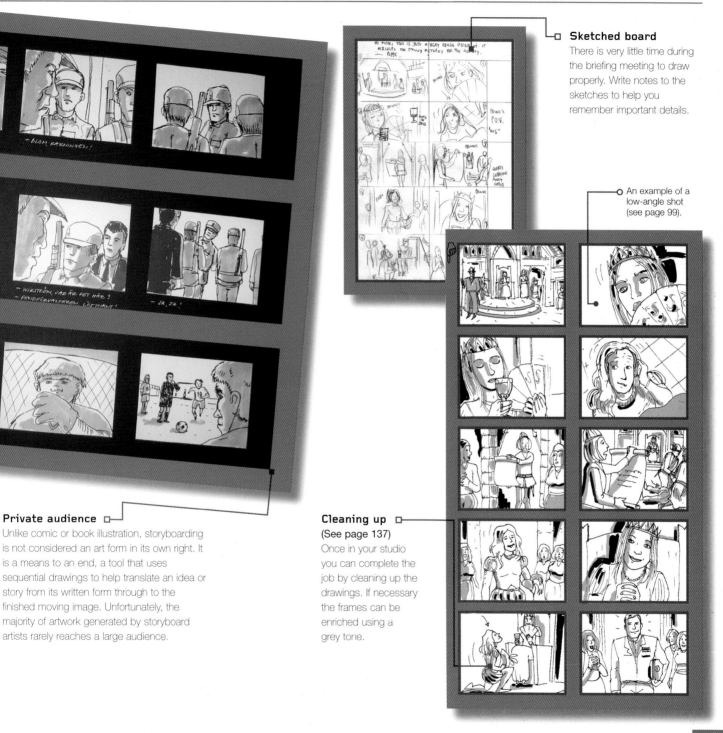

Sketched board
There is very little time during the briefing meeting to draw properly. Write notes to the sketches to help you remember important details.

An example of a low-angle shot (see page 99).

Private audience
Unlike comic or book illustration, storyboarding is not considered an art form in its own right. It is a means to an end, a tool that uses sequential drawings to help translate an idea or story from its written form through to the finished moving image. Unfortunately, the majority of artwork generated by storyboard artists rarely reaches a large audience.

Cleaning up
(See page 137)
Once in your studio you can complete the job by cleaning up the drawings. If necessary the frames can be enriched using a grey tone.

LESSON 1 TYPES OF STORYBOARD

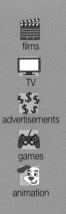

films

TV

advertisements

games

animation

There are two main types of storyboard: a client board and a shooting board – and the difference between them is very important.

The purpose of a client board is to try out or sell a concept or idea. It's generally used during development or in early preproduction. The term comes from the world of advertising. This kind of board, which is often referred to merely as "storyboard," can also be used in film and animation to raise money and to generate interest in a project. A client board is less concerned with technical details and continuity than with conveying an overall mood or style. For this reason, it is usually rendered in more detail, involves fewer frames, and is often done in colour.

The purpose of a shooting board, on the other hand, is to show how to execute an idea. It is used at a later phase of preproduction, during production, and even in postproduction by the director and team to plan the scenes and shoot, shot by shot. It contains more technical information than a client board, and focuses on continuity issues such as shot sequences, camera angles and camera placement – but in graphic terms it is rendered in less detail. A shooting board is almost always rendered in black and white, in a style that can easily be photocopied and distributed to the crew.

Client board

Often the client boards can look like a montage of images and the shots don't seem to be connected to each other. When this happens, the art director describes the action and continuity to the client.

Panning shots
(See page 110)

On a shooting board it is important to emphasize the technique, rather than the quality of the illustrations. Use the storyboard to describe a camera movement with arrows for direction.

Movement

The best way to suggest movement is to draw arrows in the frames.

Influence of schedules

Shooting boards are produced on a tight schedule. Grey tones can be added on a computer afterwards.

☐ Shooting board

A simple black-and-white board is good enough quality for the crew and actors, who will receive the shooting board at the same time as the script.

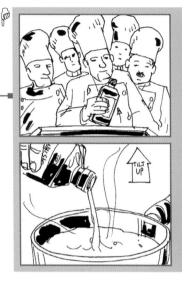
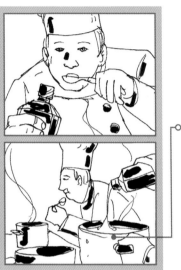

○ Objects in the foreground give depth to the composition and make the frames more interesting. Changing the focus, as in this frame for instance, will direct the attention of the audience to the product.

An over-the-shoulder shot (OTS). (See page 105.)

In a commercial it is important to display the product in an attractive way.

☐ Pack shot

This is an important shot where the product and packaging is fully displayed in a frame, usually at the end of an advertisement. In general a pack shot would take up five seconds of the whole ad.

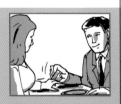

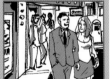

WHO USES STORYBOARDS?

Live action film, advertising, animation, computer games, websites, industrial videos, event planning, television, theatre — the list goes on. The best advice for any aspiring storyboard artist is to pick an area that interests you or that you're at least willing to learn about. Storyboarding is not just about the ability to draw well; it is also about knowing the medium in which you'll be working. So if you want to storyboard for computer games, for example, you have to know about computer games. If you're interested in advertising, you'd better know something about advertisements.

Advertising is a popular field for storyboard artists.

LESSON 2 STORYBOARDS FOR ADVERTISING

advertisements

Because of the high number of jobs and quick job turnaround, this is probably the easiest area for a storyboard artist to break into. A storyboard for an advertisement involves an average of 6 to 30 frames. You usually have one to two days to complete the job – if you're lucky. Sometimes you may just get a few hours. You need to be able to sketch quickly, come up with solutions on the fly, and work well under stress. The pay tends to be higher than in other areas, but there is no long-term job security and, of the three fields, advertising tends to be the least gratifying creatively. After all, advertisements are about selling, not making art. The quick job turnaround appeals to the freelance spirit who isn't looking for routine.

Frame 1

This is a typical close-up shot of the product. Clients are very keen, of course, that their products always look good in frame.

Frame 2

The director had a clear idea of the action in this shot. The composition came pretty close to the actual frame shot in the film.

Frame 3

Storyboards are a useful tool for introducing props into a frame. The director suggests his vision which is then visualized by the artist. The sketches will be used later on to build up the set.

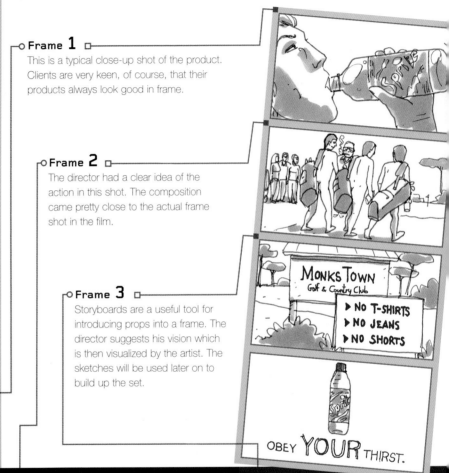

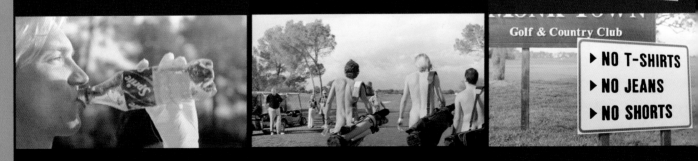

On the set

As each shot is taken, the relevant frame on the storyboard is crossed out.

Quick reference

The shooting board is always prominently displayed on the set so that everyone involved in the production can look at the work in progress.

Accurate shooting boards

This was a storyboard for a candy advertisement; the location for the first shot had already been chosen, that's why the frame looks accurate. The style and clothing had also already been decided by the production team when the artist met the director. This is probably the best scenario when working with films.

Sometimes using a different colour, for example a sepia tone, can enhance the board – even though only a small touch is used.

LESSON 3 STORYBOARDS FOR FILMS

films

When producing storyboards for live action film, you will be working on a project basis. A shooting board for a feature film generally involves over 1,000 frames, and you'll have on average two to three months to complete the job. Some boards can take much longer if the script is technically complicated and the budget permits. On a shooting board, you'll be working from your own studio but in close contact with the director. Films tend to pay less than advertising, but on the other hand, the projects are longer and often more artistically satisfying.

Considering that a film takes a long time to complete, and it's not unheard of for a production company to fold during the process, you should negotiate a 50% kill fee. This is an advance payment that the storyboard artist keeps even if a project is abandoned.

Many directors draw their own storyboards and, often, the work of the storyboard artist is to translate these notes into sketches that the crew can read. Some directors are highly skilled in drawing but, as producing a storyboard is generally a lengthy process, it is best to employ an artist. Hitchcock, for example, was a competent illustrator who often drew his own preparatory storyboard (or at any rate, the general design of the scenes). He then employed the best storyboard artists as, for him, this was the most important phase in a production.

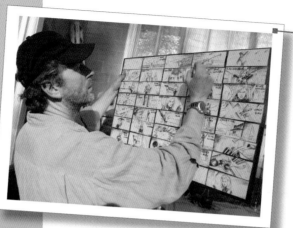

Cutting frames
The director Alexander Witt working on the storyboard for the film *Resident Evil: Apocalypse*.

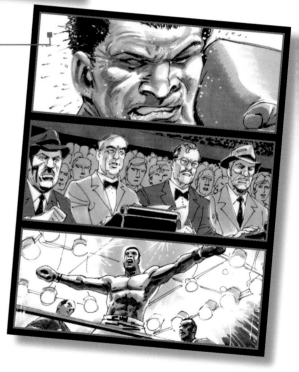

Getting the details
Sometimes, for a feature film, the director will ask for a detailed storyboard, especially if the production is still looking for funding. Often the actors have not yet been cast but the director will already have some ideas about the characters that he or she will describe to the artist. He or she will also suggest some names and provide reference pictures to help the storyboard artist. These atmospheric frames were drawn by Tim Burgard for Columbia Pictures for the film *Ali*.

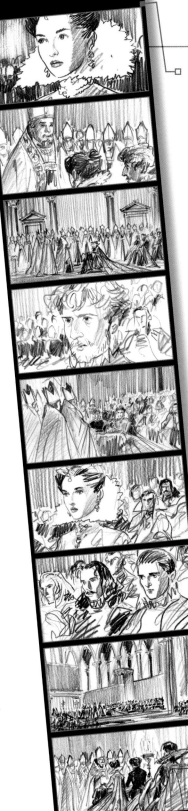

Period pieces

The director Patrice Chéreau requested storyboard sketches from Maxime Rebière in pencil for *La Reine Margot* in order to recreate the style of the sixteenth century, the setting of the film.

Thumbnail sketches

Initial sketches for the film *Mighty Joe Young* for Disney. Tim Burgard annotates the sketches with important information ready for the next stage.

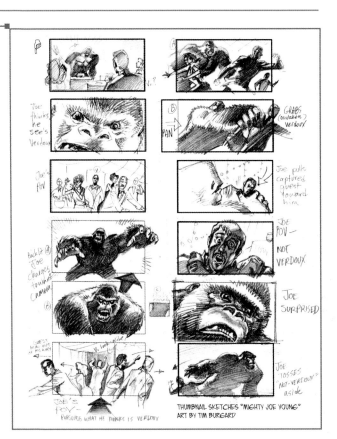

Working with the artist

The director John Huston examines storyboard frames for the 1956 film *Moby Dick*.

Locations weren't decided at the time the initial meeting took place. The artist used reference material of jungles and small villages to give an authentic feel to the frames.

At the end of the drawing process, the storyboard looked a little too much like a comic rather than a storyboard. Depending on the requirements of the director, there are often scenes that need a lot of attention to detail, especially when there are crowd scenes involved or a lot of actors in the shot.

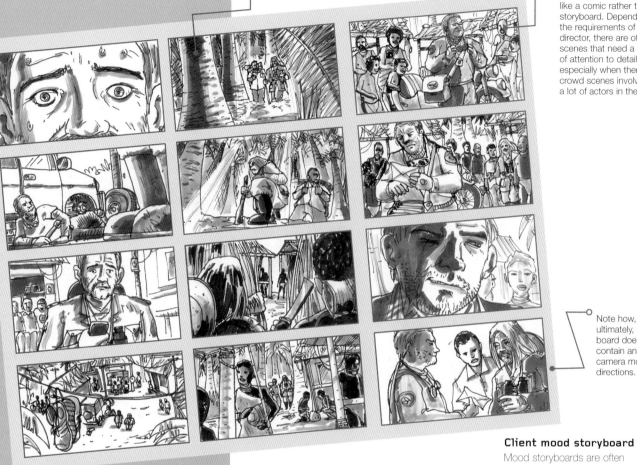

Note how, ultimately, the board doesn't contain any camera movement directions.

Client mood storyboard

Mood storyboards are often created from a work in progress script before location, cast, and props have been finalized. They can be used to secure more funding for the production.

Directing characters

Arrows can be added to illustrate movement as in Tim Burgard's storyboard for *Garfield 2: A Tale of Two Kitties*, 20th Century Fox.

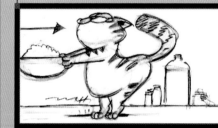
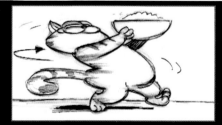
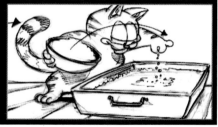

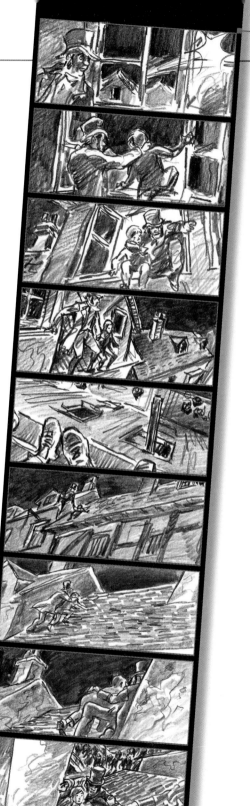

Action sequences

The storyboard is an important way of planning out action sequences in movies. This sequence was drawn by Maxime Rebière for the film *Oliver Twist*, directed by Roman Polanski.

Working in different media

Maxime Rebière was asked by the director of the film *Wings of Courage*, Jean-Jacques Arnaud, to work in colour for the client board in order to create a more realistic movie feel. The result was a gouache work on paper that captures the imagination.

LESSON 4 STORYBOARDS FOR MUSIC VIDEOS

music

Very often, advertising production houses also produce music videos. As it very often happens that the same teams (director, director of photography, set designer, and so on) work on these projects, it's possible to recognize the style of the production studio.

Budgets for music videos have been drastically reduced in the last few years and, very often, the storyboard artist is offered a sum that bears no relation to the amount of work involved. In fact, if an advertisement generally amounts to 20 to 25 frames, a music video can reach a total of about 100 frames – but the job will almost always be paid for at the same rate as if it was an advertisement.

The creative process for music video storyboards differs from the approach to television commercials or films. You generally start from a basic idea or concept, which may come from the artists themselves and which is then discussed by the production team to estimate costs and duration.

Often a music video is a series of sequences or ideas, and no storyline is required. For example, the band might suggest that the video be shot in the desert; at this point, the director will have to generate a series of images that could accompany the song. At this juncture, the storyboard artist is asked to create "key" illustrations (commonly known as "key frames") to help the team define a general working plan.

Inspiration
A music video idea can come from a simple picture. Sometimes the director will present the idea to the artist using a few sketches rather than a full storyboard.

Conceptual drawings
Sometimes it is useful for a brainstorming session to produce a number of illustrations. Budget permitting, some can even be in colour.

Styles
In style, the storyboard for a music video doesn't differ much from that for a TV advertisement. In general, a TV ad runs for about 30 to 45 seconds, while a music video can be up to 4 minutes in length. Having a little more time to work on a board makes it possible for the storyboard artist to produce a cleaner board.

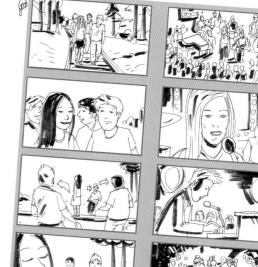

Set design

During the storyboarding session with the video director the artist could be asked to produce sketches to help create the set. These sketches are always very rough and the set will then be finalized by the scenographers.

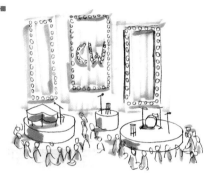

Shooting the key frames

The shooting process for a music video involves making sure the key frames are captured rather than a complicated storyline.

Key frames for costing

There are often a lot of special effects in music videos. The storyboard will also be used to budget and plan the postproduction of these effects. Sometimes a few key frames will be enough to estimate costs.

Item	Quantity	Unit cost	Total	Notes
PREPRODUCTION				
Advertising for cast and crew	1	0.00	0.00	
Audition space per day	2	10.00	20.00	
Tapes for audition	3	2.00	6.00	
PRODUCTION				
Camera rental	1	0.00	0.00	
Microphone rental	1	0.00	0.00	
Light rental	0	0.00	0.00	
DV tape stock	3	2.00	6.00	
Script	10	0.50	5.00	
Photocopies			15.00	Flowers
Props	3	5.00		
Wardrobe	0	0.00	0.00	Wigs
Makeup	1	5.00	5.00	
Catering for 8 per day	3	20.00	60.00	
Petty cash			20.00	
TRAVEL EXPENSES PER DAY				
Actor 1	3	7.00	21.00	Includes gas for car used in video
Actor 2	3	5.00	15.00	
Actor 3	3	5.00	15.00	
Actor 4	3	5.00	15.00	
Cameraman	3	5.00	15.00	
Sound recordist	3	5.00	15.00	
Makeup	3	5.00	15.00	
Director				
POSTPRODUCTION				
Editor	1	0.00	0.00	For cast, crew, and marketing
DVD-R	20	1.00	20.00	
Marketing/PR	10	2.00	20.00	Printing press pack
Total			303.00	

Using colour

It's not common but it is possible that the storyboard for a music video will need to be in colour. In this example the concept for the music video was that the colours would appear as the song developed.

The location and costumes are not always decided while the storyboard artist is working on the storyboard. Costumes tend to change continuously throughout the production process.

Get as much information as possible from the production company so that you can draw the artist as realistically as possible.

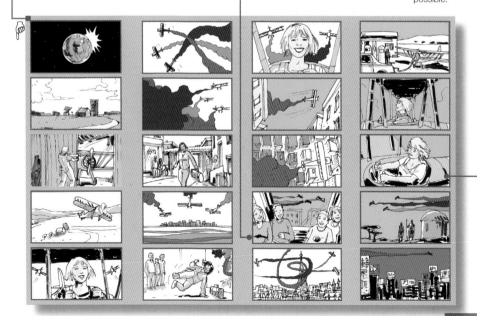

LESSON 5 STORYBOARDS FOR ANIMATION

animation

By far the most demanding field for storyboard artists in terms of detail and quality, animation is a costly, labour-intensive medium, and the storyboard will be the main form of communication that is sent from studio to studio, country to country, in the production process.

Storyboard artists for animation are hired on a long-term basis, usually one to two years at a time, and, unlike advertising and live action film, will be working at the animation studio alongside other artists. Animation is the most creative area for the storyboard artist – in part due to the high amount of detail required in the actual board, but also because it's in the storyboard phase that many jokes are polished or even created.

Storyboards for animation are very detailed. In fact, the amount of information contained in a storyboard page for a cartoon is extensive.

Animation template

To show how much detail is involved in every aspect of the animation, here is a typical template. It includes spaces for frames, text, translation (as the job is usually completed in different studios, very often in co-production with the main house), notes, references (number of locations, number of characters, special effects, and so on), and finally the timing of the sequence.

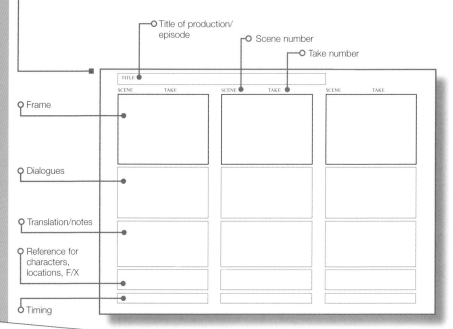

Title of production/episode

Scene number

Take number

Frame

Dialogues

Translation/notes

Reference for characters, locations, F/X

Timing

TITLE

SCENE TAKE SCENE TAKE SCENE TAKE

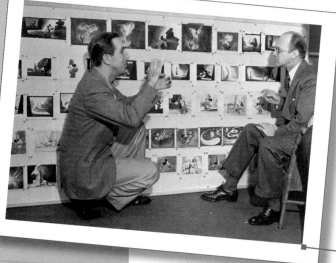

Getting the music right

Nearly 1,000 people were involved in the making of Walt Disney's famous animation *Fantasia*. Here, the director uses the storyboard to discuss the music for the film.

Storyboards for animation

It is a lot of fun to produce a storyboard for animation. Once the design for the characters is finalized it is the storyboard artist who brings them to life for the first time. Even though the drawings might be fairly rough, the real development of the story begins on the storyboard.

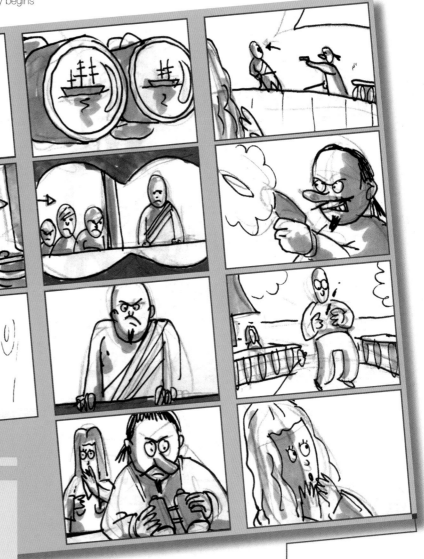

Direction

In animation, the storyboard artist is often credited right after the director. Since every single shot of the action in animation needs to be drawn, the storyboard is where the first direction takes place.

ARCHIVING AND RECORD KEEPING

In an animation studio, every aspect of the storyboard is approved and recorded, and each correction validated and dated, because it is of paramount importance that the team always use the most recent storyboard as a guide.

Continuity

As you can see from this example storyboard the action is consequential. The animation studio can then produce an animatic (see page 86) of the storyboard. Only after that can the studio proceed to produce the actual animation.

There are different types of techniques to create animation – classic cell animation, clay animation, and 3-D animation – but all begin life in the same traditional way, with sketches and a storyboard.

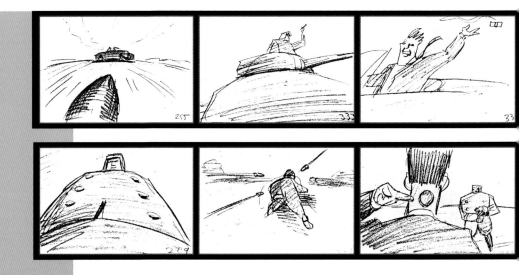

Movement lines

In storyboard frames for animation, just as in comic strips, you can emphasize a character's sense of movement by drawing movement lines.

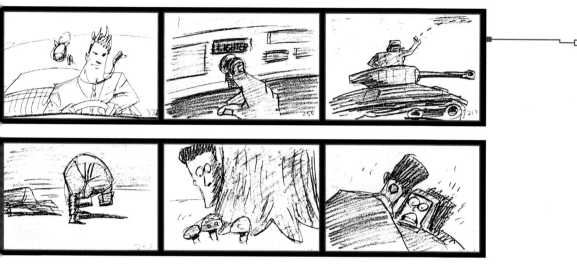

Strips for animation

These strips of storyboard frames were drawn by Bill Plympton who is also the animator and director of his works. In animation it often occurs that directors produce their own storyboards. However, if you are working on an animated series you need to adapt to the style of the show.

Every sketch counts

In an animation studio every sketch is saved. A new idea that ends up becoming part of the finished film might begin life as a very rough sketch on a piece of scrap paper.

Approvals

There is always a large amount of illustrations moving around an animation studio and it's common for confusion to arise over the work in progress. Continuous approvals of the artwork, from design to storyboard, take place so that everyone on the team knows what is the right material to work with.

LESSON 6 STORYBOARDS FOR COMPUTER GAMES AND MULTIMEDIA

games

Storyboards are also used in the creation of computer games and multimedia presentations. Video games often have detailed, animated presentations that mimic short films. If you think of the amount of work that goes into each of these introductions, which can last for up to 10 minutes, it's obvious that the storyboard phase is one of the most important in the production process. In fact, these introductions need to be considered as animated short movies, and so you need to design the characters, locations and so on. After this, you need to have a script ready – and then you move to the storyboard phase.

There are also computer games that move through various settings while looking for clues, building up a story. In this case, the storyboard works as a skeleton for the production.

In multimedia presentations, the storyboard can be used simply as a "flow chart" that maps out the project. For example, with an interactive CD-ROM, the storyboard tells us where all the information ends up and how to move inside the product.

Storyboards in this field are usually very detailed. You can find illustrations and work-in-progress features about various current productions in specialized computer and video game magazines.

Frame 1
This is known as the establishing shot. In an extreme wide shot we are shown the environment in which the action will take place. From above we spot a giant egg on the beach.

Frame 2
A wide shot. The egg has broken and a character appears from inside it while strange creatures approach showing their curiosity.

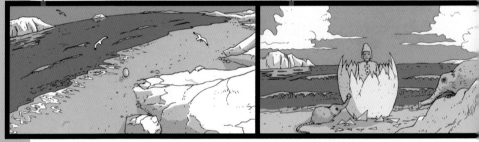

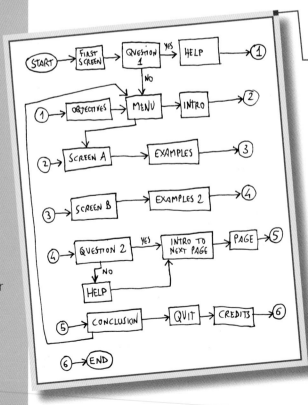

Flow charts
A simple interactive presentation storyboard is sometimes simplified further with a flow-chart layout. In this way it is easy to follow the sequence of events before work begins on the storyboard.

Prop design

Working on computer game storyboards also allows you to produce lots of designs – especially for props and costumes.

Frame 3

A wide shot of a primordial ship surrounded by giant bird-like creatures. A sense of anticipation is introduced.

Frame 4

Huge bugs begin to appear from every angle of the frame, heading towards a small village at the bottom of a white sand valley.

Frame 5

The fight scene. The huge bugs attack the human-like characters.

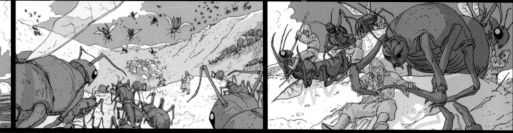

Sketching characters

Before drawing the storyboard for a computer game it is necessary to produce all the designs which will later be used by the computer animators. The sketches will be supervised by the creators of the game, although the storyboard artist can sometimes be involved in the very early planning stages too.

Sometimes, simple pencil sketches will be all that's required, especially when still in the planning stages.

Once the characters have been chosen and finalized, they are then cleaned up and coloured (usually digitally) and given to the computer animators.

LESSON 7 OTHER TYPES OF STORYBOARD

films

TV

advertisements

games

animation

Occasionally, architectural studios need a storyboard artist to visualize presentations of their projects. Usually a project needs to be seen by a panel of judges and nowadays it's possible to create virtual models of proposed new buildings, using advanced computer software to simulate lights, settings, and materials. Clearly, this type of work takes time – and so the first stage is a draft in the form of a storyboard, to define the various sequences that will subsequently be computer animated.

A similar process is used when designing an Internet website, where the storyboard is mainly drawn in the form of a flow chart, and for training videos and company presentations for fairs and business events, and so on.

A storyboard is useful in many situations. Think of it as an instrument that makes the production process clearer and speeds up production time, avoiding a waste of energy and resources.

Frame 1
When working on an architectural storyboard, the artist will work very closely with a 3-D computer artist to discover the many structural possibilities available. In this example, light was very important, as was the material of the different elements. All this realism can be controlled and manipulated.

Frame 2
In this shot it was very important to give an idea of the vision of the structure at night. This was key to the success of this particular set of buildings.

Frame 3
In this frame we wanted to show a building at dawn. With certain software it is possible to simulate different times of the day.

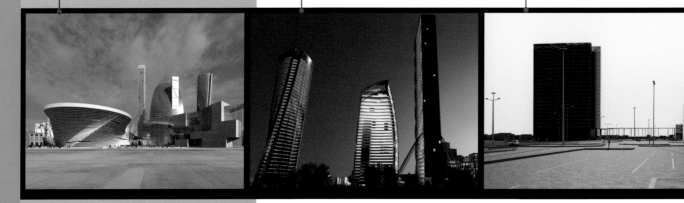

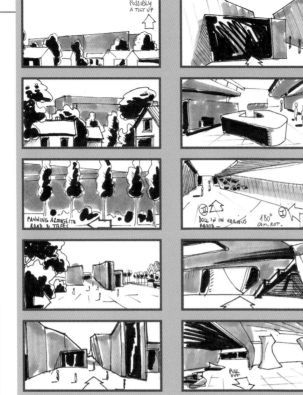

Frame 4

This shot shows another angle of the building with another source of light, this time a sunset.

Storyboard for architectural purposes

It is important that the storyboard artist knows the architectural project well. Not only the structure from the blueprints, but also the functionality of the building, its purpose, and the final use. It is also important to understand the technical language of architecture. An interest in the subject of architecture is necessary.

Since the 3-D rendering requires a lot of time, the storyboard is used to choose the angles and the "virtual" camera movements for the presentation. The storyboard artist must have the ability to visualize the structure from every possible angle. A knowledge of perspective (see page 68) is a must.

Assignments on the Web

"Unusual" but interesting jobs for a storyboard artist can come from unexpected sources. Sometimes a car manufacturer wants to include interactive features on their website so that potential buyers can interact with their cars. A storyboard artist will be employed to develop the sequence of moves.

A lot of creativity is required here, since the only reference that the car manufacturer will provide is the actual car with pictures from every angle – the rest is up to your imagination. Fortunately this kind of job is commissioned out to agencies which will have a creative team and art director preparing the material. They will be contacting the storyboard artist and giving them more visuals for reference.

UNIT 2:
WHAT SKILLS DO I NEED?

WHAT SKILLS DO I NEED?

films

TV

advertisements

games

animation

If you want to be a professional storyboard artist, you have to be able to draw with both speed and precision. This unit sets out some useful guidelines on how to set up your own studio and the kind of equipment you need. If you're a filmmaker interested in doing your own boards, however, then there are ways in which you can plan and communicate without having a great command of the pencil. Turn to page 74 for helpful tips for the artistically challenged.

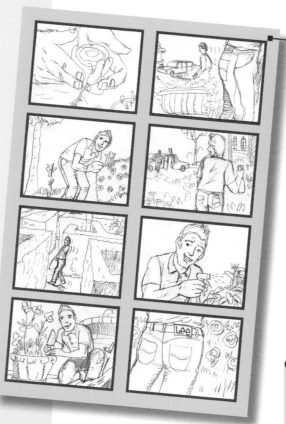

Drawing ability

You need a good command of both anatomy and perspective. You need to be able to sketch from memory as well as from reference material. You need to be able to draw realistically for live-action storyboards, and to be able to reproduce established character and set design for animation.

Speed

You don't just need to be good – you also need to be fast. You'll be working under stress and to tight deadlines, so speed is paramount. You need to be able to grasp and sketch ideas quickly in meetings, as well as work quickly in your studio.

Film knowledge

You need a broad knowledge of film history, as the people you work with will refer to films all the time in terms of style, tempo, colour and framing. You need to know what they're talking about. Watch films, live films, love films, and keep up to date. It's usually the classics and current hits that are most commonly referred to.

Technique

You need to know the medium in which you're working – the language, the limitations, the possibilities and the different roles of the members of the production team. If you don't, you won't be able to communicate the director's needs or come up with solutions.

OVER TO YOU

If you want to increase your drawing skills and speed, then the only way is to practise. Try rapidly sketching frames from the television. You should also get into the habit of carrying a small notebook with you at all times, so that you can sketch wherever there are people and action – when you're sitting in a coffee shop or on the train, for example.

Organization

You need to be organized with your workspace, your time and your finances. Not only will you be working to tight deadlines, but you will probably also be working as a freelance artist. There will be no one but yourself to make sure you get the job done on time – or get the next job, for that matter. You'll probably be juggling several jobs at once, creatively and administratively – so be organized.

Ability to work as part of a team

A storyboard artist is literally a hired hand. The degree to which you'll be involved in creative decisions varies from one job to another, but for the most part you're hired to visualize someone else's ideas. From an egotistical standpoint, you need to be able to accept this and to respect deadlines. Teamwork is essential!

LESSON 8 SETTING UP A WORKSPACE

films

TV

advertisements

games

animation

Not only do you need a space in which to work, but that space must be well organized. In addition to the tools and equipment that you'll use every day, you also need a filing system for reference material and completed jobs, and a good accounts system for invoices, receipts, correspondence and so on, so that you can find everything easily when you need it.

Clearly, having your own office (or a room set up for this purpose) is ideal. If this is not possible, then you need to be able to leave your work on your desk, so you can go back to it later in the day without having to clear your desk mid-job. Maybe you could reduce the amount of material you use for the job to the bare essentials. Wherever you work, you'll be spending a lot of your time there – so it must be comfortable and conducive to working, with everything you need close at hand.

If you know a professional storyboard artist, or if you have the chance to visit someone else's studio, take the opportunity to see how they work and manage their resources. However, you will almost certainly find that your own studio will change with time, as your needs become more apparent, and you will create a customized space for yourself.

Let's look at how the perfect studio might be organized.

Deadlines and meeting times
A good-quality and practical diary should always be open on your desk, preferably one with a week to view format, so you can see in advance your deadlines for that week.

Archive system
Not everybody will have the luxury of an archive room, but why not use your cupboards or your garage? You are not going to access your archive files very often; the important thing is to know where everything is.

WHEN YOU'RE NOT WORKING

You also have to consider your "down time" – those occasions when you do not have much work. Use this spare time for personal projects, and to advance your skills and stimulate your creative needs. The pressures of deadlines and limited resources mean that it's not always easy to give your best. You need to feel creative to avoid "burning out" artistically, or losing your motivation and becoming frustrated by the fact that you never have enough time to finish a job as you would like.

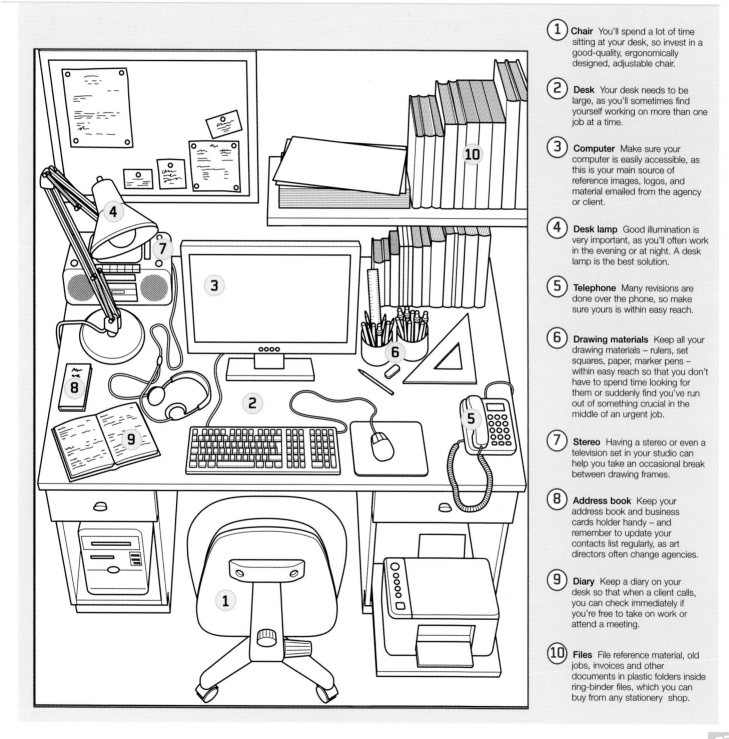

1. **Chair** You'll spend a lot of time sitting at your desk, so invest in a good-quality, ergonomically designed, adjustable chair.

2. **Desk** Your desk needs to be large, as you'll sometimes find yourself working on more than one job at a time.

3. **Computer** Make sure your computer is easily accessible, as this is your main source of reference images, logos, and material emailed from the agency or client.

4. **Desk lamp** Good illumination is very important, as you'll often work in the evening or at night. A desk lamp is the best solution.

5. **Telephone** Many revisions are done over the phone, so make sure yours is within easy reach.

6. **Drawing materials** Keep all your drawing materials – rulers, set squares, paper, marker pens – within easy reach so that you don't have to spend time looking for them or suddenly find you've run out of something crucial in the middle of an urgent job.

7. **Stereo** Having a stereo or even a television set in your studio can help you take an occasional break between drawing frames.

8. **Address book** Keep your address book and business cards holder handy – and remember to update your contacts list regularly, as art directors often change agencies.

9. **Diary** Keep a diary on your desk so that when a client calls, you can check immediately if you're free to take on work or attend a meeting.

10. **Files** File reference material, old jobs, invoices and other documents in plastic folders inside ring-binder files, which you can buy from any stationery shop.

LESSON 9 DRAWING MATERIALS

films

TV

advertisements

games

animation

Storyboarding is one of the few jobs that, at its most basic level, still requires just a pencil and paper. In that sense, it's a job that gives you a lot of freedom. You can work on your storyboards in planes, on trains, and in the back of automobiles. If winter's getting you down, you can get out of town and take your work with you.

As far as other drawing materials are concerned, what you use is really a matter of personal preference, but there are two main factors to consider – speed and reproducibility. Storyboards need to be produced quickly, so you need to work with materials that are fast drying and efficient. And the storyboard will be photocopied and handed out to the production team, so it has to be done in a style that translates well when reproduced.

Play around with different materials and techniques, and find out what works for you.

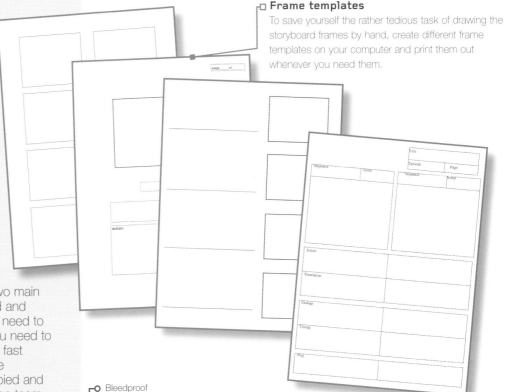

Frame templates

To save yourself the rather tedious task of drawing the storyboard frames by hand, create different frame templates on your computer and print them out whenever you need them.

Paper

Use regular letter-size copy paper. It's inexpensive and available from any office supply shop, and it's easy to scan and send by fax. You can also use special paper available from art suppliers (such as Letraset comic layout paper, bleedproof marker paper or tracing paper), which is semi-transparent so that you can trace pictures, photos or your previous sketches.

Bleedproof marker paper

Tracing paper

Regular copy paper

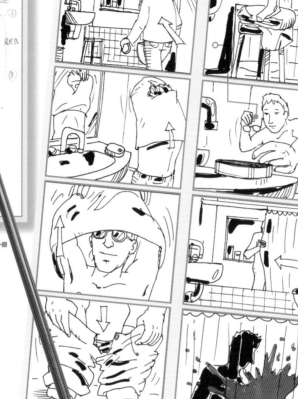

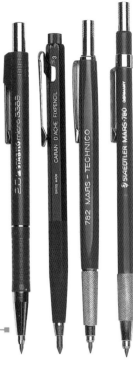

Work in red pencil

Make your original sketches in red pencil, so that you can easily clean them up with a regular pencil without having to use a light box. Red pencil doesn't show up when the work is photocopied, making it easier to do a clean-up of your work.

Pencils

Any 0.5 or 0.7 rechargeable pencils are practical.

Rulers

Keep rulers handy. If they're stashed away in a drawer, you probably won't bother getting up to use them, and you'll end up with wobbly lines. Really small rulers that you can easily take with you or use when travelling are helpful.

TIP

Have extra markers, pens, printer ink and paper available, so that you don't suddenly run out of something in the middle of the night or on a weekend when you're working to a tight deadline.

Grey markers

Use a warm grey marker to add shadow and depth to black-and-white frames.

Colour markers

Professional colour markers are easy to use and fast drying. Most brands offer sets that contain a good range of colours. Use a fine-pointed marker pen (0.3 or 0.5) and a wider (0.7 or 1.0) point for contours. To ink a large space in black, use a wider-tipped permanent marker pen.

Refillable markers

Markers are quite expensive, so buy a refillable variety and purchase extra refills of the colours that you use frequently.

TIP

To make corrections in a frame, instead of redrawing the whole thing, use a white pen or correction fluid, or even stick a white adhesive label over the top and draw on that.

Light table or light box

A light box is useful for cleaning up sketches and for tracing photos – for instance, if you have to reproduce a particular vehicle or product. There are some good light boxes on the market that photographers use for viewing transparencies. The smaller sizes – roughly 21 x 30 cm (8 x 12 inches) or A4 size – are not very expensive. They don't get too hot if you leave them on for a long time, and they're reasonably thin (approx. 1 cm/½ inch), which makes them easy to use. Some light boxes can be quite bulky and cumbersome. In animation, it's common to work at a light table, although this can be awkward if you're not used to it.

White pen

Use a white pen to quickly add highlights and details to a frame and enrich the image.

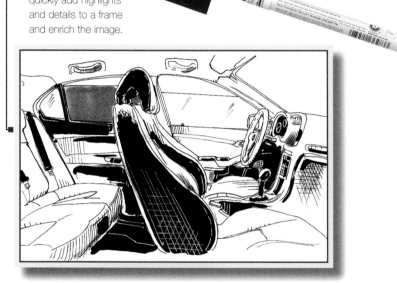

HOW TO MAKE YOUR OWN LIGHT BOX

Build a simple box out of plywood, as shown, to suit your particular requirements. For example, if you need to take it around with you, it needs to be just a little larger than an A4 sheet of paper. You can buy a sheet of glass for the top from glass suppliers or home improvement shops, or you can use Plexiglas or opaque white plastic. Add a couple of halogen lamps and a simple switch and there you have it!

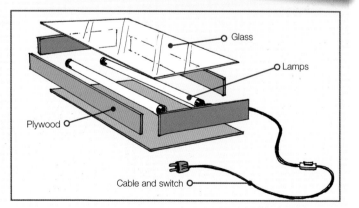

Glass

Lamps

Plywood

Cable and switch

LESSON **10** DIGITAL EQUIPMENT

films

TV

advertisements

games

animation

In recent years, the computer has become increasingly important in the creative process of storyboarding. The kind of computer that you invest in depends on your budget and the type of work you intend to use it for.

Computer

You don't necessarily need a computer to create your work, but you'll definitely need one to send and adjust scanned versions of your material to clients via email. The computer is also great for creating and printing out frame templates (see page 38). It really doesn't matter whether you use a Mac or a PC; it depends what you're comfortable with, because, for the most part, they support the same software. As for software, Adobe Photoshop is the program most commonly used.

Drawing pad

If you're skilled on the computer, you might want to consider investing in a drawing pad such as Wacom.

Printer and scanner

You'll need both a printer and a scanner. There are some good all-in-one printers on the market today, which include a printer, scanner, copy machine, fax and smart card reader for downloading photos from digital cameras. They are a good solution: with just one USB cable and a little space, you have equipped virtually an entire office.

USB key drive

These portable external hard drives are about the size of a key and come in different capacities – 128MB, 256MB, and 512MB. They're great when you're travelling or have to go to a meeting and don't want to take a laptop computer. You can back up recent work on the key, and then plug it in and work on any computer.

Digital camera

The digital camera is another instrument that has become necessary to the storyboard artist. A huge number of models are on the market, and you can often find a bargain. Cameras with a large built-in display are the most useful, so you don't need a computer to go through your pictures. Clearly, the smaller the camera, the more practical it will be when you are drawing sketches on location.

UNIT 3:
DRAWING SKILLS

DRAWING SKILLS

films

TV

advertisements

games

animation

Many aspects of storyboarding are quite technical and so can be learned, but an ability to draw is essential to start out in this field. Obviously not everyone is able to draw everything with ease – and even the best artists need to look at other images from time to time to create an illustration. So don't worry if you feel that your artistic skills are limited. In fact, knowing your limitations is good for you as it means you are aware of the areas on which you need to work.

The best way to learn how to draw is to copy. In this way you learn how to reduce your lines to the essential, and you also become more confident in your ability.

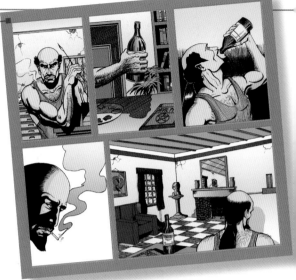

Composition and continuity
(See page 58)

The comic artist creates his or her stories in a cinematic way, which is useful for the storyboard artist to study. Look at how from the first mid shot of the character we then cut to a close-up of the bottle, then to the man drinking followed by his intense close-up, ending with a wide shot of the environment.

Effective use of perspective (see page 68) is an important drawing skill for the storyboard artist.

Viewpoints

Comic artists often use extreme views in their work, such as this low-angled shot (see page 99). The storyboard artist can learn from this method of creating a dynamic composition.

Sci-fi comics and film work

Many comic artists are specialists in science fiction and have very powerful imaginations. They are often hired to work on sci-fi films or as designers for special effects production houses.

TIP

Keep comics, art and illustration volumes, photographic books, magazines, and other forms of reference – basically, anything you can use as a source of inspiration. Gather together examples of the work of artists you particularly admire, and study their drawings. If possible, meet your idols in person. A number of storyboard artists come from the world of comics, and comic conventions, where big names from all over the world are invited to meet with the public or to present their latest creations, are a great place to meet them. The most famous is the San Diego Comic Convention in California, which is held each summer between July and August. Many artists are extremely patient with their fans and, when possible, are happy to give advice and answer questions.

OVER TO YOU

A good exercise for an artist interested in the art of storyboarding is to adapt comic book pages into storyboard frames. In a comic the size of the frames tends to vary but on a storyboard they stay the same size. Learning how to frame the action within same-sized image frames and how to create continuity are important skills for the storyboard artist.

Comic conventions

Along with publishers trading their comic books at conventions, there are also film industry people scouting for new drawing talent and agents looking for new artists to represent. These are good places to make contacts and show off your portfolio.

LESSON 11 DRAWING STYLES

films

TV

advertisements

games

animation

Nowadays, accessing storyboards created for big film productions is relatively simple: just look at the special features section in most DVDs. Be careful, though! You're looking at a feature film, and that type of job requires a different style than that used in advertising. However, this still gives you the chance to see the work of a substantial number of artists. Alternatively, make a note of the names of the artists listed in the film credits, and then look them up on the Internet. Most professionals have their own website, with examples of their most recent work.

The Internet is also the easiest way to find examples of advertising storyboards. It's really interesting to see the differences between boards created for feature films and boards created for ads. Researching artists in this way also means that you become aware of the styles that the different production houses prefer.

You can often find material lying around in the offices of advertising agencies, and their warehouses stock a number of old storyboards mounted on black card. This can all give you an idea of the type of work the agency is used to receiving from artists. Big agencies such as Saatchi & Saatchi, for example, nearly always prefer working with classic and traditional storyboards, the so-called "old school". This is because big companies have offices all over the world and very often collaborate with each other for international clients, so the style of the drawings needs to be acceptable to most cultures (see page 51).

Humorous style

A number of storyboard artists come from the world of comics, but advertising storyboards need to be as realistic as possible. Their purpose is to sell products and to convince a client to invest enormous sums of money in the production of an advertising spot, and so a humorous approach is generally not appropriate.

Different styles

As you can see, a frame can be created in a number of different ways.

Frame 1

This solution is too cartoonish and many agencies prefer not to adopt this style.

Frame 2

In this frame cross-hatching has been used ineffectively – there are too many lines which make the image look "dirty".

Frame 3

This frame offers quite a good solution. It is a little bit rough but it can be effective and it is the faster way to sketch if using a marker instead of a computer.

Frame 4

This image is the best choice – simple, clean and immediate to understand. The key is to always be "essential".

Filming style

"Style" also refers to the way in which sequences are filmed. A scene could be created by working on "corners" or by filming from just one camera position.

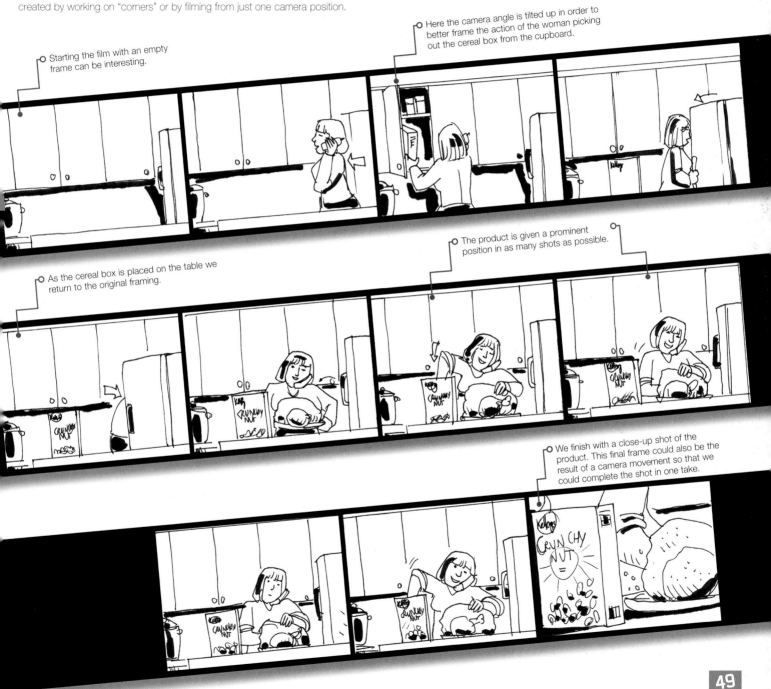

Starting the film with an empty frame can be interesting.

Here the camera angle is tilted up in order to better frame the action of the woman picking out the cereal box from the cupboard.

As the cereal box is placed on the table we return to the original framing.

The product is given a prominent position in as many shots as possible.

We finish with a close-up shot of the product. This final frame could also be the result of a camera movement so that we could complete the shot in one take.

For animation, the question of an artist's individual style is not so relevant, as here you need to be able to reproduce the style of the show on which you are working. You need to be able to assimilate the creator's style and the design specific to the cartoon. This is not always easy, and it is mainly for this reason that animation studios have a system of selection tests, which can be quite hard to pass.

In the following examples, you can see how the approach varies depending on the purpose for which the storyboard is required. The difference in approach is due mainly to the time available for producing different types of board. For example, big advertising agencies usually allow more time to hand in a storyboard – unless there is a last-minute presentation to be done. In film production, you often have weeks to complete your work – but remember that the amount of work is huge compared to that required for advertising campaigns.

① Black-and-white ink

Clean and simple black-and-white ink won't disappoint anyone. If unsure about the agency's preferences in storyboard styles this one could be your safest choice.

② Coloured inks

For a client presentation a colour storyboard is the best choice. Unfortunately to achieve such a good-looking board you need to spend a lot of time on the colours. In the example the colours have been applied in Adobe Photoshop.

③ Grey tones

Grey tone falls between the previous two examples. It's good enough for most situations and can also be presented to a client. Sometimes it's preferable to show the client a board in grey scale to make them focus on the storyline rather than the details.

④ Different strokes

Another black-and-white inked example but this time using different thicknesses of pen. Compared to the first example this rendering is softer.

⑤ Mixed up

This is a mix of black-and-white ink and pencil. It is quick to execute and preferable when working on a film and producing over a thousand frames.

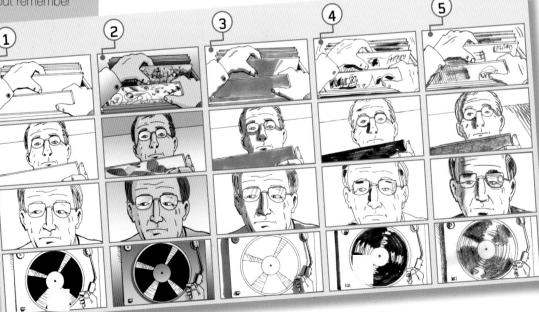

Different comic styles in different countries

The American market is dominated by the presence of superhero comics, which leads to a style that tends to exaggerate forms, muscles and action. In Europe, the predominant style has a more realistic element. There are also differences between the various European countries; Spain and France, for example, go for a more humorous approach. Italy has a number of publications in which the drawings are more realistic.

The stereotypical "muscle man" dominates the US comic market.

Simple black and white

Black-and-white ink is also one of the most practical styles as it can be faxed and photocopied easily.

Adding shades of grey

Adding shades of grey gives a more elegant style that allows you to give depth to the images.

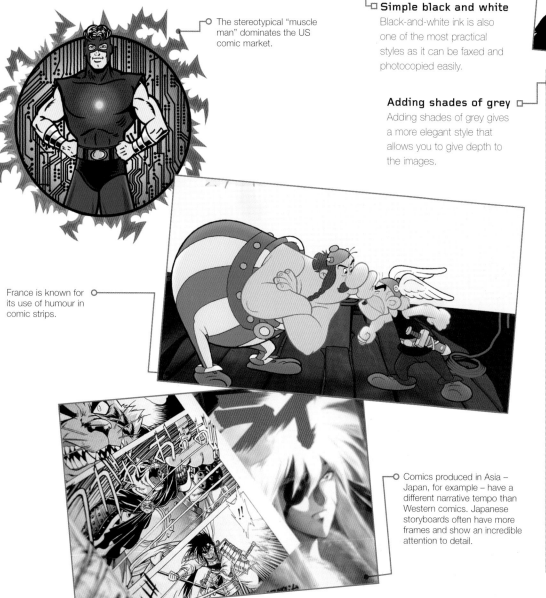

France is known for its use of humour in comic strips.

Comics produced in Asia – Japan, for example – have a different narrative tempo than Western comics. Japanese storyboards often have more frames and show an incredible attention to detail.

To develop your own skills and style, it's absolutely vital that you practise – and so you should get used to drawing even when you're not working. Have a sketch pad handy or a file into which you put all your work. If there is something you don't feel that you can achieve, then have the discipline to practise. For example, many artists find drawing cars quite difficult. Actually, drawing a car from memory is not that simple even if you see a particular model every day in the street. It's the details that escape you. These are all elements that generally appear in storyboards and so you need to be able to draw them.

Get into the habit of storing all those sketches and drawings that you do in your spare time. It can be really interesting to look back through your old sketches; you may find an illustration you never finished, or inspiration for some unrelated job.

Another suggestion is to gather reference material every time your hand goes to a magazine. You never know what will turn out to be useful in the future – for example, a photo of a beautiful galloping horse. Be honest – how easily could you draw one without reference material?

Comic shops

Comic shops have on their shelves a number of imports, or catalogues from which you can order the material you want. And you always have the Internet as a source for your research.

Practise drawing difficult subjects

If you find drawing cars difficult, draw every model that you can find, so you'll be able to recognize their basic shapes and details.

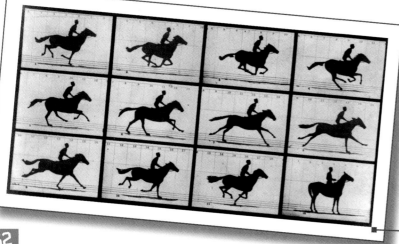

Collect reference material

Reference material showing movement or difficult poses is very helpful. Build up your own personal library of animals, people, vehicles, buildings – whatever might be useful.

Practise drawing from magazines □

To get used to drawing the human figure, copy images from magazines,
drawing people in various positions and engaged in daily tasks. After a while,
you will gain more confidence in your ability and develop your own style.

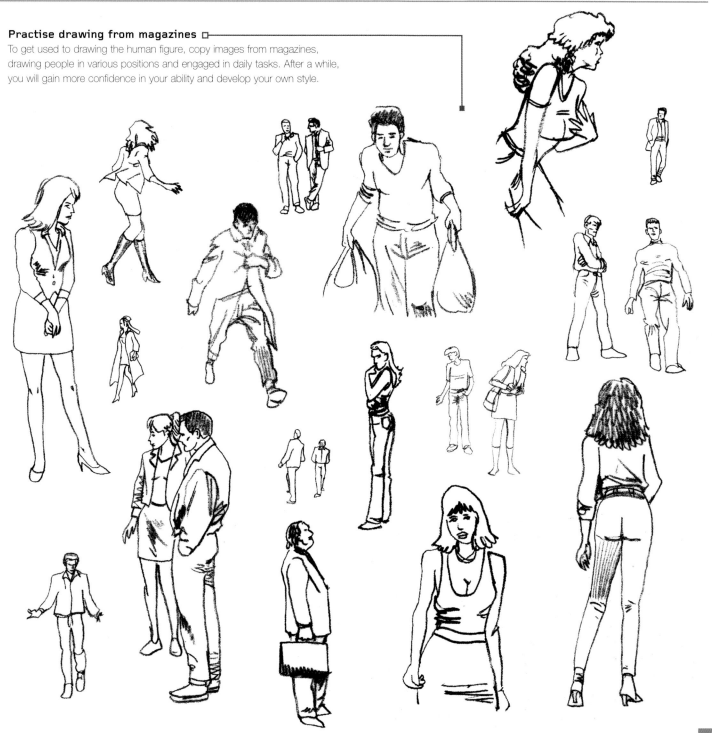

LESSON 12 SIMPLE FORMS

films

TV

advertisements

games

animation

Learning to streamline drawings using simple shapes, as in the examples on these pages, is very useful when you are working with a director who is instructing you on the frames to produce. There's always very little time available and a lot of work to get through, so you need to reduce the time you spend in meetings to the minimum. Obviously, everyone has a different drawing style; the important thing is that your sketches will be clear to you once you get back to your studio. If necessary, write any important notes in the frames.

A lot of information in a storyboard remains vague in any case, even once you have finished the job. For example, it's possible that no specific location has been decided for a given scene; in this case, it's better to reduce all details to the bare minimum, as seen in the examples.

To get used to sketching with simplified shapes, use photographs (see page 57).

Annotate your rough sketches ▫
Remember, directors are very busy people who can't be contacted easily, so it helps to add annotations with all the information you might need before you begin.

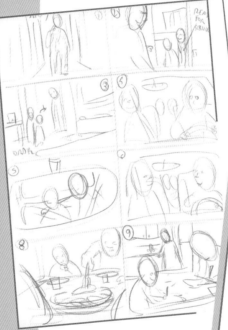

▫ **Simplified forms**
In rough sketches the bodies of the characters can be suggested with circles for heads and a few lines for the bodies.

Filling in the details ▫
Try working on the rough sketch on your way home from the initial meeting or if you have to wait for another meeting.

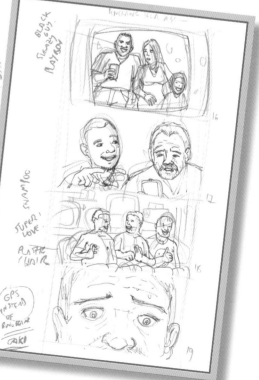

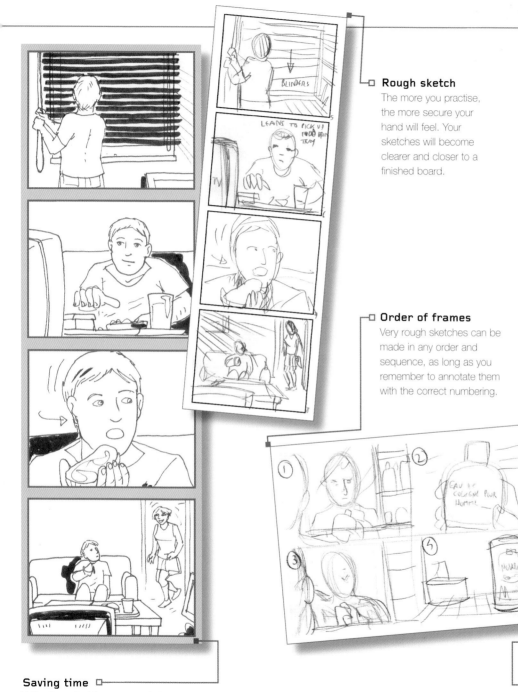

Rough sketch

The more you practise, the more secure your hand will feel. Your sketches will become clearer and closer to a finished board.

Order of frames

Very rough sketches can be made in any order and sequence, as long as you remember to annotate them with the correct numbering.

Saving time

With clean sketches not much time is needed for clean-ups when you've finished and your output rate will become more effective.

Finished storyboard sequence

For the final storyboard, the order of frames needs to be correct as there will be no numbers.

First series of sketches

After the initial meeting the director, or another member of the creative team, might want to take photocopies of your sketches for reference. If this happens, wait for their comments before working on the clean-ups as you'll need to incorporate their comments.

Doubling up

Don't be afraid to copy and paste frames on your board. It's common practice in advertising because storyboards for commercials often need to be delivered the next day.

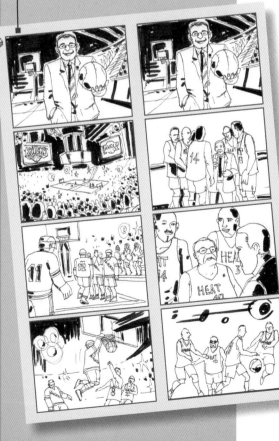

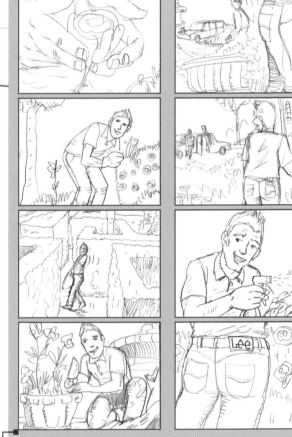

Using pencil

After a briefing meeting you might have to draw cleaner sketches, perhaps more detailed than usual, in order for the director to discuss the film with the producers and take the production to the next stage. However, you won't be expected to make these sketches during the meeting. Work in pencil: it will be faster and easier to make adjustments and revisions.

OVER TO YOU

To get used to sketching with simplified shapes, use photographs. With the help of a friend, shoot your own photo sequence and then draw the photos as rough sketches, as quickly as you can. Then complete the drawings, using just the sketches, without looking at the photos. This will help you get used to simplifying your drawings and to using just a few lines to convey all the information you need.

1 Photo sequence
Plan a sequence as if you are shooting it for a film. Start with a mid shot and then move to a close-up, as shown in the example below.

2 Rough sketches from photos
With the digital camera display in front of you (or a monitor if you can download the photos on a computer) execute quick sketches from the images you have taken.

3 Finished drawings from sketches
At this point, with the help of a light box, trace your sketches into stylized and simple drawings.

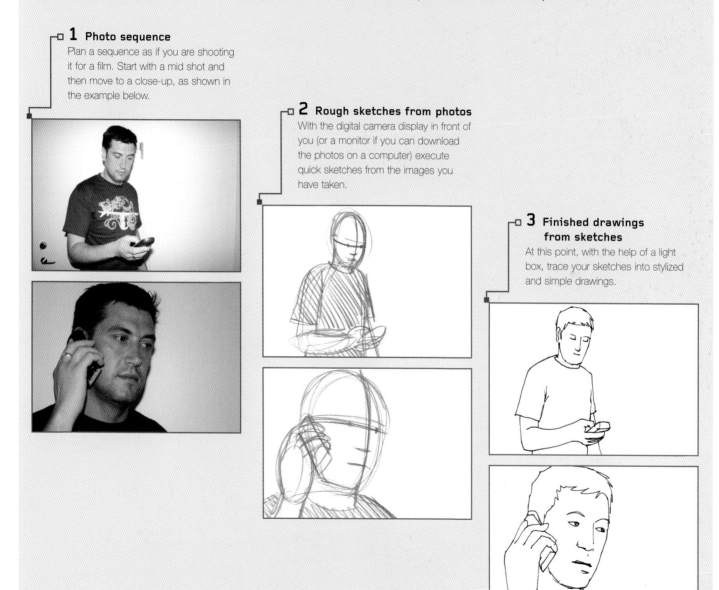

LESSON 13 COMPOSING FRAMES

films

TV

advertisements

games

animation

The way you compose storyboard frames is very important. In many cases, you will only be producing a guideline for the film crew, with no guarantees that it will be followed to the letter, but you should always make sure that the frames are clear and well drawn, and that all the elements are balanced. Never add details that might distract from what is really important.

Nevertheless, it can sometimes be useful to add some elements, if only to give the composition a better balance. This can provide the production team with inspiration – and your suggestion may even be picked up by the set designer and used in the film.

Unbalanced composition
In this frame there is a large amount of white space on the right-hand side that gives an unbalanced feel to the composition.

Balanced composition
The addition of the tree echoes the dominant object of the frame (the figure) without detracting from it.

Head room
A good general rule is to leave more space in front of a character than behind. For example, in close-ups and during dialogues when a character is positioned in a three-quarters shot, it's natural not to centre the character in the frame. The amount of room that you leave around the head is also extremely important.

In-camera composition

Use a camera to practice and improve your compositional skills, and try to compose the shot through the viewfinder so that good composition becomes an instinctive process. Practise analysing photographs and cropping the image according to your needs, so that you get used to creating a strong composition quickly.

Director's viewfinder

On a film set the director will use a viewfinder in order to find the best composition for a shot.

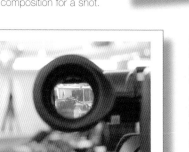

Framing a scene

Have you ever seen a director positioning his or her hands to "frame" a scene? This is the easiest way to isolate elements and to create a good composition. Why don't you try it? Once you've done that, quickly sketch the scene from memory.

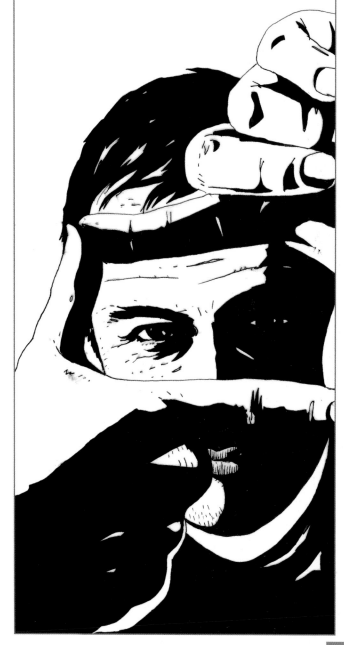

LESSON **14** DRAWING FIGURES

films

TV

advertisements

games

animation

As a storyboard artist you do need to be able to draw the human form. Not only this, but you also have to be good at drawing people in different positions and of different ages. All this can be achieved with practice.

Start by drawing the "perfect" human body illustrated in all art books or medical manuals, so that you learn the proportions of the body and its parts, and understand the differences between the male and female form.

The best anatomy books are those used by university medical students, and you can easily find them in large bookshops. There are also a large number of books aimed at artists, full of photos and illustrations of the human body in motion.

You should also practise drawing the naked form from life. Ask your local art school or college if they run life-drawing classes. Some colleges will allow you to take part in just one class without being enrolled in a full course.

When drawing figures in movement, an artist's lay figure is a great help. These are made of pieces of wood connected by wires, enabling you to move each joint or body part as required. Because they present a simplified version of the human form, they also show you how the body can be broken down into a series of simple shapes, which is a good starting point for any drawing. Lay figures are available from most art and craft shops, and vary in both price and size.

The male figure

Lay figures are androgynous, so you will have to rely on your own observation and experience to differentiate the male from the female form.

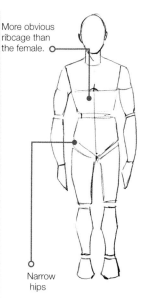

More obvious ribcage than the female.

Narrow hips

The female figure

The "standard" female has narrower, more sloping shoulders, wider hips, a longer neck and slightly shorter arms than the male. There are, of course, many differences from person to person – in a very thin woman the skeletal structure will be obvious, while in a larger-sized woman the bones will only show at certain key points, such as knees, wrists and ankles.

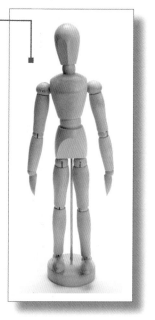

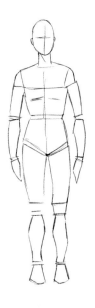

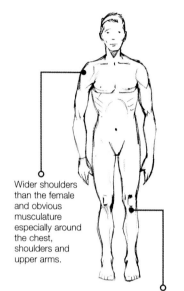

Wider shoulders than the female and obvious musculature especially around the chest, shoulders and upper arms.

Knees and shin bones are more obvious than those of the female.

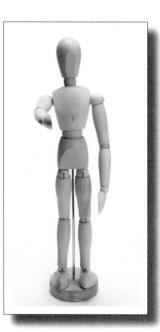

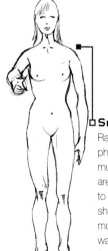

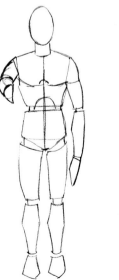

Male figure, walking

When a person walks, the centre of balance shifts from one foot to the other, with the shoulders and arms moving to act as a counter-balance.

The muscles of the chest, shoulders, arms and legs will be flexed, and thus more obvious than in a relaxed pose.

Less of the bone structure and musculature is visible on a woman.

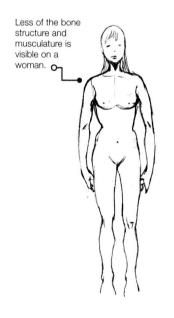

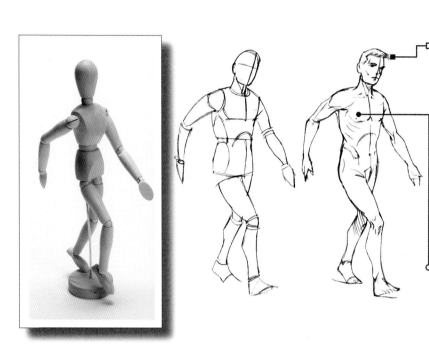

Small movements

Raising an arm requires little physical effort, so the only muscles that are affected are those of the arm, and to a lesser extent the shoulder. More strenuous movements, such as walking and running, affect the whole body.

Once you have mastered the basics, you can start to change body shapes. This is an excellent exercise as it helps you to understand and summarize the different types of bodies in a few lines. Remember that when you work on a storyboard, you are working on shapes that are very simple and approximate. For example, in a picture of a man running we are interested in the dynamics of movement and his shape, which will generally be roughly sketched in the final frame.

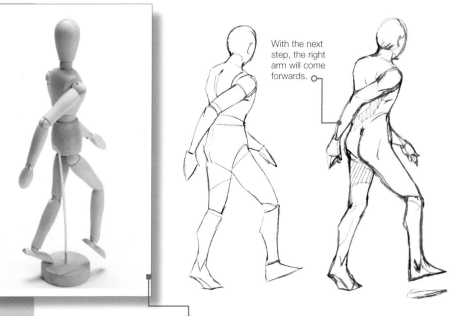

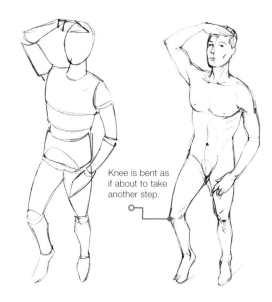

With the next step, the right arm will come forwards.

Walking, rear view
This drawing gives a clear picture of the way the whole body moves according to which leg is taking the weight.

Looking uphill
This drawing is hinting at a specific story, with the walker in mid-stride, and apparently considering the difficulties of the uphill gradient he is about to tackle.

Knee is bent as if about to take another step.

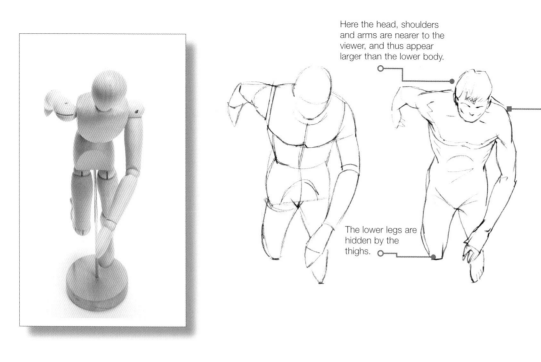

Here the head, shoulders and arms are nearer to the viewer, and thus appear larger than the lower body.

Walker seen from above

If you want to change the viewpoint from the normal eye-level one, you must observe the effects of perspective.

The lower legs are hidden by the thighs.

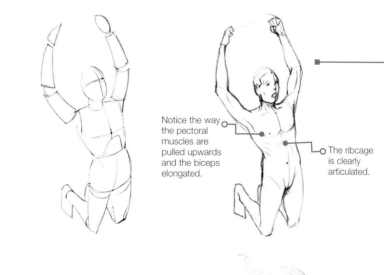

Jumping

The lay figure really comes into its own for poses like this, but an understanding of anatomy will make the drawing more convincing.

Notice the way the pectoral muscles are pulled upwards and the biceps elongated.

The ribcage is clearly articulated.

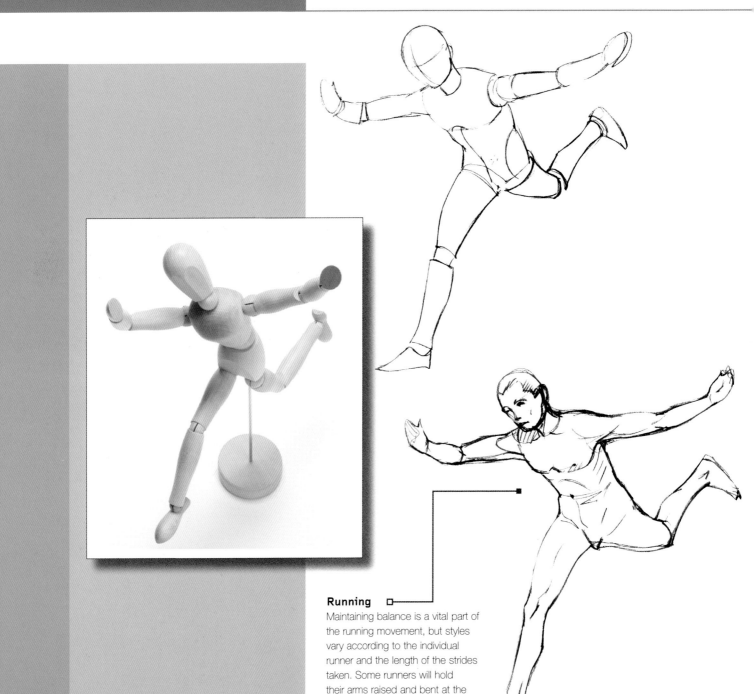

Running

Maintaining balance is a vital part of the running movement, but styles vary according to the individual runner and the length of the strides taken. Some runners will hold their arms raised and bent at the elbow, with fists clenched rather than outstretched as in this dramatic depiction.

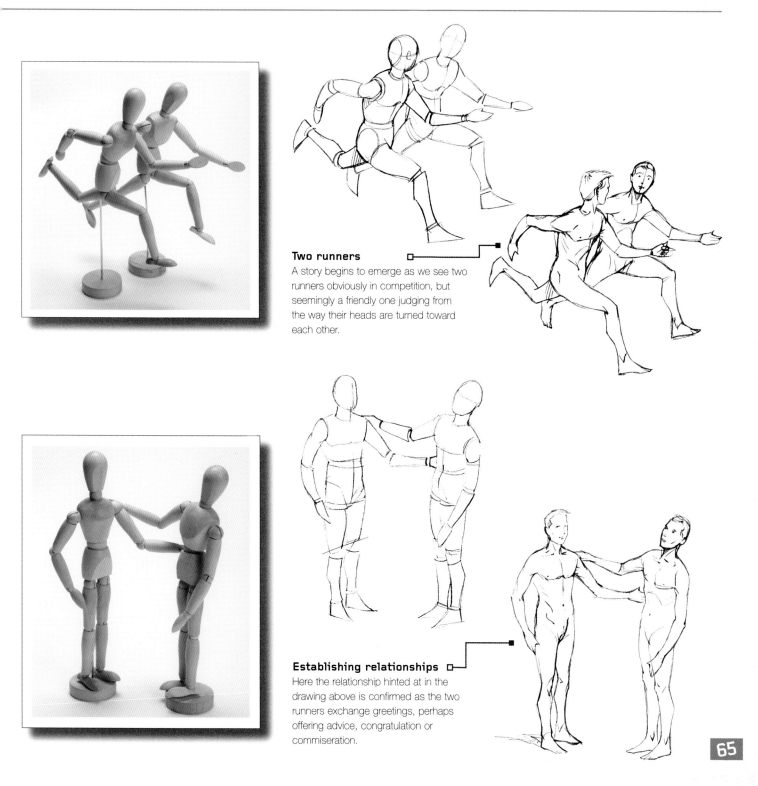

Two runners

A story begins to emerge as we see two runners obviously in competition, but seemingly a friendly one judging from the way their heads are turned toward each other.

Establishing relationships

Here the relationship hinted at in the drawing above is confirmed as the two runners exchange greetings, perhaps offering advice, congratulation or commiseration.

65

DRAWING RESOURCES

One of a number of mistakes that beginners make is to forget that the human body has a certain "weight". You need to be able to represent the body's weight in your illustrations.

A camera is of great help when practising, but studying the work of the great artists of the Italian Renaissance, such as Leonardo da Vinci and Michelangelo, can also be very instructive. From their work, especially from their sculptures, you realize just how much they knew about the human body. It was the result of years of study.

Another useful exercise is to try and construct anatomies in complicated positions or from different camera angles. For example, how would you see someone from above, or from a certain angle?

Get used to working on faces. Many artists have a mirror next to their desk, so that they can study a particular facial expression when needed. And even though they are not often needed in storyboards, if you have some spare time, study shadows. Knowledge of the human body and the way in which shadows work will be useful if asked to do conceptual art drawings.

Leonardo da Vinci's sketches

Study sketches of human anatomy by Leonardo da Vinci. He made hundreds of illustrations while analysing the human form.

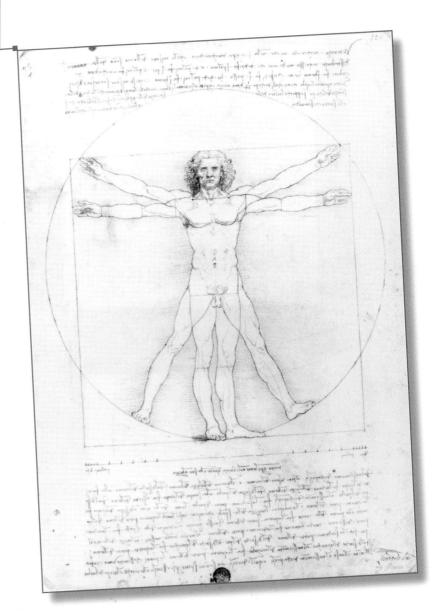

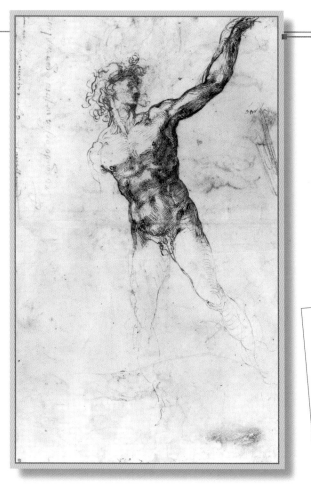

Sketches by Michelangelo

Michelangelo devoted much time to the study of nude figures and was able to complete them quickly. Look at his sketches and note his rendition of anatomies.

OVER TO YOU

An interesting exercise is to copy someone from a photo, maybe from a newspaper, and then to age it or change it to create different versions of the same person. This exercise will help you to pinpoint the facial characteristics of an individual and to simplify them to just a few lines. The ability to do this is extremely important when you are working on a screenplay with a large number of characters who need to be reproduced in hundreds of frames.

LESSON **15** PERSPECTIVE BASICS

films

TV

advertisements

games

animation

Perspective – the two-dimensional representation of three-dimensional objects, or creating the illusion of depth – is another important element that storyboard artists need to study. Here's a brief summary of what it all means.

If you draw two separate figures on a sheet of paper, it isn't obvious which one is closest – but if you superimpose them, then you create the illusion that one is closer than the other. If you want to give the illusion of depth using two figures that are the same shape and size, all you have to do is reduce the size of one of them, which has the effect of making it seem further away.

Another classic way of demonstrating perspective is to look down a set of railway tracks. In reality, the tracks are parallel to each other – but to create a sense of distance in a drawing, they need to converge at a point known as the "vanishing point". This is known as single-point perspective, because both tracks converge at the same point.

When you apply the same system to a more complex subject of which you can see two sides (the front and side walls of a house, for example), each side has a different vanishing point. This is known as two-point perspective.

One-point perspective

Here we can see the most obvious example of a one-point perspective: railway tracks receding into the distance and the imaginary vanishing point on the horizon.

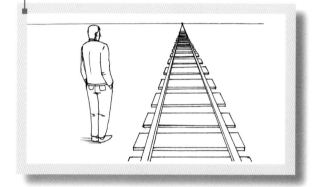

The vanishing point

Two-point perspective

Two-point perspective exists because we live in a three-dimensional world. By constructing two vanishing points, each one appearing at a different point on the horizon, we can simulate the three-dimensional effect of objects in space on a two-dimensional, or flat surface.

First vanishing point

Second vanishing point

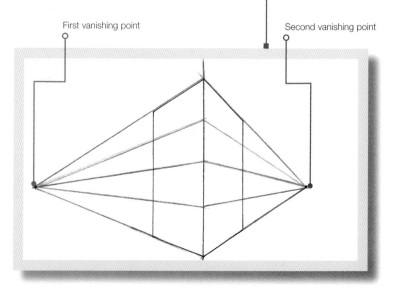

Creating distance through variations in size

By reducing the size of the farthest figure on the right, the impression is given that he is the farthest away from the viewer.

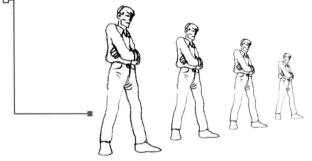

Three-point perspective

Three-point perspective takes into account the concepts of up, down, length, and breadth. With three-point perspective we can create bird's eye (see page 102) or worm's eye views (see page 103). This is achieved by showing that, as well as tapering off into the two-point distance, objects in space also go off to a third point either above or below, depending on where we are standing when we observe these objects.

Third vanishing point

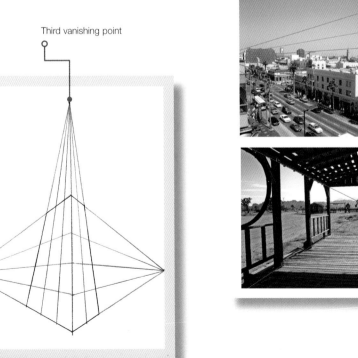

OVER TO YOU

To understand how perspective works, look at things in a photo that have straight lines – roof lines or a pavement, for example – and try to detect their vanishing points, as shown in the pictures below.

By using a digital camera, you can also see how the perspective changes when you change the slant and angle of the image. Changing the angle of an image is a really useful exercise, because when you draw a storyboard you often need to exaggerate some shots to make them more obvious, even if this angle will not be so dramatic in reality. For example, if you exaggerate a low-angle shot in a storyboard, the production team will be aware of it, even if they then shoot it from a normal low angle.

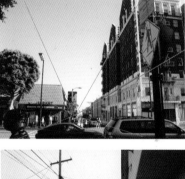

LESSON **16** DEVELOPING YOUR OWN STYLE

films

TV

advertisements

games

animation

As a storyboard artist, your style needs to be clean and simple, so that your lines are clear and can be easily understood. A clean, simple style also enables you to work quickly, which is essential in a deadline-driven world, and will also leave you time to make any necessary corrections.

It's natural for your style to develop over the years, but there are also things that you can do to help yourself along the way. Clearly, the more you draw, the more confident you become and this gives you a nice fluid hand. You must keep practising. It's normal to have a "heavy" hand if you haven't picked up your pencil for a while, so don't worry if, for example, you get home from a holiday and find that you can't draw as fast as you used to. It happens to everyone, professionals included; the important thing is to carry a small sketch pad with you at all times to jot down anything that catches your eye, so that you don't get out of practice.

You also need to have some sort of idea of how other artists work, so that you remain aware of what styles are commercial. Generally, production houses do not like working with storyboard artists whose style is too elaborate and "arty". An underground style, which would be all the rage in the comics world, does not work in storyboards.

Same image, different materials

A good artist always has a wide range of drawing materials in his or her studio. Experiment with them by reproducing the same frame in different media in order to get to know the effects and results of each of them.

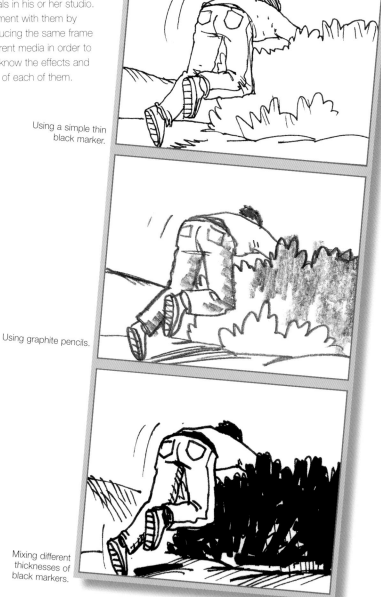

Using a simple thin black marker.

Using graphite pencils.

Mixing different thicknesses of black markers.

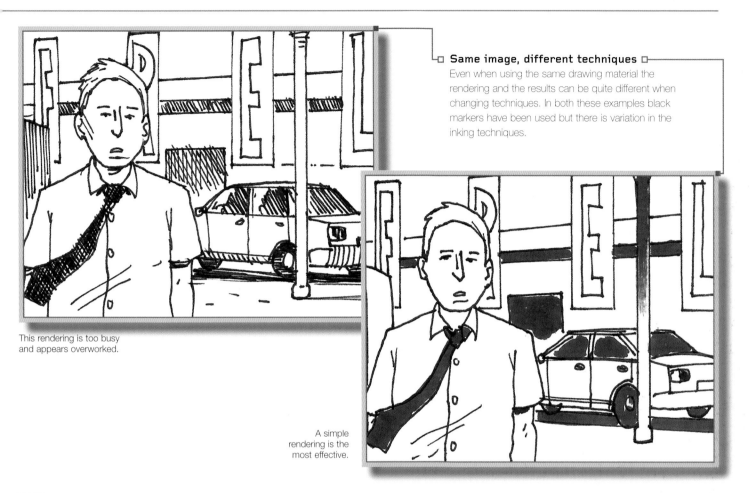

Same image, different techniques

Even when using the same drawing material the rendering and the results can be quite different when changing techniques. In both these examples black markers have been used but there is variation in the inking techniques.

This rendering is too busy and appears overworked.

A simple rendering is the most effective.

TIP

If you go over the outline of your main subject with a large-tipped marker, it will stand out more from the scene. However, do not overdo your storyboards. Often it is better not to keep touching up the board because there is a risk that you'll add unnecessary and distracting details. Begin by evaluating how much time you have to produce your work and act accordingly.

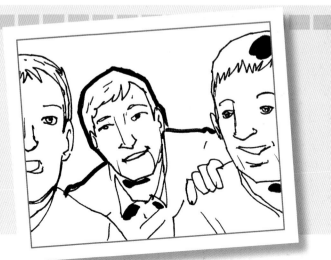

71

One of the more effective exercises to develop your own style is to draw an illustration and then reproduce it as quickly as possible, as if you were drawing without really thinking about your subject. At a certain point you will notice how your hand moves naturally and how drawing has been simplified to its basic components.

Detail is important for an artist and so, when you are just starting out, you always have a tendency to add details and to embellish your work, going over the image countless times. This is fine if the image is going to be published as an illustration or work of art, but for storyboards it is unnecessary.

You need to be versatile and to be versed in a number of styles, because this will enable you to adapt to different assignments in different settings – vital for a professional freelance storyboard artist.

Line techniques

Using one pen allows the storyboard artist to be as fast as possible while remaining true to the brief. Hatching and cross-hatching are used to show form and the direction that light hits the face.

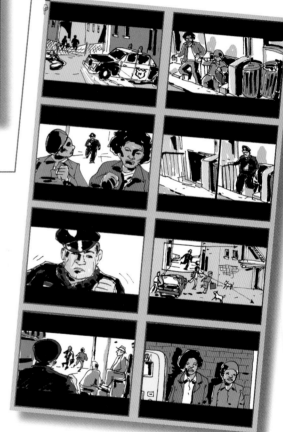

Introducing colour

This storyboard for a television commercial required a seventies feel. A black marker was used for the large black areas and the colours were added digitally afterward.

Creating atmosphere

This storyboard is an exercise in style and composition. A good way of developing your style is to copy stills from a well-known film in a sequence – this also helps with continuity practice. In this example only one pen was used and the techniques of hatching and cross-hatching created atmospheric shadows and patterns.

OVER TO YOU

Look at how the same illustration can be drawn by the same person in a variety of styles, simply by using different materials, which necessitate a slight change in technique. A line drawn with a marker is very different from one drawn with a pencil or painted with a brush. So, if you want to develop your own style, you need first to master materials and techniques. With a bit of experience you'll learn to use different tools to the best of your ability, and also to combine them to achieve a better end result. As an exercise, start by drawing the same image using different pens, markers and pencils, so that you get used to the different effects each one creates. This will help you to choose the right tool in future jobs.

The next stage of the same exercise is to use more than one tool in the same illustration and to work as quickly as possible. Remember this is not a speed competition; it's more to do with honing your skills and becoming more efficient in your drawing. Each of you will decide on the rhythm and speed that works best for you.

Sketches in red pencil.

Pencil sketch.

Black ink sketch.

Black ink and black marker.

Black ink and sepia marker.

Black ink and colour markers.

LESSON 17 GAINING CONFIDENCE

films

TV

advertisements

games

animation

This lesson is for all those people who need to develop confidence in their drawings and who are interested in the opportunities that this skill can offer – just don't expect to become Michelangelo over a weekend. It requires a lot of hard work, and you can only get better by practising. Although some simple ideas can be communicated by simple sketches (often created by the director or director of photography), as a storyboard artist you will need to create more realistic renderings.

One of the first ways to learn how to draw is to copy other people's work – from comics, for example. This is not cheating. All artists have done it at some time or another – yes, even famous comic artists and illustrators. Copying is also a way of improving your style and learning different techniques. There are amazing artists out there and copying gives you great insight into how they do their work.

Copying photos is another classic way of learning to draw, and it's a great way of improving your sense of realism and proportions. In fact, if you have a digital camera you can take your own photos and draw from them.

Pencil versus ink

Trace from your chosen photograph using pencil to begin with. Look at how little detail you need to draw a face. Once you are ready with the pencil work you can make a tracing of the pencil image in ink. If you are uncomfortable with ink, remember that sometimes storyboards can be drawn and presented in pencil.

Film language

Obviously, not everybody is talented enough to produce drawings on a highly professional level. But nevertheless, in this kind of business interpretation is an important skill. The positive aspect is that everything rotates around the same media. Once you know the language of films and the techniques, you'll be able to understand the notes and the codes that the director of photography will use in meetings and during production.

Floor sketch
This is the way many DoPs (directors of photography) or directors plan their shooting. The numbers represent the camera placements and the order of the action.

Simple sketch
The DoP or the director might create rough sketches to suggest the action in the scene. Sometimes this is what the storyboard artist receives and has to improve for the shooting board that will be handed over to the production team.

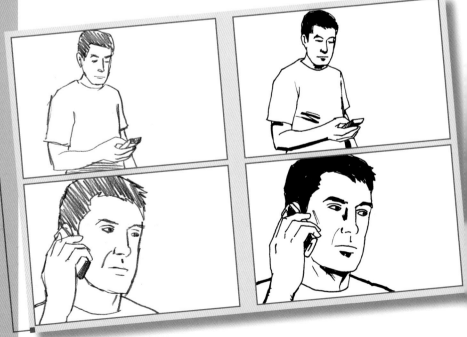

OVER TO YOU

Practise tracing and redrawing from photographs.

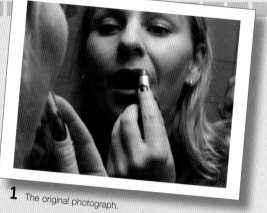

1 The original photograph.

Take a series of photos – for instance, a sequence of a friend entering a flat, opening doors, talking on the phone. Import them into your computer and print them out. Place them on a light box or light table and trace them. Then redraw the pictures using different materials and techniques.

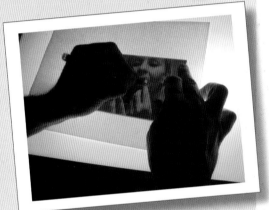

2 Tracing the photo.

An art projector is a similar tool that you may find helpful. Some kinds allow you to enlarge or reduce an image and project it on your desk so that you can trace or copy it. They are very convenient and easy to use. You can find projectors in any art supplier or on the Internet, and they are not very expensive.

3 The tracing.

Collect as much reference material as you can – a book about anatomy to help you draw figures, an animal atlas, car catalogues, and so on. The Internet is also a great resource for images and references; you can access almost everything you need, from the latest model of a car to a logotype, instantly.

Trendy magazines have lots of photographs featuring fashion and interiors that can not only be used as a source of inspiration, but also be useful for practising drawing. Drawing things like clothes, hairstyles, and shoes can be quite a task, especially if you have to reproduce or draw something realistically – so the best thing is to start by looking at photographs.

It's also really helpful to collect pictures, illustrations and photos from magazines in a binder so that every now and then you can just consult your personal archive for ideas. File the images by subject matter so that you can find them easily.

You can also copy from films. This will help you understand not only composition, but also framing.

Above all, remember that practice really does make perfect!

Original photograph
Quick snapshots of friends and family are useful for practising facial features and expressions.

Drawing
When working from photographs, remember that the drawing doesn't need to be too realistic. You are trying to get down the important shapes on paper and not create a portrait-style likeness.

OVER TO YOU

Get into the habit of carrying around a sketchbook and drawing from real life. If you're sitting at home or in a coffee shop and you have an object in front of you, just draw it. This will not only help you gain confidence in your drawing skills, but it will also help you to really start to look at things. Practise drawing people, too. People move, so you have to learn how to be essential with your sketches, and capture the moment as quickly and economically as possible.

Edit out details

When copying from photographs you'll learn not to include unnecessary details like the flower print on the shirt or the pattern in the wood of the floor.

Drawing

Only the basics of the kitchen are needed. Extra details such as the kitchen implements would detract from the main action of the scene.

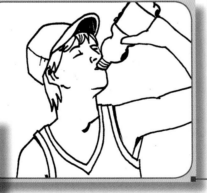

Cleaned-up version

If you work with red pencil first, your final image can be cleaned up and your "try-outs" will not be visible. The more you practise, the fewer unnecessary details you'll end up with in your drawings.

Sketching in red pencil

Using red pencils will make your life easier. While sketches are still unfinished and messy you can use a black or blue pen or pencil to define the cleaner lines for the finished image. The eye will then select and focus on the black lines that have been drawn over the red pencil.

UNIT 4:
REQUIREMENTS FOR DIFFERENT TYPES OF STORYBOARD

REQUIREMENTS FOR DIFFERENT TYPES OF STORYBOARD

films

TV

advertisements

games

animation

A storyboard artist must know and understand the different fields of work he or she could be involved in, in order to be able to adapt to the different requirements of various assignments. Every job varies for many reasons. It is not just a matter of drawing pictures on demand. Often extensive research is required about the approach to the job, how meetings will be set up and how to follow the development of a project in a particular production company.

To evaluate all of that you first need to know the possibilities and the types of work for which you might be hired.

Illustrations for a print commercial
When drawing an illustration which will be used later on by an ad agency you will also be instructed on the space available for the copy. The key here is to keep your drawing simple. Sometimes it will be your picture that is used as a guideline for the photographer.

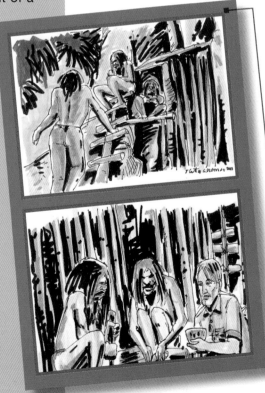

Conceptual art
(See page 156)
Producing conceptual art is interesting because it allows the artist to experiment and be more artistic than the usual storyboard panels job will allow.

As always, plenty of research is needed. You will be provided with material, but collect as much as you can yourself too. Sometimes the production company offers to reimburse your expenses for research material as long as you save the receipts. Always get this agreed in writing before you begin!

Feature film production drawing

Sometimes key frames (see page 128) are produced when presenting a feature film project. The sketches vary a lot depending on the stage that the production has reached. They may be quite vague if the filming locations have not yet been scouted.

Production drawing stages

As you can see, the house has changed from the very first sketch. The initial sketch would have been circulated around the studio and amendments suggested.

Colour in advertising

Use colours only when really necessary. If their client is a difficult one, the advertising agency might suggest that you keep things simple since many redraws could be necessary.

Final stage for feature film

Sepia tone can give an artistic look to the illustration. If no preferences for colour are given, don't be afraid to make your own suggestions during the initial meeting.

Advertising sketch
(See page 16)

Pencil is good enough for storyboards for commercials. Learn to sketch quickly during the meetings while being briefed on the project.

LESSON 18 CLIENT BOARDS

films

TV

advertisements

A client board is used by an advertising agency to present an idea or concept to a client and in internal meetings. It's usually detailed, often in colour, and consists of only a few key frames – the most important and relevant moments of the film. The art director or the person in charge will describe the proposed film using the boards as visual aids. At this stage, the concept has not been approved, nor has a director been appointed, so there is no need to go into the technical shooting details. And even when a director has been appointed, he or she will most likely rewrite the idea – in which case, a new client board may be required, still without getting into the technical details.

A client board is also used if a television commercial needs to be tested on an audience before the company embarks on the costly procedure of filming. In this case, the storyboard needs to be as clear as possible and in full colour.

Remember, a client board is about selling an idea, not executing it.

One mistake that storyboard artists tend to make while working on a client board is to start worrying about discrepancies in the sequence or the technicalities of shooting. Don't. At this stage, focus on the mood and the general concept.

The worst thing is having a client request revisions to illustrations that you've worked so hard on. Some of these requests are a real waste of time – changing the colour of a character's shirt or a character's hairstyle, for example. At the client board stage, these kinds of amendments are not necessary, but script revisions are. Fortunately, most advertising agencies will explain what's important in the storyboard if the client is worrying about unnecessary details.

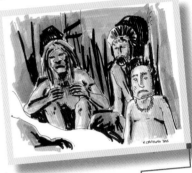

Mood pictures ▢⌐

"Mood pictures" are used in animation rather than client boards and give the general feel of the cartoon or depict key moments. Sometimes these can be really beautiful paintings and are published in the "making of" books.

Feature film storyboard ⌐▢

Live action feature films sometimes require a storyboard for a whole script that still has no director, in order to help attract financiers to the project. It may not be used once a director is appointed. Here we can see how a sketch can change from one meeting to another. Compare this initial key frame sketch to the ones below.

⌐▢ **Image 1**

The new director decided to widen the ratio of the frame in order to show a larger room with more characters in the frame.

⌐▢ **Image 2**

Widening the screen suited the script better and showed that the room belonged to a big mansion.

⌐▢ **Image 3**

Once the sketches were agreed upon with the director, a clean-up could be done and black ink added in appropriate places.

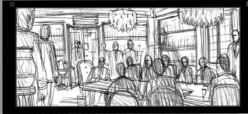

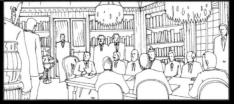

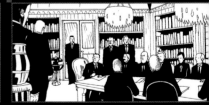

Print ad sketch

A storyboard artist is often asked to draw illustrations for potential print ads. The same process used for client boards applies here.

Music video board

Music videos might start with just an idea, which is illustrated to the client with the aid of a simple client board. Once that's done and approved, the director, or sometimes the director of photography, will probably draw their own shooting board, unless the video clip requires a lot of special effects (F/X), in which case, they'll need a professional storyboard for the production team and F/X studio.

Making revisions in Photoshop

If you use the computer for adding colours, save them on different Layers in Photoshop. Often a revision can be easily done by simply redrawing a small element of the frame.

Image 4

Shades of grey were also added digitally to complete the image.

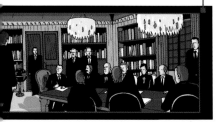

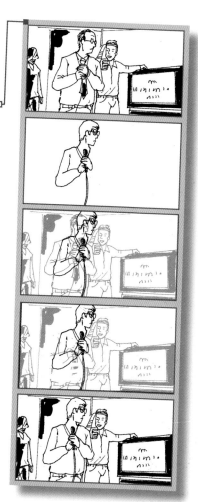

LESSON **19** SHOOTING BOARDS

films

TV

advertisements

games

animation

A shooting board is intended for the director and production crew. It will be rendered in less detail than a client board, but will be more technically detailed when it comes to continuity and shot flow. The shooting board is what the director and production team use to plan the shoot, so it will also involve more frames. The most important thing to keep in mind while doing a shooting board is that this is the closest you get to making the actual film, so you really need to be aware of the rules and film techniques (see pages 94–95).

You also have to remember that all the frames in the storyboard need to be filmable, which means that you need to consult the director or art director before drawing any really ambitious sequences. Usually, you will be told about any possible limitations on the shoot – so if you are tempted to add a helicopter shot, for example, it's a good idea to make sure that this has been allowed for in the budget.

When you're working on a shooting board, you'll be working with a director. Sometimes there will be a shooting list – the director's shot-by-shot list of the material – ready for the initial meeting, but more often than not this will be decided during the meeting. This is especially true when it comes to television ads. At this stage, you'll also be shown a variety of reference materials and even clips from other commercials or films to help define the photographic style or overall mood of the piece.

Remember that the shooting board will be distributed to the crew. It will be photocopied and often sent via fax, so a clear reproducible style is essential; colour and too much detail can muddy image quality. In fact, colour is not normally necessary, unless there is going to be a particular special effect.

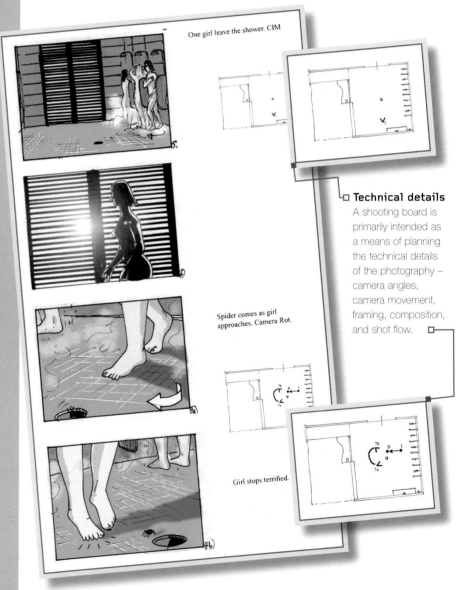

One girl leave the shower. CIM

Spider comes as girl approaches. Camera Rot.

Girl stops terrified.

Technical details

A shooting board is primarily intended as a means of planning the technical details of the photography – camera angles, camera movement, framing, composition, and shot flow.

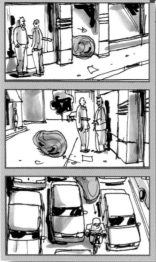

Using colour to indicate digital effects

In this example, the water was going to be created digitally and added in postproduction, so colour was added to it so that it could immediately be located in each shot. This way the production company was able to easily see how many shots would have to be retouched.

Commercials

For a shooting board for an advertisement you can expect on average between 12 and 30 frames and a deadline of one day – two if you're lucky.

Sketchy style

A shooting board requires many more frames than a client board and tends to be rendered in a more sketchy, less finished fashion.

LESSON 20 ANIMATICS

films

TV

advertisements

games

animation

Sometimes an advertising agency needs to test out an advertisement before going through the costly process of filming, or a production company wants to visualize a film or a particular sequence in order to attract investors. In these cases, they produce an animatic.

An animatic is simply an animated storyboard, frame by frame, with the addition of sound – dialogue, music, F/X. With the exception of animation, animatics are not true, seamless animations. They're more like a slide show with some simple movement such as "A" and "B" actions.

The first thing you need to find out is on what format the animatic is going to viewed – television, computer screen, or email. If this information is unavailable, then scan the images as jpegs – 720 x 576 pixels at 72 dpi resolution. This is full-screen broadcasting quality, meaning that you can transfer the film onto a VHS or DVD and it will look all right on television. Files can also easily be sent via email at this size.

The demands of making an animatic for animation, advertisements and feature films vary, so let's take a look at each one in turn.

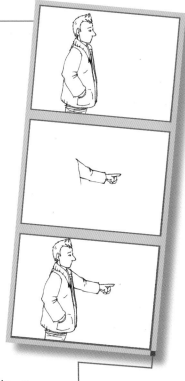

Using Layers in animatics

Using Layers in Photoshop can really help when drawing the frames that you need to animate. For instance, if a character needs to turn his head, you can draw just the main frame and the turned head.

Small movements

Small movements such as pointing can also be produced using Layers – just draw the pointing hand and add it to the main frame.

ANIMATICS FOR ANIMATION

In animation, the animatic is an essential stage of the production. Storyboards for animation are much more precise and detailed than for film and commercials in terms of their picture quality, composition and design.

A storyboard for an animation animatic shows exactly what the final film frame will look like, minus the colour. It's the main tool that will travel from the various animation studios and production companies involved in the animation process. It will be copied many times, and therefore needs to be rendered as clean as possible and in black and white. Once the storyboard is complete and animated, the character voices will be recorded and added. These will be the final voices for the cartoon, with the exception of any retakes.

ANIMATICS FOR COMMERCIALS CHECKLIST

- Before you start, make sure that the agency or client is not expecting animation.
- Then make a precise shooting list. Sketch each frame at the agency to agree upon the sequence. There probably won't be a storyboard at this stage, so you'll be sketching the frames for the first time.
- At your studio, clean up the sketches and email them to the agency for approval. These sketches will be in black and white, possibly in pencil.
- Next, get details from the agency of all the changes and revisions that are required. If possible, make sure the sketches have been approved by the client, too.

- Do the clean-up and add colour. If you feel insecure about the clean-up, send it in for approval. To add colour, you can use the computer or markers. Before adding colour, make black-and-white copies of the board. This will make colour changes simple, if necessary further down the line. If you use the computer, get into the habit of saving all files as the work progresses so that you can easily make changes or revisions. It's normal at this phase to be asked to draw extra frames just to smooth out some of the movement or sequences in the animatic.

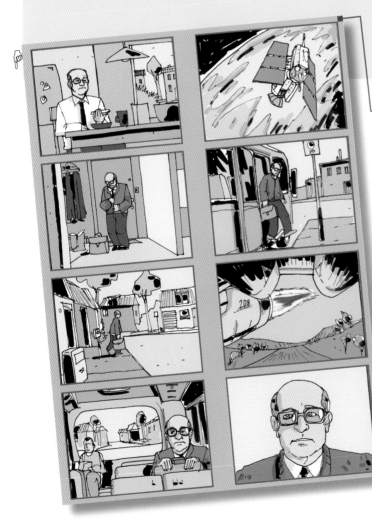

Adding colour
You can add colour to the frames on the computer (left), but markers (right) give a less mechanical, more lively look.

FEATURE FILM ANIMATICS

On a feature film, a production company usually creates the animatic from the existing storyboard frames. You may be asked to draw some additional frames to flesh out the animatic, but there won't be as many frames in an action as there are in a commercial animatic. You'll also be able to reuse frames, especially during "talking heads" scenes. Most importantly, all images will be in black and white.

□ Reusing frames

A skilled editor will be able to reuse a lot of frames during dialogue scenes.

Tip

Don't forget to save your work as often as you can when you're producing an animatic. The preference section of the software usually allows you to choose at what intervals the program will automatically save the work.

PRODUCING AN ANIMATIC

Most advertising agencies and production companies hire a postproduction facility to edit and produce the animatic, which is preferable to ensure professional quality and save time. To make the job easier for the editor, number the frame files in progression.

In addition to its original format, an animatic is often produced as a QuickTime film to be sent over the Internet. This will, of course, reduce the size and resolution, but unless the agency requests otherwise, supply the frames at full resolution.

If you are very confident in your computer skills, it's possible to prepare an animatic on your own with some of the higher-end editing software available today.

You'll need a good computer, a scanner, and, of course, the software. If you work on a Mac, I recommend the editing program Final Cut which allows you to export the finished film in a number of formats. For PC platforms there are quite a few choices, but the newest version of Adobe Premiere seems to have improved a lot of features, such as real-time preview, which allows you to view the work in progress without having to render the film each time. Premiere is available for both Mac and PC. All the editing programs are basically structured in the same way, so once you learn one you can easily get the hang of the others.

Frame 1

First things first. To begin with you will be given the option of starting a new project or opening an existing one.

Frame 2

Starting a new project leads you to a page where you can choose the format for your work.

Frame 3

NTSC and PAL are technical standards adopted by the different nations of the world and refer to the resolution, size and the number of frames per second of the film. In the U.S., NTSC is used; PAL is the system used for Europe and the rest of the world. They differ in number of frames, lines and even in the screen aspect ratio.

Frame 4

When you have entered into the program you'll have a complete overview of your tools on the screen. The program is very straightforward. It uses the "drag and drop" system and after a while you'll learn the common keyboard shortcuts for actions so that the whole editing process becomes faster.

Continued on next page →

PRODUCING AN ANIMATIC

Frames 5 & 6

Start by importing the material you need to produce your animatic – for example, the frames of your storyboard. These can be in various formats (jpegs are preferable since the files are smaller), sounds, or music you recorded previously.

Frame 7

The files you have imported will arrive in the project window. By clicking on them you will see a small preview and information about the file in the same folder. Double clicking on them will open the file on the monitor.

Frame **8**

To place the file on the timeline (which is the area where you'll be doing the actual editing), you simply drag it and drop it onto one of the channels – for example onto "Video 3". Music and sound effects go onto the audio channels. When you are positioned on the file, this will show on the monitor.

Frame **9**

Within the project window you also have the option to choose from a variety of transitions and editing effects.

Frame **10**

When happy with the result, export the animatic in the format that best suits your needs. You can produce a clip by exporting it as a "movie". Choose from a number of formats, including Quicktime, Mpeg, and Avi. Or render the film for Internet streaming so that the software compresses the film, making it compatible for different Internet supports such as QuickTime, Windows Media Player and Real Video.

TIP

There are lots of shortcuts and tricks that you'll learn by using the program. You can also get useful information about plug-ins, tips and new releases on various Internet forums.

UNIT 5:
THE LANGUAGE OF STORYBOARDS

THE LANGUAGE OF STORYBOARDS

films

TV

advertisements

games

animation

Fluidity is an essential component of filmmaking. It is also one of the prime concerns of storyboarding. A film is made up of many different elements. Storyboard artists need to connect not only plots, but also frames and actions, in a manner that creates the illusion of a seamless, continuous flow. In order to achieve fluidity from cut to cut, we need to respect some rules and be fluent in the "language" of film – the different angles, shots, and camera movements that filmmakers have at their disposal. This chapter examines the elements of which storyboard artists need to be aware.

Screen direction □
(See page 96)
The most important notion with regard to continuity is screen direction – simply the direction of the action on screen.

Framing expressions □
(See page 106)
Different shots can be used to set the scene, to emphasize and draw attention to certain details or actions, or simply to accentuate a particular piece of dialogue.

Cuts □
(See page 113)
Usually directors and editors like to draw as little attention to the cuts in a film as possible, aiming for a seamless flow. One of the most common cuts used is a match cut, where you cut from one scene to another using a common "matched" element that connects the two scenes.

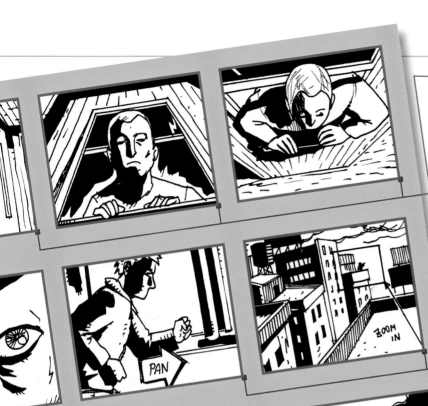

Camera angles
(See page 98)

There are several different camera angles used in filmmaking to create different effects, and storyboard artists need to know what these are so they can represent them when building a shooting board. Notice how the effect changes using these different camera angles: in general, a low angle suggests menace or superiority, whereas a high angle is often used to suggest inferiority or fear.

Camera movements
(See page 110)

Pan, zoom, tilt, dolly – camera movements are used for a number of reasons, from simply rotating the camera left to right to establish a scene to zooming in and out to emphasize confusion and surprise.

Composition
(See page 120)

In general, composition refers to the arrangement and relationship of elements in a frame. Storyboards don't usually require a large amount of detail, so composition in the frame can be simplified as much as possible. Don't get hung up on details. Generalize. Eventually exact locations are going to be found or created and filmed. These frames just need to act as reminders for the production team.

SKELETON WOMAN

page 4

Sq 2 Sc 90
Action: Cut to hands winding thread around baited hook. (working noises)

Sq 2 Sc 100
Action: Cut to underwater shot. (S.woman P.O.V. camera move) Fish passes by, up and away. boat revolves slowly.-(uw sound)

Sq 2 Sc 110
Action: cut to fish jumping

(Splish) ■

Sq 2 Sc 120
Action: Man looks up excitedly looks down at his work again

Sq 2 Sc 130
Action: Cut to hands pulling string. tightening knot.

Sq 2 Sc 140
Action: cut to u.water shot. looking up at boat, fish passes by. Camera wavers mimicing p.o.v.

Written notation
(See page 110)

Amplifies and clarifies the visual storyboard instructions.

Arrows
(See page 14)

Arrows illustrate movement within the frame (actors walking) or the frame moving itself (camera panning).

LESSON 21 LINE OF ACTION

films

TV

advertisements

games

animation

The most important aspect of continuity as far as storyboarding is concerned is screen direction – the direction of the action on screen. For example, let's take two characters involved in a conversation. The "line of action" is an imaginary line that establishes the position of the actors on screen. In order to maintain visual continuity and avoid confusing the audience, it's recommended that you locate the line (or "axis") of action in a scene and keep the cameras on one side of that line. This is also known as the 180 degrees rule.

It is, however, possible to cross the line of action during a scene provided the camera then remains on that side of the line. In this situation, the audience should see the crossover and, from that moment on, the camera should remain at 180 degrees to the new line of action.

Line of action

In this example, there are two characters on the set. The man is positioned frame left, facing right, and the girl is frame right, facing left. The "line of action" is an imaginary line passing through them. (The "action" in this case is the dialogue between the two characters.)

180°

LINE OF ACTION

Avoiding confusion

From the set-up in the previous diagram, we have learned where the characters are positioned – so if we go into close-ups, we know, without actually seeing, what they're looking at. If, however, we suddenly cross the line of action and place a camera on the other side (as in the bottom frame), the man will appear to be looking in the opposite direction, which is confusing for the audience.

180°

LINE OF ACTION

Crossing the line

If we need to, we can cross the line of action by showing the movement of the camera behind the woman. This would lead the audience to understand the new "direction" on screen.

LESSON 22 CAMERA ANGLES

films

TV

advertisements

games

animation

A director has tools and techniques to help him communicate his vision to the screen and one powerful way of doing this is through the effective use of camera angles.

During the planning stages of a film the director will meet with the storyboard artist to illustrate the shots that will best tell the story. Most films are shot using traditional straight-on camera angles, so an unusual camera angle emphasizes the scene and drama. There are, however, films built entirely with constructed camera angles. This can be a tiring process for the storyboard artist, because every shot has to be created. This type of job is down to the personal vision of the director or photographer, and you'll need to be given lots of direction if you are working with this kind of director.

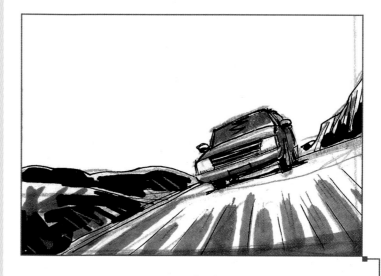

Canted-angle shot ❑

Also called a Dutch shot, or a Hong Kong shot, this shot is achieved by tilting the camera so that the horizontal frame line is not parallel to the horizon. This shot is used to make action more dynamic.

Use of canted angles ○
As this image shows, when a character enters a room in a canted-angle shot the viewer's attention is readily captured.

Low-angle shots

In general, a low angle suggests power, strength and superiority,

Making an entrance

When a character is introduced in a film, usually an angle is chosen that suggests their importance to the story. A striking entrance in a scene is always assisted by a low-angle shot.

Low- and high-angle shots combined

These angles have a natural relationship. In the example below, a character enters a room. A low angle is used to introduce the character, followed by a high-angle shot to reveal the room. This is a sequence that you probably recognize from many films.

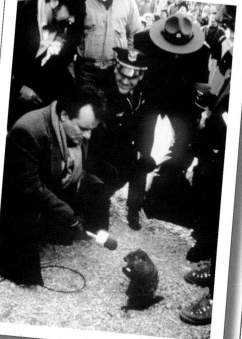

High-angle shots

A high angle is often used to suggest weakness, inferiority or fear.

The whole picture

The high-angle shot can give a great overview of a scene, like the one shown here which suggests the point of view of a bystander or the possible position of a TV camera.

Low-angle shot to convey menace

How many times have you seen this situation in a film – particularly in a horror or thriller film? The low-angle shot of the house clearly expresses a certain menace. Remember Hitchcock's *Psycho* – the house was not only shot in low angle but also placed on a little hill.

Travelling shot

In a travelling shot the camera follows the action, for example, following the movement of an aeroplane as it approaches its destination or the motorcycles in this memorable scene from *Easy Rider*. This could involve the camera moving from one location to another. Tracking shots are also types of travelling shots.

Top shot

A bird's eye view can also be a fly-over as shot from a helicopter – a top shot of the city, for instance. In this case, we're travelling, and have probably not yet focused on a particular subject. It's only a descriptive shot, so we may as well stay high up in the sky and continue in a montage of top-shot scenes.

Top shot follow-up

If someone is being chased by the helicopter, however, then you can be sure that the top shot will be followed by a low-angle shot such as this.

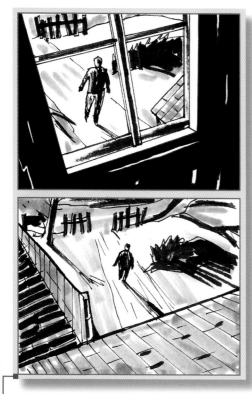

Natural progression

Certain shots can give away the scene that follows. In the frame where we see the character through the window, we can be sure that he will eventually enter the house – perhaps not right at that moment, but at some time during the film. Otherwise, why would we be watching him from inside? This angle also suggests the possibility that someone inside the house is watching him. If the camera is placed over the roof, as in the bottom frame, then you can be sure that the character will turn back at the last moment.

Combining shots

Nowadays most shots in films tend to be combined with various camera movements. For example, the top shot portrayed here included a panning camera action that followed the character's jumping sequence.

Bird's eye view (or top shot)

This is one of the so-called "extreme angles", with the camera positioned directly above a scene looking straight down. In a sense, the bird's eye view can be considered an extreme high angle. It's a dramatic angle, and requires an "answer" in the form of a low-angle shot. As in the standard low- and high-angle shots shown on pages 98–99, when you use one, you have to use the other.

Low-angle response (1)

A response to the top shot could be a low-angle shot of someone getting out of a car at ground level.

Low-angle response (2)

Another possible response to the top shot could be to show the character positioned on the roof. The bird's eye view that we see in the top shot would have been from their viewpoint. By doing this we connect the two shots in a logical way.

Worm's eye view
A worm's eye view, with the camera placed very low on the ground and tilted upward, is an extreme low angle.

Close-up sequence
This is a sequence of frames built up from a series of very tight close-ups.

Hand-held camera
If it is suggested in the script that a scene should be filmed "documentary style" it means that the camera will be hand-held throughout the whole scene.

Long shot

A long shot is a great way to dramatize a scene. When combined with impressive landscapes, certain long shots become iconic.

Anticipating the action

A ground shot works well when you want to surprise the audience, although, at times, it can actually cause the audience to anticipate the action. Say someone is walking down an alley on a ground shot – we can predict that someone or something is about to enter the frame.

Ground shot

Prevalent in 1970s spaghetti westerns, the ground shot is achieved by placing the camera on the ground and having all the elements on the same horizon line. In contrast to the worm's eye view, the camera is not tilted upward, but positioned parallel to the ground.

Putting shots into action

The following storyboard example contains a number of dramatic shots each of which was designed in order to build up and emphasize the emotional meeting of the two characters.

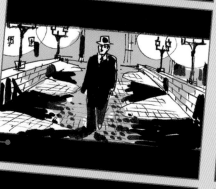

High-angle shot
The woman is alone, apparently waiting for someone. The purpose of the high-angle shot is to emphasize her loneliness.

Close-up
Something or someone captures her attention and she turns her head. A close-up isolates everything else in the frame, focusing solely on her expression.

Wide shot
In a wide shot a man is shown walking toward the camera. The viewpoint of the camera also suggests the viewpoint of the woman.

Mid shot
In this shot the man enters the frame giving a sense of continuation from the previous shot.

Wide high-angle shot
This frame is the most dramatic of the sequence. The two characters face each other in the staged lighting and the spotlights create an intense scenography. Although in reality the storyboard artist is not involved in the lighting process, you can still make suggestions for possible effective compositions through your drawings.

Two shot/mid shot
A "two shot" is when there are two characters in frame. Because we are coming in from a previous wide shot, we want to keep some distance from the characters before moving to close-ups. It is good practice to gradually move closer to characters step by step from a very wide shot.

High-angle close-up
The male character in the sequence is dominant so when his face is shown for the first time he is placed above the woman in order to suggest this.

Tight over-the-shoulder shot
As a response to the previous shot the woman is now shown in a close-up. This time the shot goes in much tighter to emphasize her emotion.

LESSON 23 FRAMING EXPRESSIONS

films

TV

advertisements

games

animation

A framing expression is a term used to specify the proportion between the frame and the subject within the frame.

When working with film – in every genre and media – you should be familiar with all technical terms since in this business everyone refers to them when calling a shot. They are also always mentioned in scripts and are often in their abbreviated form.

Every frame has a meaning and a purpose so it is like learning a new language.

A series usually begins with an establishing shot. This establishes the place and time. In cartoons, every time the location changes, there is an exterior or interior establishing shot of the place we are about to enter or where the action is taking place. The same is true for television series. Even if a show uses primarily one set, establishing shots are used to tell us if it's day or night, winter or summer. The establishing shot is not mentioned in the script – but as the storyboard artist, you need to identify it.

Master shot
A master shot refers to when the set-up of a scene is displayed in one frame. It shows the character and the place where the action will occur.

Full shot (FS)

A full shot is when a character is shown with all of their body in a frame.

Medium shot (MS)

A medium shot frames a character from the hips upwards (or downwards). The camera would be sufficiently distanced from the character's body for the character to be seen in relation to his or her surroundings.

Medium close-up (MCU)

A medium close-up is a tight shot of a character including his or her shoulders or possibly framing the character from the chest.

Close-up (CU)

In a close-up shot the subject framed by the camera fills the frame. Close-ups of faces give the audience a sense of intimacy with the character and of having access to their thought processes.

Over the shoulder (OTS)

A shot taken over the shoulder of one actor, focusing entirely on the face and upper torso of the other actor in the scene. OTS shots are generally shot in pairs so that both actors' expressions can later be edited together.

Extreme close-up (ECU)

An extreme close-up is often used to make the audience aware of certain details (like what is written on a piece of paper) or simply to accentuate a particular piece of dialogue.

Framing expressions in action

How can we use framing expressions to build up a scene in an interesting way and convey information to the audience? For example, let's look at this short sequence of frames:

Shot 1
We begin with a close-up to introduce the character.

Shot 2
The second shot is a wider close-up to establish that the character is driving a car.

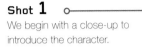

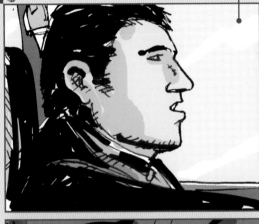

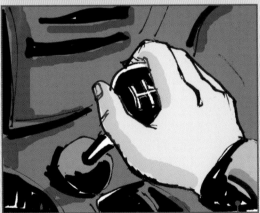

Shot 3
A close-up shot of the hand shifting gears gives the impression that the car is moving quickly.

Shot 4
Another close-up shot, this time of the front of the car in motion.

LESSON 24 CAMERA MOVEMENT AND NOTATION

films

TV

advertisements

games

animation

A film is made up of sequences of shots, many of which are achieved using special equipment in order to get certain effects, for example, the Steadicam which was invented in the early 1970s by Garrett Brown and was used extensively in Stanley Kubrick's *The Shining* and many other films from then on. The movements in the camera are used to focus the attention of the audience and to involve them in the events of the film. It is vital for the storyboard artist to be aware of the functions of camera equipment, and for the notations on the storyboard to communicate these movements to the director and director of photography.

Pan

Probably the most common camera movement, a pan is a horizontal motion achieved by rotating the camera on its vertical axis from left to right or from right to left. A simple pan is used to establish a scene or location and it is noted on the storyboard with an arrow to show the direction of the pan.

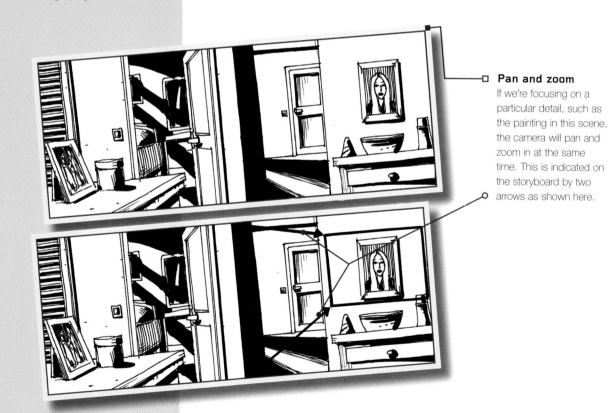

Pan and zoom

If we're focusing on a particular detail, such as the painting in this scene, the camera will pan and zoom in at the same time. This is indicated on the storyboard by two arrows as shown here.

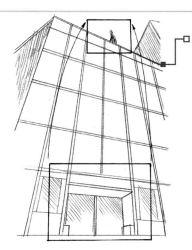

Tilt

A tilt is achieved by moving the camera vertically up or down. It is used, for instance, to reveal a tall building or to move up or down an object. You can also combine tilting with a zoom.

Dolly

A dolly is a platform with wheels on which a camera is mounted. The dolly can move along tracks to precisely determine the direction of the movement or it can be used without tracks. The camera usually moves horizontally.

Steadicam

A Steadicam is a camera control device that permits the camera operator to carry the camera on his body while avoiding the idiosyncratic bumps and shakes of a hand-held camera, resulting in a very fluid movement.

Crane

A crane is a mechanical arm mounted on a trolley to which a camera can be attached. A crane can move up and down. It can also be used combining the various movements such as crane plus dolly, for instance.

Vertigo effect

Vertigo, sometimes referred to as dolly zoom, is obtained by zooming in and dollying out, or by zooming out and dollying in. The effect is usually used to emphasize confusion, surprise or shock and works by keeping the subject in the frame at the same size while the perspective around it seems to change. The shot got its name from Hitchcock's 1958 film, *Vertigo*. On a script or storyboard it would be noted by text in the margin rather than arrows.

Crane shot

The crane technique is used to create wide, interesting and revealing shots. In this frame the arrow suggests that the camera moves down and towards the parked car.

111

Focus pull (or rack focus)

Sometimes, you may want to change focus between two subjects in a frame. On set, the camera assistant – referred to as the focus puller – is the person who makes this operation. In a storyboard, the movement is denoted by text or by drawing two pictures with different focus. The effect in the example is obtained by using the "blur" plug-in provided by Photoshop and other similar graphic programs.

Zoom

A zoom is an optical effect that increases or decreases magnification, giving the impression that the camera is moving towards or away from a subject. This technique is used to draw attention to certain details or actions. It can be quick or slow, depending on the pace of the scene, and is denoted on a storyboard by means of arrows.

Whip pan

The camera pans very quickly from one view to another. This movement can sometimes be used in editing, but it is most often done with a whip cut, which is made using two different shots. The cut is very fast so the eye won't notice.

Animation whip pan

In animation, a whip-pan effect is achieved by simply drawing a series of blurred lines in the approximate colour palette of the two scenes that are going to be connected.

POV

In a POV (point-of-view) shot, the camera shows the audience what a particular character is seeing. The POV is a subjective shot that is used to increase audience participation in the on-screen action.

CUTS AND TRANSITIONS

To create continuity in film it is often necessary to create special shots which are referred to as "cuts". These are simple scenes and inventions that will help connect the consequential action. These cuts are almost never written into the script and are mainly "inventions" of directors and storyboard artists.

Transitions are methods of moving from one scene or shot to another. They are most often created in editing and in postproduction, and are usually only noted on the storyboard (most often in the later stages of production).

Cross fade

One of the most common transitions is a cross fade or lap dissolve – the gradual fading-out of the final frames of one shot with the simultaneous fading-in of the opening frames of the following shot. It can be denoted on the storyboard like this.

Match cut via common element

Some match cuts can be connected by a common element in both scenes, such as from water in one scene to rain in the next, or, as in this example, from the television screen being watched by the man in the armchair to the television set on the wall of the bar.

Wipe

This is a very effective transition. It is achieved when a new scene pushes the previous one out of frame. The storyboard artist is not always aware of these transitions unless the director has suggested them. A simple arrow will suggest the direction of the wipe.

Split screen

The split screen shows two or more different sequences on screen at the same time – for example, both sides of a telephone conversation. All the storyboard artist needs to do here is draw the different actions in the same frame with a clear dividing line.

MORE CUTS AND TRANSITIONS

Jump cut

Although directors normally like to draw as little attention to the cuts in a film as possible, jump cuts – consciously cutting from incongruous shots – can be an effective way of making a point or emphasizing a particular mood. For instance, in a scene where a character is in a hurry to clear out of his motel room because someone is after him, jump cuts of him packing could be an effective way of conveying the stress of the situation. There isn't any notation for this on a storyboard; it would be drawn in the frames.

Cutaway shot

A cutaway is a single shot inserted into the main sequence of action. It can be used to accentuate a detail or to cover up a mistake in the master shot. A good director usually takes several shots in a scene that can be used for this purpose. Even the most professional actors don't give exactly the same performance each take, but good cutaway shots can disguise the problem.

Inserts

In some scripts, during the story there might be a need for flashback sequences, scenes that don't follow the style of the film, a collage of images or even an animation. These are called "inserts".

Match cut

The opposite of a jump cut is a match cut. In a match cut, you cut from one scene to another using a common, or "matched", element that connects the two scenes – in this case, from the wristwatch to the clock on the wall. This is not written into the script; in fact, all you'll read in the script are the words "cut to".

Montage

A montage is a sequence of images or scenes in a film, usually without dialogue, that is used to compress the passage of time or an event. If an athlete is preparing for a big competition, for example, a montage might be used to show his months of training. The script will tell you that a montage is called for and if you want to make sure that this isn't misread on the storyboard page you can make a note of it.

LESSON 25 CONTINUITY AND STORYTELLING

films

TV

advertisements

games

animation

In terms of storyboarding, "continuity" refers to the general shot-to-shot flow. This kind of continuity is sometimes confused with the continuity with which a script supervisor is concerned – the continuity of details such as props, set dressing, costume and so on. Although the two concepts are related, storyboarding is primarily concerned with making sense of the action from cut to cut and as a whole sequence.

Every shot should lead naturally to the next. A "wild shot" in a film – a shot that feels out of place or unexpected – immediately lets us know that something is about to happen in the story. To achieve this continuity certain rules, such as the 180 degrees rule (see page 96), have to be followed in order to avoid confusing the audience. There are exceptions; indeed, many directors search for new ways to tell a story, often dismembering a script and inverting the order of events or looking at the story from various angles simultaneously. Nevertheless, in order to consciously break the rules, you need to know and understand those rules in the first place.

The script will give you nothing more than brief descriptions to work from. Still, it's important to visualize the scene in order to build up a sequence. What's important are the elements of the scene – the setting, the character(s) and the situation being described.

In the example shown here, the different elements are the road, the farm and the man.

Visualizing the elements

If you haven't been supplied with concrete references, then invent the material. Draw something that resembles an abandoned farm. A road is a road, so make it simple. Remember, what's important for the director are the cuts and sequences. Later, the storyboard will be adapted to match the location.

A man is walking on the side of a road. In the distance, over a field, he sees a small cottage. He leaves the road, heading towards the house which appears to be abandoned.

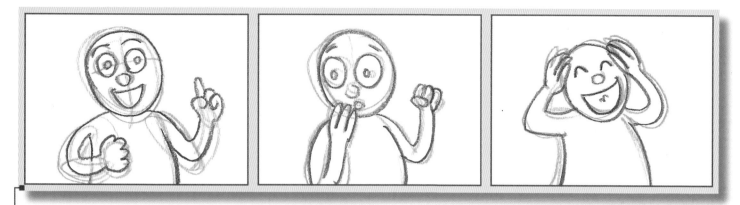

Continuity in animation

In animation, both set and character design are complete by the time the storyboard process begins. There will be changes along the way but, for the most part, everything is available in the studio. Since the characters will not be real people, every single gesture in a dialogue scene has to be drawn, so continuity is more detailed than in any other media.

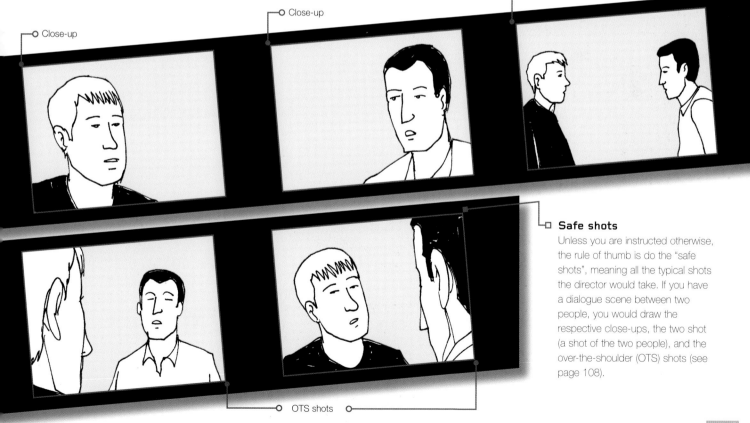

Two shot

Close-up

Close-up

Safe shots

Unless you are instructed otherwise, the rule of thumb is do the "safe shots", meaning all the typical shots the director would take. If you have a dialogue scene between two people, you would draw the respective close-ups, the two shot (a shot of the two people), and the over-the-shoulder (OTS) shots (see page 108).

OTS shots

Brainstorming with someone else will spark off new ideas. That's why meetings with the director are so important – otherwise he or she could just write a shooting list and send you off with an assistant (which does happen sometimes). Storyboarding varies from script to script. There may be times when you don't know how to get started or how to solve a particular scene. Some scripts may have inherent problems that need solving – for instance, a writer may get out of a scene that he or she doesn't know how to end by simply writing "fade-out".

Let's look at different ways in which this could be handled in the storyboard.

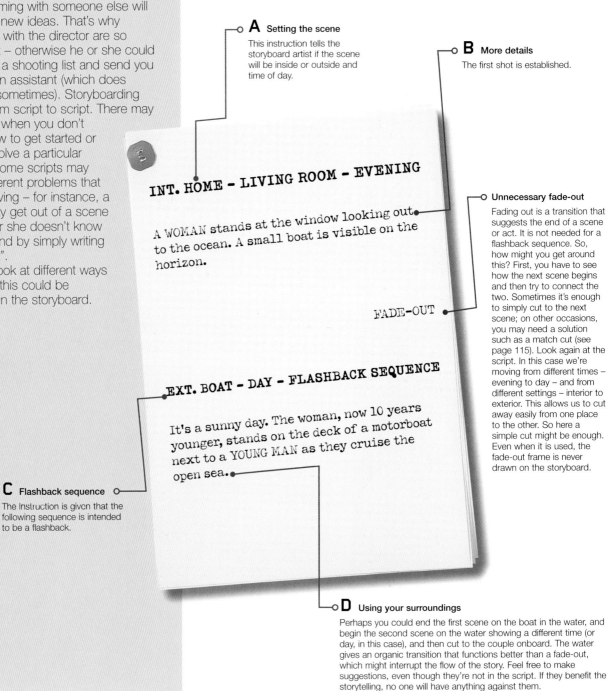

A Setting the scene

This instruction tells the storyboard artist if the scene will be inside or outside and time of day.

B More details

The first shot is established.

INT. HOME – LIVING ROOM – EVENING

A WOMAN stands at the window looking out to the ocean. A small boat is visible on the horizon.

FADE-OUT

Unnecessary fade-out

Fading out is a transition that suggests the end of a scene or act. It is not needed for a flashback sequence. So, how might you get around this? First, you have to see how the next scene begins and then try to connect the two. Sometimes it's enough to simply cut to the next scene; on other occasions, you may need a solution such as a match cut (see page 115). Look again at the script. In this case we're moving from different times – evening to day – and from different settings – interior to exterior. This allows us to cut away easily from one place to the other. So here a simple cut might be enough. Even when it is used, the fade-out frame is never drawn on the storyboard.

EXT. BOAT – DAY – FLASHBACK SEQUENCE

It's a sunny day. The woman, now 10 years younger, stands on the deck of a motorboat next to a YOUNG MAN as they cruise the open sea.

C Flashback sequence

The instruction is given that the following sequence is intended to be a flashback.

D Using your surroundings

Perhaps you could end the first scene on the boat in the water, and begin the second scene on the water showing a different time (or day, in this case), and then cut to the couple onboard. The water gives an organic transition that functions better than a fade-out, which might interrupt the flow of the story. Feel free to make suggestions, even though they're not in the script. If they benefit the storytelling, no one will have anything against them.

Two other options for treatments of this transition are shown below, in storyboards.

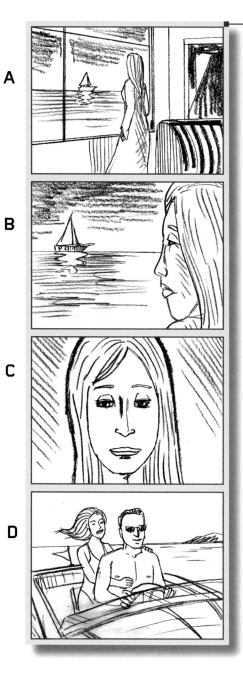

A

B

C

D

Option 1: Close-up
It may be important to emphasize the fact that the woman is having the flashback. If that is the case, you could end the first scene on a close-up of the woman before cutting to the flashback. Close-ups are a logical way of showing which character is having the flashback. Here, the sound from the next scene could overlap, starting on the close-up of the woman at the end of the previous scene.

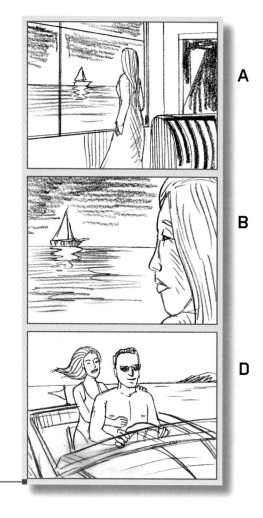

A

B

D

Option 2: Cut to
Suddenly cutting away to another place and time could be a more effective and surprising solution than focusing on the character who is having the flashback. On the script, the notation "cut to" would be written to indicate this.

LESSON 26 COMPOSITION

films

TV

advertisements

games

animation

Composition has just as important a role at the storyboard stage as in the final piece of filmmaking. This is not only for simple aesthetics but for technical reasons as well – perhaps because of the demands of a particular set or action sequence in the scene, or because of direction and choreography. Some directors are really keen on doing a lot of preparation for their films. Alfred Hitchcock said that for him the fun of filmmaking was the preparation required for the shooting. Looking at some films you can see just how much effort has been made to prepare sequences that have become memorable over the years. Think of Stanley Kubrick's classic opening sequence from *2001: A Space Odyssey*, among others.

So, even when still only at the storyboard stage, composition is an important factor, especially in films and animation. You need to consider the composition in the storyboard frames and in order to achieve that successfully you'll need to research and collect as much reference material as possible from the production company and your own reference archives.

Generalized indication of setting

In most cases, the script won't give you much material to work from, so a generalized indication of the setting is sufficient.

Forest

Cityscape

Beach scene

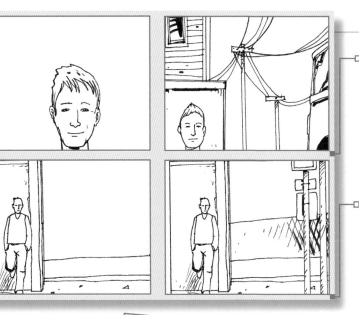

Balancing a scene

With practice, it becomes second nature to "balance" a picture. For instance, you wouldn't normally cut a man's head off in a shot like this.

Empty space

Sometimes just looking at a frame you will "feel" that something is missing. It is a natural instinct as the eye is looking for balance. You do this instinctively when you take a photograph with a camera.

Off-balance frames

Sometimes, however, the director may deliberately want a shot to be "off-balance". This can be effective in arthouse films and those that try not to conform to the usual rules of compositon – producing an unsettling effect in the viewer.

Invent details to improve composition

Here, a wall and street signs fill the empty space on the right of the frame and balance the composition. Get into the habit of composing your frames well, even when you're just working on rough sketches. Invent a detail to fill up the empty space and give the frame balance. With practice, you'll get used to detecting these kinds of compositional problems and correcting them automatically.

Improving your skills

If you want to improve your compositional skills, try sketching in forms like this. Let your hand run free on the paper no matter what you are drawing. It's a good exercise that develops fluidity in your style.

Eye level

Another important factor to consider in maintaining continuity is eye level. Watch any film and you'll notice that from cut to cut within a scene, the eyes of the characters remain more or less framed on the same level. Usually, when we talk to someone we look at their eyes. The same is true on screen. If the eye levels continually change, it will be difficult to follow the conversation.

Deliberately leave space

When it comes to composition, one of the most important rules is to leave some space in the direction in which a character is facing. The empty space suggests the presence of another character as the viewer's attention is brought to look in that direction.

UNIT 6:
FROM WORD TO IMAGE

FROM WORD TO IMAGE

films

TV

advertisements

The storyboard artist sometimes receives a script and nothing else from the production company, whether for a film or a commercial. It's then up to the artist to collect all the information needed for the job (location information, costume references, etc.), but fortunately this doesn't happen very often. In general, the production company or the creative team at the advertising agency will have had extensive brainstorming sessions while developing their ideas and their thoughts are delivered to the artist in a treatment or a pitch to help the process of storyboarding. Often a storyboard acts as a sort of visual bridge between an idea, often in verbal or written form, and the finished moving image. This chapter examines some of the different forms from which a storyboard artist works.

The pitch

At its simplest, you may just be verbally pitched an idea. Ideally, this will be accompanied by visual reference material. If you aren't supplied with reference material, this is when your growing personal reference library comes in handy. Even if you know what a certain time period or architecture style is, it doesn't necessarily mean that the person asking you to draw it does. So, to avoid confusion and unnecessary revisions, try to confirm verbal references with concrete visual reference material whenever possible.

Working title: **Yantra**

Think of it as an Asian Lara Croft meets Pi.

May is Eurasian and a highly gifted mathematician. She is also a brilliant computer hacker and an adept martial artist. When she hacks into a museum piece computer she uncovers a surprising bit of information. When her life and that of her "employer" are put under threat they flee the country.

They travel through the Middle East, India, over the Himalayas, and into China and Japan pursued by some very shady people determined to stop them. As May uncovers the source of a universal mystical power, she realises it could be the end of the world – or the beginning of a new one.

It's 2011 and London is getting ready for one of the biggest events in its recent history. Despite all the planning and money spent on the 2012 Olympic Games, the city centre has been hit by a major economic slump caused by forced decentralization. It's no longer the same bustling metropolis that beckoned in the new millennium.

May King was born in Hong Kong of an English father and Chinese mother who then relocated to London. As a child May was a mathematical and musical prodigy. She earned a doctorate in computer science by the time she was 18.

May is hired to hack into an old computer stored away in the basement of University of London and take her findings to Shaw – her "employer".

Shaw doesn't understand the results so May has to explain them to him, and some of the esoteric meanings of the numbers.

Two suspicious-looking men go looking for Shaw but he gives them the slip and warns May they could be in trouble.

May is nearly shot when she is in Chinatown but doesn't know if the bullet was for her or part of a gang fight crossfire.

Synopsis

The synopsis is the storyline boiled down to its most essential form. It is often used to summarize a longer format, most commonly a script. A synopsis for a feature-length screenplay is usually between one and two pages. It covers the main action of the story. If a production company or a producer is trying to finance a project, you may be asked to illustrate some key frames from a synopsis.

Shaw sat staring into the coffee grains in his glass. He couldn't see any future in arguing with May. He had to admit to himself that she was too smart for him, on all counts, and yet he still wanted to know the answer and understand what it meant. Of course, she had a point about his life – it hadn't amounted to much. He'd made some money, quite a lot of money by some people's reckoning, and he'd never got into trouble with the law. Shaw was convinced that his good luck was down to the huge amounts of self-confidence he was imbued with. It was something he'd had since he was a child. He didn't even know where it came from; it was who he was and he had assumed that everyone was like that. Shaw just had this aura around him that allowed him to be left alone, when he wanted it, but he was never shunned, either.

It was happening now. His was the only European face in the bar, and he had arrived with a Eurasian girl and, apart from the initial cursory glances, no one had given him a second look, not even as May strode out, leaving a trail of perfume in her wake. All their eyes followed her out, but not one turned back to see why she'd left alone. Now was a good time for him to leave. He was about to stand up when two men, who obviously did not belong

Treatment

A treatment for a feature film is longer and more detailed than a synopsis, and may be between 10 and 50 pages long. It describes the main action of each scene without getting into dialogue. Treatments are mostly used to attract the interest of potential producers and financiers. A storyboard artist may be asked to draw a few key frames, mood pictures, or even some designs to help visualize the treatment.

In advertising, you will most often be working from a treatment. The contents vary from client to client and from agency to agency, but generally the treatment gives not only the basic storyline, but also information about the product, casting and shooting style. There's also a huge difference between treatments from an advertising agency and a production company. An advertising agency is usually more concerned with the idea than with how it's going to be executed, and the treatment will need to be rewritten once a director comes on board, while a treatment from a production company tends to get right to the point of filming. The agency will often give you all the material that they have produced for the commercial. Remember that much of this is aimed at the client as well as the crew, so you need to be able to extract the information that is relevant to you.

LESSON 27 WHAT TO LOOK FOR

advertisements

Because of the long preproduction and research phases of feature films, these projects are usually accompanied by a lot of extra material that the storyboard artist can work with. The budget also usually permits the artist to gather as much reference material as he or she needs, for example the production company pays for certain books or films to help the artist.

In the advertising field it is a different story; time is always the important factor and is in short supply! Usually the storyboard artist receives the brief the day before he or she needs to deliver the board. Because of these time limitations the artist should be concentrating all his or her efforts to obtain as much information as possible in the initial meetings with the agency.

So, from all the material you get together, what should you look for in order to start your board?

Storyline
This is a quick description of the film. It may include dialogue, but sometimes the script will be attached to the treatment. The storyline can often get weighed down with explanations and too many details, so you need to be able to get to the essentials and lift out the information that is relevant to the storyboard.

Pack shot and/or payoff
How will the product and logo be prepared or arranged? Will it be a digital effect or just a composition? Will the text be superimposed over the picture or presented on a separate plate?

Casting
What kind of characters do they have in mind? What are their physical, social and behavioural traits?

Campaign for Lamore Coffee

Tagline: **The whole world is falling in love with our coffee**

Concept: Show couples from around the world having coffee together in romantic settings. Apart from establishing shots, everything else is shot in close-up, mostly hands holding hands and cups.

Rio during Carnival: Late at night, a couple leave the noise of carnival and enter a small café where they order two coffees.

New York: Couple run from a yellow cab into a typical diner where they sit in a booth and have coffee poured for them from a pot by a waitress.

Rome/Florence/Milan: Pavement café and couple are drinking cappuccino, oblivious to the noise around them.

Paris: Typical Parisian-style café and couple are sharing a classical romantic novel and coffee.

London: Couple in bed in the morning. The man gets up to make filter (or instant) coffee and bring it to his lover.

Locations

Where will the film be set? The agency may have already scouted locations but most often, especially at the client board stage, they have only a general idea of what is desired.

Photography style

What will the film look like? This is very important. Usually the director includes some reference photos in the treatment that suggest the kind of framing and colours he or she wants.

Sound

Will there be a particular song or a certain style of music? The music and sound suggest what kind of tempo is desired.

Comment

The treatment often includes notes from the director or person in charge regarding their personal vision of the advertisement, explaining to the client how certain creative choices will benefit a product. As a storyboard artist, you need more concrete information, such as a description of a particular visual effect or general style reference.

Campaign for Lamore Coffee

Rio during Carnival:
Establishing shots: Night-time at Carnival. Elevated wide shot of procession, with full sound of drums etc. Camera tracks through procession capturing close-ups of costumes and moves into crowd. Show back of couple watching.

Show man's hand taking girl's and leading her through crowd to café in side-street. Use hand-held camera. Café has very low light and candles on the table. Noise from Carnival. Couple sit at table with close-up of holding hands.

Close-up of barista coffee from pot sho... Close-up of cups be... table. Close-up sho... holding another an... holding the coffee cup.

Tagline: The whole world is falling in love with our coffee

LESSON 28 MOOD BOARDS AND KEY FRAMES

advertisements

A mood board is a collection of images of people, locations and style that the agency has chosen for the film to show the general mood of the commercial. All these pictures are mounted on big black boards and shown during brainstorming sessions and client meetings.

During your meeting with the agency, you'll be drawing sketches based on the treatment and instructions that you have received. Nevertheless, you can make suggestions about framing, composition, the character's expression, the location, and so on.

Sometimes the art director will specify exactly how many frames you are to draw. This may be because they want to visualize the idea for the client in a particular way or because of budgetary or time constraints.

The first step is to get some references – mood pictures from the agency or even the actual product.

Let's look at an example of a storyline:

IT'S MORNING.

A man wakes up. Walks to the kitchen, opens the fridge and takes out a carton of orange juice. At that moment someone rings the doorbell.

He opens the door and the postwoman starts to deliver the post as she notices the juice on the kitchen counter behind him. Suddenly, she throws the post in the air.

The man is surprised; he collects the letters from the garden and sees that the postwoman is gone.

He walks into the kitchen where he finds the postwoman drinking the juice.

Pack shot.

□ **Mood board plus script** □

While writing the treatment for a script, the art director and the creative team will have met for some brainstorming meetings to collect inspirational material for the project.

Colour

For the mood board anything goes. Images cut out from magazines, digital photographs, frames grabbed from films and so on. One quick look at the board should also give an idea of the colour palette of the film.

Locations

The mood board could also suggest locations. At a stage where nothing is yet decided a simple photograph will provide a springboard for ideas.

Casting

At this stage nobody has been cast. You might spot somebody famous on the mood board but this is just to suggest the "look" of the actors that the casting director will have to source.

OVER TO YOU

When travelling, take photographs of places and people you see. Create your own mood boards for your studio wall and gradually build up a reference library of cities, backgrounds, people and anything else that appeals to you.

PICKING OUT THE KEY FRAMES

KEY FRAMES

Let's take another look at the text. From the storyline, you should be able to quickly pick out the key frames. Key frames are the frames in which the most important action occurs.

We know that we need a client picture or product shot, which is commonly referred to as a pack shot with text, and we also know that we'll need a starting frame or establishing shot. Analysing the script further we also find out that there are other important shots we need to tell the story and to ensure that the story makes sense in its visual continuity – showing the man waking up, in front of the fridge with the product in his hands, opening the front door, and so on.

IT'S MORNING.

 A man wakes up. Walks to the kitchen, opens the fridge and takes out a carton of orange juice. At that moment someone rings the doorbell.

 He opens the door and the postwoman starts to deliver the post as she notices the juice on the kitchen counter behind him. Suddenly, she throws the post in the air.

The man is surprised; he collects the letters from the garden and sees that the postwoman is gone.

 He walks into the kitchen where he finds the postwoman drinking the juice.

Pack shot.

For a five-frame + pack-shot solution, the structure could be:

① **ESTABLISHING SHOT**
(exterior house or man waking up)

② **SITUATION/SET-UP**
(man standing in front of fridge holding juice, someone rings the doorbell)

③ **SITUATION**
(man opens the door for postwoman who sees carton of juice)

④ **ACTION**
(postwoman throws letters in air, man collects them)

⑤ **CONCLUSION**
(man finds postwoman in kitchen drinking juice)

⑥ **PACK SHOT**
(product + payoff)

Clearly, more frames are needed to tell the story, but this is often enough to present the idea to the client.

1 Establishing shot
A wide shot of the bedroom with a man waking up. We understand it is morning. This picture is necessary to start telling the story.

2 Situation/set-up
A mid shot showing the man opening the fridge and picking up the juice carton. A good possibility to show the product. We didn't need to see the man walking to the kitchen as it is not relevant to the story. We could have added another frame to show that someone is ringing the doorbell, but to simplify the board you could add a few lines (as shown) that visualize the sound happening off frame.

3 Situation
The man has opened the door to find the postwoman delivering his post. An OTS shot allows you to show the product in the background.

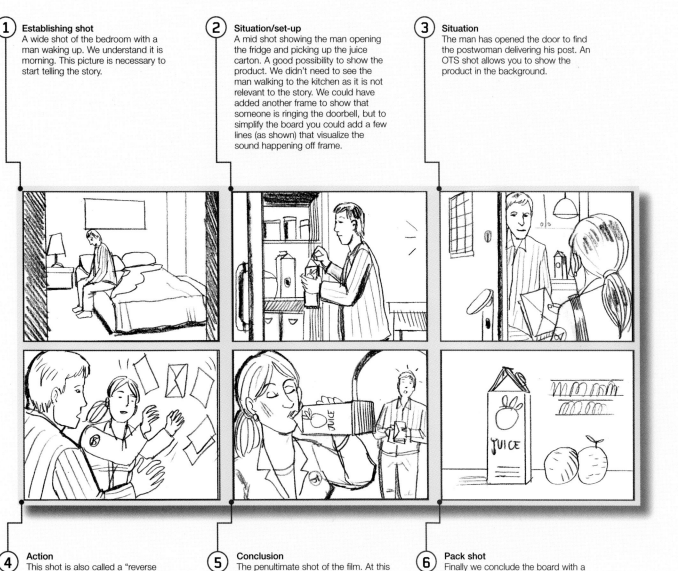

4 Action
This shot is also called a "reverse shot". It is response shot to the over-the-shoulder shot in the previous frame. Note that the position of the characters is kept according to the 180 degree rule (see page 96).

5 Conclusion
The penultimate shot of the film. At this stage it isn't important to show the man collecting the dropped letters in the garden. That shot could be in the film but it would be better to discuss it with a director in order to stage it correctly. This board is to present the idea to the client.

6 Pack shot
Finally we conclude the board with a product shot. In general the agency will have a precise idea for this shot since they already have the copy text. Often the client has a recalling slogan and the same pack shot for every ad they make.

LESSON 29 WORKING WITH SCRIPTS

films

TV

advertisements

On a feature film you'll most often be working from a script. A script for a feature film is usually around 100–120 pages long. Get a hard copy of the most recent version from the production company. The fact that you're working with a script doesn't necessarily mean that you'll be drawing the shooting or production board. You may be asked to produce a storyboard that the production team can use to draw up the budget – in which case, you'll be the "director", so to speak. At this stage you'll generally just follow the text – although, of course, you will need to come up with your own creative solutions to any problems that arise. Without a director, this can be a complicated process – you will have to create every shot.

Working on a production without a director may allow you more time to do the job because you won't have the meetings to attend – but beware! In the early stages of preproduction, there will be lots of corrections and additional scenes coming from the production company or producer, all of which add up to extra work for you.

At this stage, the producer is usually concerned with emphasizing production value, showing potential investors how they'll make a profit. Therefore, these illustrations tend to be rendered in more detail and often showcase the action and spectacle in a script.

Once a director is attached to the project, a new board will be necessary to reflect his or her vision. In this case, the best thing is to abandon the old board. There may be shots here and there in common, but generally you're better off starting from scratch.

Your first reading

Before you begin storyboarding, read through the script once to get an overall feel for the story and tone. The first thing you have to do is to understand the cinematographic style, tempo, tone and vision of the director or writer.

EXT. DAL LAKE, SRINAGAR, KASHMIR – DAY

May and Shaw are sitting in a shikhara being paddled toward the houseboat where they are staying. They are enjoying the lotus fields and the tranquillity.

MAY

It's hard to believe there was ever a war here. But then who wouldn't want to own this piece of heaven?

SHAW

I haven't seen you this relaxed in months. What is it? The mountain air?

MAY

I don't know. There's something special about this place. Or maybe it's just the feeling that no one knows where we are.

This is always a sign that something is going to happen and it does. There is a dull explosion and they are showered with water. The shikhara wallah shouts in Urdu and starts paddling furiously for the nearest houseboat. Another shikhara, with a small outboard motor, is racing toward them. There is pistol fire, but not very accurate.

SHIKHARA WALLAH

Allah protect me. Please get off my shikhara. Those men will destroy it if you stay.

SHAW

There's no way I'm getting in that water. I'd rather die quickly. (beat) Go between those two houseboats.

The shikhara wallah deftly manoeuvers his vessel. May is already standing, grabs the ladder to the houseboat and swings herself onto the deck. The other boat is getting closer. As it nears the houseboat May pounces and with one move is

Reference material

Make sure you have all the reference material that you're going to need. Model cars, for instance, are very useful if you are working on a chase or crash sequence. For a costume piece you'll need references from the appropriate time period.

Floor plan

For the most part, stuntmen work with a floor plan (as shown), but a proper storyboard is more useful for the director and director of photography as it shows the framing and shot flow.

F/X

F/X is an abbreviation of the word effect, also known as special effects (SPFX). The term refers to all the visual elements added in a film and those which are often created during postproduction, for example, simple smoke or fog. F/X can be mechanical, such as animatronic characters and models, or digital, such as 3D computer animation and effects. If a film has F/X, then a storyboard is essential for the production team to evaluate cost and time. The board needs to be very precise, so you will also need to meet with the F/X production team. The director may or may not be present at these meetings. Sometimes there will be a second unit director in charge of the F/X sequences.

Mocking-up stunts

For stunt sequences the director and stunt coordinator often work the scene out using models. Toy cars are available (in any size and model) in every toy shop. They are a small investment that will make the job of the storyboard artist easier when sketching car chases.

Stunt scenes

For stunt scenes, you will need to meet not only with the director, but also with the stunt coordinator in order to define the scenes. These storyboards help the production team to evaluate risks, as well as cost and time.

Costume references

Many films require design – from scenes to costumes and props. Period films are easy to research from books but the production company would need to finalize the design to their own needs. For example the director might have decided on a certain colour palette for the film, in which case the costume designer will have to adapt the outfits to that choice.

TIPS

- Pin key reference images to a wall of your studio so that you can access them simply by turning your head.

- Keep all the reference material that you receive from the production company in a ring-binder file for easy access.

LESSON 30 NOW YOU'VE GOT THE JOB

films

TV

advertisements

Finally, the moment has arrived. You have been contacted by someone who has been reviewing your portfolio, your work and style have been approved and you have the job.

You may have already been in meetings with the agency or the production company and have produced some work for their presentations, but now it's time to meet the director.

Fortunately, you will have time to read the script before the meeting and I strongly recommend that you do so. Read through the script once to get the overall feel of the story. Read through the script a second time, making notes and jotting down any questions and ideas that occur to you. You can write down questions on a separate paper or directly in the script. Fluorescent markers are really useful for highlighting key passages.

Early draft ▫

Scripts vary greatly depending on what stage of development they're in. Early drafts of a script, written before a director has been appointed, aim at attracting a reader's interest and tend to be denser, with more description and subtext. If you're asked to storyboard an early version of a script, you need to be able to cut through the description and find the visual flow of the story.

INT. CAFE – DAY

Bar Maroc is like a bit of Marrakesh transported to London. It is mostly the bastion of middle-eastern men. Oblivious to the ban, the room is filled with smoke from the hookahs that sit on most of the low tables. It is noisy from excited conversations carried out in Arabic, French and Italian. As May and Shaw enter the dark room they know they are being scrutinized, if not directly watched.

They sit at a table in the corner of the room. Shaw orders coffee and pastries. May sits watching the room.

MAY

Come here often?

SHAW

Only when I need to have a private conversation away from prying ears.

(beat)

So what's with the number and symbols?

MAY

From what I can gather it's a cosmic number that keeps appearing in different esoteric cultures. Two squared times three cubed makes 108. There are 108 beads on a Buddhist rosary. Hindu deities are given 108 names to be recited. I can only guess it is the mathematical interpretation of the question I input for you, or maybe it is the answer. Or maybe the question has no answer that can be expressed.

SHAW

There you go with your mystic zen rubbish again.

MAY

Maybe it isn't rubbish. Maybe you're looking for your answers in the wrong place.

May drinks the coffee in one shot and eats one of the pastries, sucking her fingers afterwards.

MAY

I don't think you'll ever find the answer. Do you know why? Because you are too important in your own mind. You want to know the meaning of life because your life has no meaning.

Shaw clenches his fist and looks ready to jump out of his seat to vent his frustration on May. May slips her foot out of her shoe and rests it on Shaw's lap.

MAY

Shall I tell you another thing about 108? In the Wing Chun system of martial arts there are 108 movements in a kata. There are also 108

INT. CAFE – ← — *Location or studio set?*
DAY

Bar Maroc is like a bit of Marrakesh transported to London. It is mostly the bastion of middle-eastern men. Oblivious to the ban, the room is filled with smoke from the hookahs that sit on most of the low tables. It is noisy from excited conversations carried out in Arabic, French and Italian. As May and Shaw enter the dark room they know they are being scrutinized, if not directly watched.

They sit at a table in the corner of the room. Shaw orders coffee and pastries. May sits watching the room.

MAY

Come here often?

SHAW

Only when I need to have a bit of privacy.
(beat)
So what's with the number and symbols?

MAY

From what I can gather it's a cosmic number that keeps appearing in different esoteric teachings. There are 108 beads on a Buddhist rosary. Hindu deities are given 108 names to be recited. I can only guess it is the mathematical interpretation of the data you gave me, or maybe it is the answer. Or maybe the question simply has no answer that can be expressed.

SHAW

There you go with your mystic zen rubbish again.

MAY

Maybe it isn't rubbish. Maybe you're looking for your answers in the wrong place.

May drinks the coffee in one shot and eats one of the pastries, sucking her fingers afterward.

MAY

I don't think you'll ever find the answer. Do you know why? Because you want to know the meaning of life because your life has no meaning.

Shaw clenches his fist and looks ready to jump out of his seat to vent his frustration on May. May slips her foot out of her shoe and rests it on Shaw's lap.

MAY

Shall I tell you another thing about 108? In the Wing Chun system of martial arts there are 108 movements in a kata. There are also 108 pressure points on the body. I only need to use one of those movements on one of those points and

Steadicam medium shot on wide as they walk through crowd

OTS shot from over Shaw's shoulder

Close-up of May's foot

Close-up on May's face

Close-up of May's foot

WORKING WITH A DIRECTOR

When you're working with a director, remember that they're busy people. The sessions need to be effective. You need to be able to complete sketches as fast as they're described to you. The ability to sketch quickly and find the shot, combined with an understanding of film technique, is vital. During the first session with a director on a feature film, you might only be able to get through 10 pages of script. As you continue to work together and become familiar with the director's personal style, the process will speed up; by the end of the project, you may find you can get through more than 20 pages per session.

Feature films

When you're working on a feature film, try to have your meetings with the director as close together as possible – maybe two or more a week until you get through the script. Some artists prefer to wait until all the meetings have been completed before they start work on the storyboard, so that they can move freely around the script working wherever they feel inspired. Others start work directly after the first meeting, even though meetings with the director may be spaced far apart. Choose whichever method you feel most comfortable with.

 If the job is extensive, as can be the case with feature films, it may be a good idea to get another artist to assist you with things like clean-up, or at least to take care of the more pedantic and time-consuming jobs such as scanning. Scanning 1,000 frames is no small task.

Deleting scenes

On feature films the script goes through changes even though you are already drawing sketches with the director. Some scenes become unnecessary and the director will decide to eliminate them on the spot.

Clean version

When cleaning up the sketches don't forget to note when a scene has been removed. The script has already been distributed to a lot of people in the production team and they need to be kept in the know.

Floor plan

Sometimes before starting to draw the frames for a scene, it's necessary to rapidly sketch an overview of the area where the action will take place.

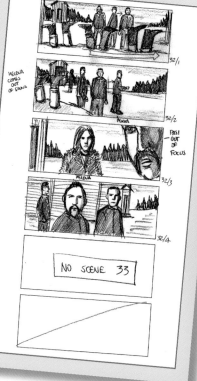

Advertisements

Advertisements are a completely different story. The whole film is discussed in one session, and in most cases the meeting lasts less than one hour. The script varies depending on the ad and on what information the agency or director has included. It can be anything from a few lines of text to a couple of pages.

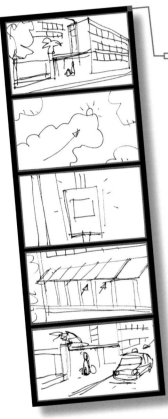

Initial sketches produced during meeting

If location pictures are available it's a good idea to spread them around the table during the meeting in order to have a good overview of the set-up. This will help with the rough sketches that you produce in the meeting.

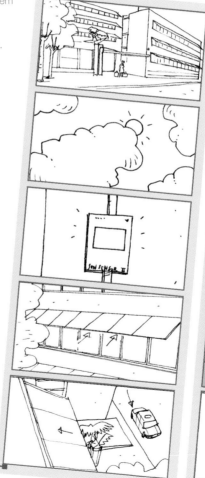
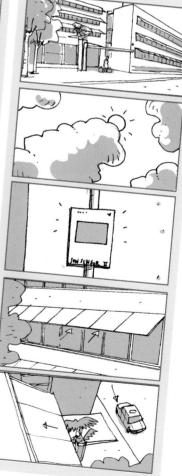

Sketches cleaned up after the meeting

As you can see, the last frame in the strip of images has changed. After a second discussion with the director a different angle was decided for the scene. It is good practice to give the rough sketches to the director right after the meeting so that he or she has time to re-think the shots. There is always a photocopier available for use at production companies (so you can take a copy home with you too); otherwise scan the sketches as soon as possible and email them to the director. Wait for approval before starting the clean-up sketches.

LESSON **31** ADVERTISEMENTS: WHAT TO DRAW?

advertisements

It's six o'clock in the evening. The advertising agency has just called and they need a client board by the next morning. You have the storyline that they've just emailed over in one hand, and you're staring at a blank page. Now what?

Of course you would begin with an establishing shot – but would it be an exterior or an interior shot? An exterior might be an interesting way of establishing the character's social status by, say, the kind of cars parked outside, but it could also waste time. The film could also start on the product with a close-up, or with an action.

Before you can decide, you need to identify the style and tempo of the film. You also need to be aware of the target audience that you're aiming to reach.

You might have a hunch about style and tempo just from the kind of product being sold or the production company that is producing the advertisement. In advertising, many production companies have very distinctive styles, and after a while you can recognize their work.

Unfortunately, not all of this information is necessarily available when you're preparing to draw, so you'll need to be able to come up with solutions on your own.

IT'S MORNING.

A man wakes up. Walks to the kitchen, opens the fridge and takes out a carton of orange juice. At that moment someone rings the doorbell.

He opens the door and the postwoman starts to deliver the post as she notices the juice on the kitchen counter behind him. Suddenly, she throws the post in the air.

The man is surprised; he collects the letters from the garden and sees that the postwoman is gone.

He walks into the kitchen where he finds the postwoman drinking the juice.

Pack shot.

TIP

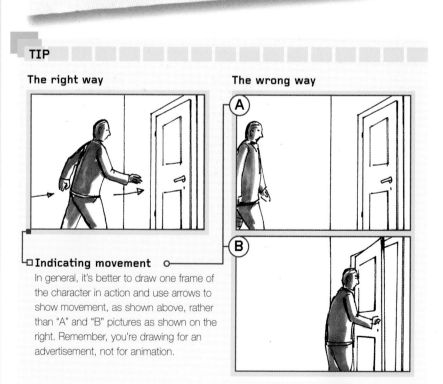

The right way

The wrong way

Indicating movement

In general, it's better to draw one frame of the character in action and use arrows to show movement, as shown above, rather than "A" and "B" pictures as shown on the right. Remember, you're drawing for an advertisement, not for animation.

CLICHÉS

When it comes to products, there are some standard clichés. The next time you're watching television, analyse the commercials. What are they selling? What style are they using? It's an interesting exercise and will help you on the job.

Sometimes directors try to do something different, but most of the time the client is afraid to take the risk. After all, the purpose of the commercial is to sell the product, not to make art.

Family-oriented product

If the ad is for a brand of pasta or breakfast cereal, for example, it will be very traditional and family oriented – which means set studio shots using a stationary camera and warm, colourful frames, rather than elaborate or unusual camera angles.

Clothing product

An advertisement for casual clothing, such as jeans, could go in any direction, but often ends up being close to a music video in feel.

Beauty product

Perfume and beauty products tend to focus on beauty and elegance.

Hi-tech product

An advertisement for a product such as a car will most often feature the product and look very hi-tech – slow motion, metallic feel, using a variety of lenses. Most car ads tend to be very similar. It can be difficult to do something really original unless you want to break with tradition, and many clients are afraid of doing that. You really need to sit down with the director and go through the text shot by shot.

LESSON 32 TAKING DIRECTION

films

TV

advertisements

When you're working with directors, for the most part they'll tell you what to draw, but they're very open to suggestions. The meeting is more of a brainstorming session, because at this point they're not sure themselves about certain shots and are looking for opinions.

The sketches help the director to visualize an idea. Sometimes this leads to new ideas, so patience is another trait that you need to have as a storyboard artist.

Since the session is an exchange of ideas and solutions, the more you understand and know about film technique, the better and more smoothly the job will go. Watch as many films and commercials as possible and keep up to date with the industry.

SHOOTING LIST

Most directors prepare a shooting list – a numbered shot-by-shot breakdown of the script. You just have to follow the instructions, helping out with composition, balance, framing and choice of angles.

① ② ③ ④ ⑤ ⑥ ⑦ ⑧ ⑨ ⑩ ⑪ ⑫

IT'S MORNING.

A man wakes up. Walks to the kitchen, opens the fridge and takes out a carton of orange juice. At that moment someone rings the doorbell.

He opens the door and the postwoman starts to deliver the post as she notices the juice on the kitchen counter behind him. Suddenly, she throws the post in the air.

The man is surprised; he collects the letters from the garden and sees that the postwoman is gone.

He walks into the kitchen where he finds the postwoman drinking the juice.

Pack shot.

A shooting list could look something like this:

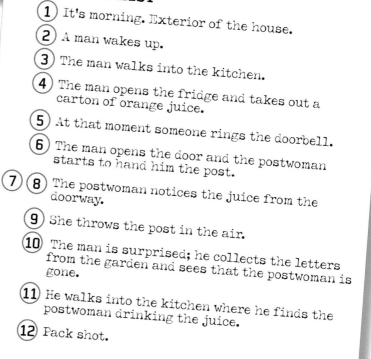

SHOOTING LIST

① It's morning. Exterior of the house.

② A man wakes up.

③ The man walks into the kitchen.

④ The man opens the fridge and takes out a carton of orange juice.

⑤ At that moment someone rings the doorbell.

⑥ The man opens the door and the postwoman starts to hand him the post.

⑦ ⑧ The postwoman notices the juice from the doorway.

⑨ She throws the post in the air.

⑩ The man is surprised; he collects the letters from the garden and sees that the postwoman is gone.

⑪ He walks into the kitchen where he finds the postwoman drinking the juice.

⑫ Pack shot.

Possible solution

Here is a possible solution in storyboard form from the shooting list. Remember to include pack shot opportunities where possible!

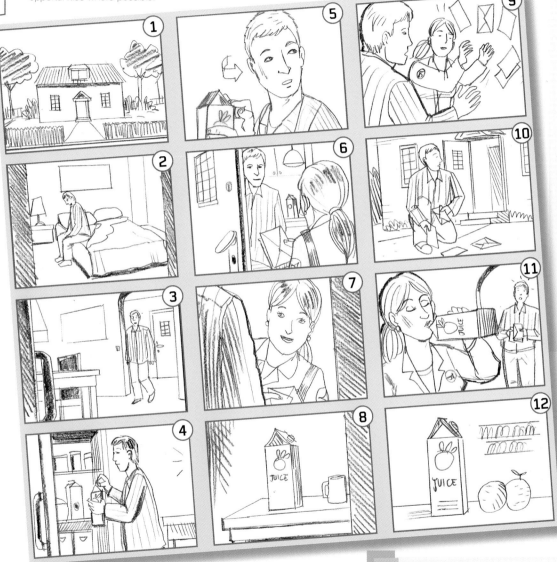

OVER TO YOU

Unfortunately, if you want to practise, there aren't very many advertisement scripts and treatments available on the Internet. There are, however, plenty of websites from which you can download screenplays of released films. Try out a few pages and then compare your boards with the same scenes in the finished film. It's best to pick screenplays of films that you haven't yet seen so that you're not influenced by your memories of the film.

TIP

Remember to be quick and essential in your drawings. On a feature-film script, it's actually better to sketch the whole film before you start to do the clean-up.

LESSON 33 DEVELOPING AN EFFICIENT WORKING PRACTICE

films

TV

advertisements

A good storyboard artist should have a few different styles up their sleeve and be able to render the work in various ways depending on the assignment. A board for a television ad won't require more than 20 to 30 frames while a feature film needs over 1,000 to 1,500 frames so different approaches are needed for each. Before getting started, you need to find a rendering style that you are comfortable with and that's quick to produce. If you are comfortable using a computer you can speed up the process by scanning images and using computer tools to render them.

Computer adjustments
Once you've scanned the frames and have them on your computer (left), you can adjust the tone so that the final result looks as if it was drawn in pen (below).

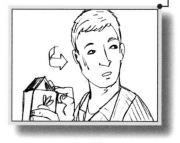

Adding tone on the computer
If you're skilled on the computer, you can even use it to add the grey tone – although the result can sometimes look rather flat and cold.

SUPPLYING IMAGES DIGITALLY

If you are able to work digitally and supply your images in this way then always find out what resolution the illustrations need to be first. Some companies like to work with the storyboard as one frame per page, while others prefer working with a sequence of three or four frames per page.

Some companies prefer to keep the originals, but for the most part people are happy with digital files. Jpegs are a good format to work in – but beware! Once you scan the images, you can't change the resolution, so be sure of the size first.

Supplying the frames digitally makes it much easier to remove frames or make changes later on. Just remember to number them in a way that makes it easy to add or remove pictures in the sequence. For instance:

 title_0000X.jpg

This way, not only do you have all the pictures in sequence, but it is easy to insert additional frames. If the director then decides he or she wants to add a new frame after viewing the completed board, all you have to do is give the new frame the same title as the one immediately preceding it and affix the letter "a" – so the titling sequence is as follows:

 title_00020.jpg
 title_00020a.jpg
 title_00021.jpg

Sometimes it's helpful to number your frames by scene number – for example, if you're going to be jumping around the script during the storyboard and meeting process. You might, for instance, start with all special-effect sequences, and then move on to other scenes, winding up on the "talking head" dialogue shots. Here you might want to number the frames like this:

 title_scenenr_shotnr.jpg

So shot 1 of Scene 10 becomes:

 title_010_001.jpg

STORYBOARD DOCTOR

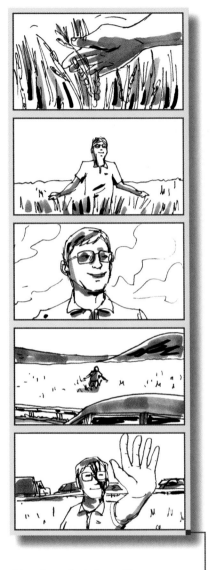

Improving images
Use tone to complete pictures and add depth. Look at the difference between the line drawing on the left and the version below, to which tone has been added.

Pencil line drawing
If adding tone is too time consuming, you may want to consider using just pencil.

Storyboard strips
For commercials, try to deliver the storyboard in sequences of four or five frames. The agencies prefer this so that they can simply print out the strip, enlarge it and mount it onto black boards to show in meetings. However, only do this when your sketches have been approved so that you don't have to continuously revise the boards by adding and removing frames.

TIP
Deliver the storyboard in jpeg format if delivering digitally. This way the production team can work on it easily in any program, cutting frames out, pasting pictures in Word documents, or even adding colours to the frames.

LESSON 34 BEFORE YOU START THE JOB

films

TV

advertisements

There are many professional aspects that an artist needs to consider in order to pursue a career as a storyboard artist. It is not just a case of being able to draw the required frames according to instructions; there is a lot more involved.

To be a professional means that your client should feel comfortable and happy when assigning you the job. They shouldn't feel worried about anything.

Of course as you build up experience and a portfolio you'll reach this point and you'll also be building up your reputation with each new job. We all have to start somewhere so let's look at some key points that you should address before you begin a job and that will help you to develop your professionalism.

Make a checklist □

If for some reason you can't meet the production company in person, here's a checklist of things you should make sure you've done before you begin.

CHECKLIST

1 Make sure you receive the script or treatment along with enough additional information such as mood boards, style references and so on.

2 Make sure that the production company has seen your portfolio and is aware of your style and capabilities.

3 Have a good communication system – Internet site, email, phone, fax – and make sure you know the details of the contact person you'll be dealing with. (The fewer people the better!)

4 Make sure your expenses will be paid, in case something suddenly has to be shipped by courier, for example.

5 In the case of a feature film, sign a contract. It could easily end up being a two- or three-month job, and you never know what can happen in the interim.

6 Read the script and review the material before you decide upon a fee or accept a job.

7 Make a schedule accounting for unexpected delays. For a feature film, add on a couple of weeks or so. In the case of an advertisement, double your time: allow two days if you know you can do it in one.

Once you've taken care of the above, you can start reading the script seriously, making notes and planning key frames (see page 130).

1. Often, after the meeting, it can be difficult to reach some of the people involved in the project or they could be busy with another project, so collect everything you can before leaving.

2. This is very important if you don't want to end up disappointing the production team. Agree on style and digital image resolution during the meeting.

3. It's good practice to have a database of your contacts. This should not just be the phone numbers registered in your mobile phone. Keep and organize all the business cards you receive. Do not rely only on office numbers – very often the reception desks of large companies have limited access hours.

4. For certain jobs – feature film storyboards for example – estimate all expenses such as taxi fares you'll have to cover to go to meetings or delivery costs of printed materials. In general, the production companies are aware of these costs and will ask you for the receipts in order to refund you.

5. Never take a job purely on a verbal agreement. For feature film projects do not forget to include the "kill-fee" paragraph in the contract (see page 18).

6. Do not accept a job without evaluating it first. Check all the pros and cons and remember that you are the only person who knows the amount of work you are able to fit into your schedule. You know your possibilities and limitations better than anybody else.

7. Even if you know you are able to work very quickly, don't give too much away. If you tell people that you can complete a job in one day, rest assured they will ask you to do it in half the time next time!

TIP

If the production company has always previously worked with other storyboard artists, ask to see old material to gain some awareness of the styles they are used to. You could also ask why they have chosen a new artist for the job – perhaps they want to change styles.

GOOD WORKING PRACTICE

Sometimes starting on page one can be daunting psychologically, perhaps because the opening scene is difficult or maybe just because you aren't feeling particularly creative that day. For this reason, get in the habit of starting a new strip for each scene. This allows you to easily move around to any scene you like. When the scene is over, simply cross out the remaining empty frames.

If you work with one frame per page, then it's simple to jump around in the script. Use ring-binders while you're working on the board and file the frames by scene. Remember to make a note of whether or not the scene has been completed.

Delete remaining empty frames
If you strike through any empty frames nobody is going to look for missed scenes.

The drawback of having only one frame per page comes at the scanning phase. You can scan the finished frames as you go (which sometimes interferes with the numbering) or get an assistant to do the scanning for you.

It's not merely the scanning process that's time consuming. For each page you'll have to adjust contrast, size and margins, clean up a little, and perhaps even do corrections. The good news is that most scanning software allows you to set macro settings, which cut set-up time in half. You can create different scanning presets such as storyboard in black and white, storyboard in colour, storyboard for animatic, and rough sketches. Basically, the differences are in colour or black and white, contrast and resolution.

UNIT 7:
ON THE JOB

ON THE JOB

films

TV

advertisements

games

animation

Each one of us will, in time, achieve a style and a work technique that is personal and unique. For example, some of us work better under stress and to tight deadlines, some prefer to work at night, some are happy working in a studio as part of a team and some like to be in their own environment.

The next few pages look at a number of working methods that you can adapt to your own needs.

Director of photography (usually abbreviated to DoP)
It doesn't happen very often, but sometimes, the DoP will also be present in meetings with the director. The DoP, in tandem with the director, decides how the film will look. It's generally not necessary to meet them both, but some scenes might require a different approach, perhaps because there are special effects or other technical needs to take into consideration.

Producer
The producer is generally the person who manages and controls the production, schedules, relationships with clients and so on. With small agencies, you always have direct contact with the producer as he or she is often the person who manages the budget, and therefore effectively controls the budget for the storyboard. With large advertising agencies, you don't normally have much contact with the producer as he or she will be involved in more than one production at a time.

Computer animators and special effects team
Very often these teams have their own artists, but the director with whom you are working may want to have more direct control of the special effects. In this scenario you may find yourself working with two studios; alternatively, you may be subcontracted to work for the studio in charge of special effects and animations.

Scriptwriter

It is quite rare to meet the author of the script, unless he or she is also involved in directing. But sometimes a scriptwriter will rely on an illustrator to create storyboards of a few key frames in order to sell a script.

Production designers

This category includes all the various categories of designer who manage the set, costumes, props, and so. Their materials are normally looked after by production assistants, but you may have to deal with the designers personally, especially during work in progress.

Art buyers

The art buyers are in charge of the economic side of the project. These are the people who have the most contact with artists and photographers. The role of art buyer exists mainly in large agencies, where there is a more pressing need to keep track of each transaction. In a small agency, there is usually only one administrator who deals with all financial matters.

WHO'S WHO

As we have seen, a large number of people are directly involved in any production, from a simple advertising spot to a film. As a storyboard artist, you need to have a clear idea of the role of each one of these characters. Here is an overview of the people with whom you will be most closely involved. Of course, not all of them will be sitting in your first briefing meeting!

Director

The director is the person with whom you will have most contact in a production company and also in an advertising agency, when the project is given to a specific director.

Stunt coordinator

The stunt coordinator works with the director and may be present when the storyboard is discussed, as scenes involving stunt men can be highly expensive and dangerous.

Art directors and copywriters

These are the people with whom you will liaise when dealing with advertising agencies or when a director has not yet been appointed to the project.

Production assistant

The production assistant manages the material among the different parts of a production. For example, storyboards that need to be printed and organized for meetings will end up on this person's desk, and he or she will make sure they are sent on to the right person. The production assistant also organizes meetings and supplies any materials such as location or casting pictures that are needed. This is generally the person with whom you will be in contact during the job.

LESSON 35 AD DESIGN

$$advertisements$$

Sometimes an advertising agency needs to test or develop an idea for a print campaign. They often hire a storyboard artist to sketch conceptual illustrations to help define and refine their idea. Depending on the job, this may entail producing just one or several illustrations.

The process is similar to working on a client board – but instead of working from a treatment, you will be given sketches done by the agency. The sketches are usually self explanatory, and all you have to do is redraw them in a better style. You may be asked to do the illustrations in colour, but they can still be quite sketchy.

It can be a pretty relaxing job – unless you're working for a huge campaign or an event production, where you're asked to visualize a certain moment of an exhibition or expo. In this kind of situation, the concept is often confused, and the purpose of the illustrations is to help clarify the work in progress and present ideas to the client – difficult when the agency itself doesn't really know what it wants.

Just testing...
Sometimes, if the agency is just trying out different ideas, the brief may be quite confused and it may not be clear what you're being asked to do. This sketch was done for conceptual designs for a famous brand event; it ended up being a set design for a hypothetical museum exhibition. To this day, I'm not sure if what I produced was what the agency wanted...

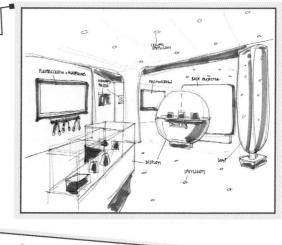

TIP

- Work no bigger than A4-size, because it's easier to fax and photocopy.
- For adding colour, markers always look great in these sorts of illustrations.

From agency sketch to finished storyboard

Don't worry if the agency hasn't prepared any sketches for the initial meeting: they usually have an idea of what they want and have already been brainstorming prior to the meeting. If this is not the case, then you have to be creative and put forward your own suggestions for images, composition and style. You can make notes on your sketches and then if approved, execute the idea in your finished storyboard.

CHECKLIST

- Get as much information as you can from the initial meeting. Take notes, ask questions and get a copy of any available reference material.
- Do a first series of clean-ups and present them to the agency for approval and feedback.
- Make the revisions and present them for approval. Add colour only after they've been approved.
- For ads, always make sure you understand where the "super" (the superimposed logo), the product package or the logo is to be placed.

Pack shot

Sometimes an ad design can consist of nothing more than a huge pack shot. All it shows is the packaging, along with the slogan that the agency has come up with. You might wonder why they don't just take a photo – but sometimes the product is brand new and the packaging is still being designed. Alternatively, if the agency is bidding for the job, they may want to give the client the impression that they're not desperate for the job and therefore haven't put too much time into it.

LESSON **36** WORKING ON AN AD

advertisements

Advertising is an environment in which things generally have to be done as soon as possible. Usually the storyboard is required within one or two days. That doesn't sound long – but when you consider that an ad usually last for about 30 to 45 seconds and requires a maximum of 20 frames, it's perfectly achievable.

The first step is to make sure you get all the information you need in one short, effective meeting. In most cases, you'll only meet the agency once and the rest of the communication will be done by phone and by email. The rest is all a matter of your own organization – but make sure you respect deadlines, because that is the most important thing.

As for rendering, a realistic style, with no cartoon or funny characters, is generally best, particularly if the board has to be shown to the client.

First draft

These initial sketches were for an advertisement for a popular beach resort. The client wanted to show a girl reminiscing about her honeymoon trip in a dreamy, *Baywatch* meets *From Here to Eternity* sequence. She and her husband should be shown on the beach, at the hotel, having a romantic dinner, etc.

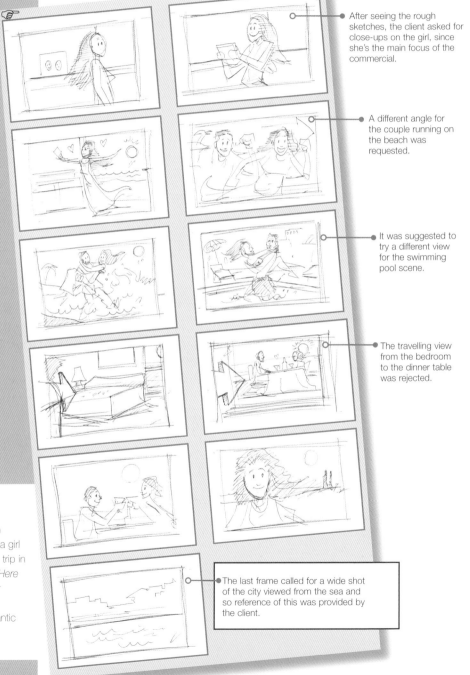

After seeing the rough sketches, the client asked for close-ups on the girl, since she's the main focus of the commercial.

A different angle for the couple running on the beach was requested.

It was suggested to try a different view for the swimming pool scene.

The travelling view from the bedroom to the dinner table was rejected.

The last frame called for a wide shot of the city viewed from the sea and so reference of this was provided by the client.

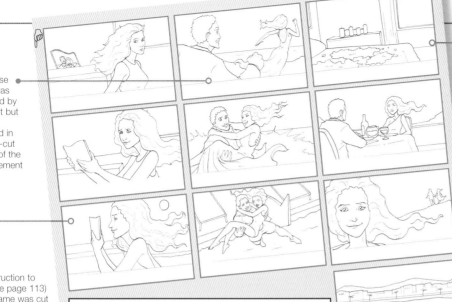

The chase scene was approved by the client but it only remained in the long-cut version of the advertisement.

The bedroom frame wasn't working and it was decided to cut it completely for the final version.

The instruction to wipe (see page 113) in this frame was cut completely in the final version. The picture frame in the girl's hand is also to be removed – she is already at the beach of her memories.

Second draft

After the first roughs, clean line drawings are done in ink and shown to the agency for further comments. Some minor changes were asked for before the final board was produced.

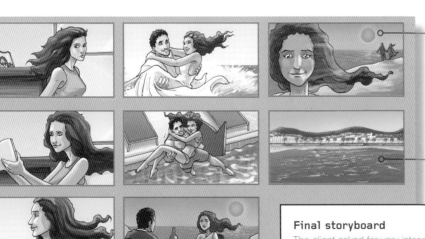

The close-up of the girl with the couple in the background walking toward the sunset was blended, to reinforce its dreamlike quality.

All of the water and sky effects were added at this stage, to avoid a cartoon look.

Final storyboard

The client asked for very intense colouring, mostly warm colours, except for the last wide shot of the resort. This couldn't be shown at sunset since it would lose detail and clarity.

CHECKLIST

- Meet with the agency. Get all the reference material that you need and quickly sketch a rough sequence. Try to get all comments at this stage. Write down all notes or suggestions that the agency gives you.

- Back at your studio, do a rough clean-up and finish on a light table. Send the frames in for approval.

- Make any necessary revisions. If you've done a good job and clarified what's required in the first meeting, you won't have to change much.

- The agency will then show the board to the client. Expect more changes at this stage.

- Discuss the changes and produce the new frames. If at this point a lot of changes have been requested, possibly even storyline changes, then you'll need to renegotiate your fee.

LESSON 37 WORKING ON A FEATURE FILM

films

This is a longer assignment than working on print ads and commercials, and can take anywhere from two to three months, or even much longer in the case of a bigger production including a lot of special effects.

On a feature film, you'll be meeting with the director on several occasions. It's a good idea to group these sessions as closely together as possible, ideally three per week. This way, the ideas and notes are still fresh from meeting to meeting. A feature film requires more than 1,000 frames. During each meeting, you may not get through more than 10 to 15 pages of the script – and that's being optimistic. Things will go much more slowly in the beginning. The more you and the director work together, the faster and smoother the process will become.

If possible, start the clean-up job after all the meetings are completed – but be prepared for the fact that this may not be possible due to deadlines.

The right environment

Working on a feature film project requires several long meetings with the director and you'll need to be able to easily display previously completed work. Most production companies have a conference room that will be suitable. However, in order to reduce interruptions from the production team, you could hold meetings in your own studio.

Don't worry, just sketch

It's not important that the director understands the sketches that you do in the meeting – as long as you understand them and can use them for your clean-up!

TIP

On a feature-film storyboard, work in pencil to accommodate the many changes that will occur during the course of the job. It's also a good idea to draw just one frame per page, so that you can easily eliminate or insert scenes and frames. This does make faxing the storyboard a cumbersome job, but for feature films you usually work with photocopies and courier service. Alternatively, if you have your own website, you can upload the board on the Internet. Always deliver a back-up copy of the work on digital supports, such as CD ROM or DVD.

SPEED-READING TECHNIQUES

A shooting script for a feature film usually has 100 to 120 pages and sometimes it is difficult to find the time to sit down and read it thoroughly. To add to this, once the storyboard artist receives the script they have very little time to make a decision about taking on the job.

In theory a script is not difficult to read. There are many pages but the formatting of the pages makes it easier to read them quickly. With a rapid overview of the script you should be able to locate the dialogues and the action. You need to understand the story first and locate the potentially troublesome scenes (the ones including lots of effects or complicated action), before going into the dialogue in more detail.

You'll also get a good overview of the scene to follow in the paragraph at the beginning of each scene which helps speed reading. The language of a script is simple compared to a novel – the present tense is always used.

It is possible to find all sorts of information on speed-reading techniques on the Internet and in bookshops. Here are some tried and tested tips:

1. Make sure you've got your own copy of the script so that you can make notes on it.
2. Use a marker to underline every scene before starting to read it. This gives you a quick reference of where you are. Usually there is a new page for each new scene but not all scripts are formatted like this.
3. Make notes of the names of characters as soon as they appear in the script. Do this on a separate piece of paper and don't lose it!
4. Skip dialogue in your first reading.
5. The most important part of the script is the beginning; for the first few pages read more attentively as characters and themes are introduced here.
6. Use a pointer – perhaps your pen – to help you follow the text rapidly. Mark the important parts with your own symbols.

CHECKLIST

- Meet the production team and director to get a general idea of the project. Get a copy of the script to evaluate the job and decide upon a fee.

- Once you've taken on the job, be ahead of deadlines. Make your own schedule to meet the production's needs. Plan the meetings and make sure you spend as much time with the director and director of photography as possible. Use all media possible to take notes and sketches. At this stage, make sure the production team has seen and approved your style or the technique you've chosen.

- If you think it's necessary, look for someone to assist you in the production. It's important to have a certain chemistry because the sketches will sometimes be very rough and you'll need to understand each other without spending too much time explaining.

- Start drawing, even though you haven't finished your meetings with the director and team. Use pencil; don't bother with ink.

- To save expenses, make sure you can use the production offices for simple things like photocopying and printing.

- When possible, deliver the material as soon as it is completed – but be aware that this could invite additional revisions and second thoughts.

- Deliver the material digitally and keep the originals. You may have to do further work on some pictures, so it saves time if you have them close at hand.

- Once the job is over, get a copy of the bound storyboard that the production team has made (the one with all notes, dialogue, and so on). It's useful to have a record of your work.

LESSON **38** CONCEPTUAL ART

fillm

TV

advertisements

games

animation

"Conceptual art" is the term used to describe all artistic work produced for preproduction and production of films or animations, as well as for video games and some theatre performances. These illustrations often become bona fide paintings, and they can be produced in classic media such as oil, acrylics or gouache, as well as using contemporary aids such as graphics tablets and software programs like Adobe Photoshop.

On reading a film's credits, you will often discover that a comic artist was employed to work on the film's creative content, and it sometimes happens that this role is given to the storyboard artist – so it's good to have a solid artistic base.

There is no specific rule regarding conceptual art. Often the general style is decided by the production company using previous work, or other studios' work, as reference. This does not mean, however, that you should not contribute your own ideas regarding an appropriate style for the project (and, above all, one that suits your own capabilities).

Working as a conceptual artist is definitely stimulating, as you have more creative freedom and more time available. You will be working during preproduction, so this stage of the project might go on for a few months or even a year or more. Conceptual artists have access to a lot of information about the project and it is not unheard of to be asked to sign confidentiality agreements.

Video game project
This flying pod was created for a video game concept. Layers of colour were added with markers.

Using watercolours
To create the sense of a magical environment, the artist of this forest god character used watercolours and worked from light to dark. The character was part of a study for a feature film.

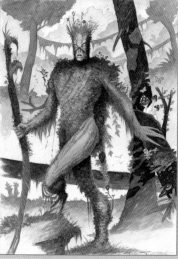

ARTIST MATERIALS

The most important quality in conceptual artwork is its ability to design and capture atmosphere. Every art material has potential for this but you should use the ones that you know best – you can work fast and get the best results from the techniques that you're already familiar with. Of course, adding new materials and techniques to the ones that you already know is a good idea, especially in this area where each project "asks" for a different approach. If you're limited to only one or two techniques you won't be able to catch certain climates or atmospheres. However, if you want to use a new technique, you should try it out between jobs first – never on a new project with a tight deadline.

Using reference material

Use books and pictures. If you're asked to design a monster like Godzilla, start with dinosaurs. Or if you have to create an alien civilization, take inspiration from the ancient Egyptians or the Inca civilization.

Spirit of the woods

This conceptual illustration was created for a puppet in a feature film. The client wanted a character that was funny, magical and dynamic.

WORKING PRACTICE

- Spend your free time in research and looking at other artists' work. Above all, exercise your hand and train in different media.

- Conceptual artists mostly work from their own studio using their own resources, as the terms for the job are not defined. And the job can last for months, requiring many meetings with the production company.

- At the very beginning of the job, the production company will already have chosen some start-up points of reference, to define a certain mood for the design and the direction in which the project will be moving. During the research phase, the production team looks for anything that can provide inspiration. You will then be given all the reference materials and sometimes even the tools to complete the job.

- To get started you need a lot of imagination. The director or the production team will limit themselves to giving an indication of what they are looking for. The rest is in your hands. Always remember, though, that you run the risk of submitting to endless revisions and you'll have an enormous number of drawings to do, so look at the contract carefully. As a rule of thumb, always have your sketches approved before going on to the phase of inks and colour.

OVER TO YOU

To get a more specific idea of a conceptual artist's work, look through your DVD collection and find the "Making of" sections in the special features. You'll often find a further section about the design of the film, where you'll see the drawings made in preproduction.

Tree of fire

This illustration, created in acrylics, was intended for the climactic final scenes of a feature film.

LESSON 39 WORKING WITH ANIMATION

animation

This is completely different from working on any other kind of storyboard. First of all, you'll be working in a studio together with the production team – designers, animators and so on. You'll be working to strict deadlines and will need an assistant because the pictures need to be cleaned up and must match the style of the production. The character and set design must look like those in the finished cartoon. The actual frames need to be as close to the final product as possible.

Being part of the team, you'll be in direct contact with the director and will meet on a regular basis to go through the work. You'll also need to keep the design department informed of any changes in location and character design, and make sure all information you receive is up to date.

In animation, you also have quite a lot of creative freedom. The jokes are often created at the storyboard stage, rather than written in the script.

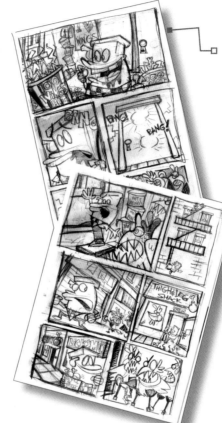

Storyboards
For the flash animation *Chicken Limb*, the artist and animator Amitai Plasse began his project with rough storyboards in his sketchbook.

Sketches for background
From the storyboards, rough scene sketches were made, which were then traced and inked to create the basis for the background. This background was scanned, vectorized and coloured using Adobe Illustrator. The character was added to the coloured background, on separate layers, and taken into Flash for animating.

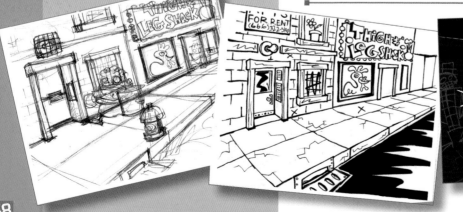

INSIDE STORY

- Meet the production team to look at the material and discuss the contract. Take a look at the studio to understand the structure and value of the job.

- Look at one of the scripts and, of course, the production "bible" (a binder with design and information about the production).Meet the director, and take a little time to decide whether or not you want to take on the job. This will be a full-time assignment and might end up being a one- or a two-year job.

- The routine varies from studio to studio, but generally you'll start working very tightly with the director and gradually be allowed more freedom. The first thing is to create your space in the studio. Make sure you have all communication working. Get a copy of the production "bible" and all reference material, and familiarize yourself with the style.

- Read the scripts, and feel free to point out potential problems in an episode. Always make sure that you have the latest approved script.

- Be available. You should be around the studio as much as possible. Try not to prove how fast you are, because in the end it will just turn against you when the producer starts factoring your speed into the schedule. But never miss deadlines.

- If you sense you're getting in over your head, suggest that you may need an assistant. It's common in animated productions to have a few storyboard artists working on the same job.

- In the beginning, be in the studio as much as possible to observe the different phases of production. You can learn a lot, and it can be very useful in the future.

Finished short

Note that the look of the main character has changed from the initial storyboard sketches. The finished short was created in Flash. Flash maintains all the layers when importing files so it is easier to execute the final animation.

LESSON **40** CALLING IN THE STORYBOARD DOCTOR

films

TV

advertisements

games

animation

Occasionally artists are hired to come in and "fix" someone else's storyboard. Sometimes this is because the agency realizes they have other needs or sometimes it is simply because the storyboard, even if it is well rendered, doesn't really work. Perhaps the artist has been drawing the scene from a high-angle point of view and the production company doesn't want to use cranes or other machinery. Or maybe the storyboard simply lacks continuity.

This kind of work is pretty similar to what a script doctor does to a screenplay. Sometimes it's just a matter of adding some shots to make it more cinematic. At other times, an agency might contact you to adjust a client board for a presentation or ask you to translate a client board drawn by another artist into a possible shooting board. You may also be contacted when a storyboard needs a real overhaul because of mistakes in screen direction and poor shot choices.

It's rare to be asked to draw better pictures in the sense of rendering style. Most often, it's a question of drawing "smarter" pictures in terms of camera angles, framing and shot flow.

COMMON PROBLEMS

First of all, find out what's wrong with the original board and what the director or agency wants from the revised board. With experience, you'll be able to spot this right away. Some of the most common problems in a storyboard are:

- Comic or cartoon-like characters
- Lack of continuity
- Poor screen direction, crossing the line of action

- Jump cuts
- Extreme choices of angle
- "Unfinished business"
- Unclear sequences
- Too few cuts
- Too many cuts

Cartoon characters

Sometimes the drawing style is not realistic enough. When cartoon-like characters occur in a storyboard intended for a live-action medium, the client can find it hard to envisage the finished product. For some reason, this mistake seems more common with ads than with film. Don't confuse realistic drawing with photographic realism. The drawings will still be sketchy but rendered in a realistic fashion.

Increasing the sense of realism

If the client wants more realism in the board, you'll need to render it in a more realistic fashion. Sometimes, you can cheat by adding a few more background details so the illustration looks richer.

Lack of continuity

If lack of continuity is the problem, the director will generally talk you through the revisions that are required, but your suggestions are always welcome. Poor screen direction is the most common problem, and you'll be able to locate it immediately when looking at the board.

Unclear sequences

The same goes for unclear sequences. Sometimes you need to redraw the frames to make them comprehensible or more explanatory.

TIP

Don't be afraid to speak up when you sense that a scene is unnecessary or too long. But remember, you're the hired hand: ultimately, it's not your personal vision that you're rendering, but the director's. So if the director or person in charge doesn't agree with your suggestions, even if you think something is wrong, you need to be able to let go and follow instructions.

Extreme angles

Extreme angles need to be chosen intelligently, meaning that they need to have a clear purpose, otherwise they'll look out of place. A poor choice of angle can sometimes suggest another shot that never comes, confusing the audience and leaving them unsatisfied.

Too few cuts

The problem of having too few cuts is especially common in advertising when going from a client board to a shooting board. Once the original idea has been approved by the client, it needs to be fleshed out with all the technical details in order to be executed. The first two frames below could represent an accident but more frames are required in between to make this clearer.

Jump cuts

The most common jump cut is when you have two shots of the same character back to back, in almost the same position – for example, in a mid shot. If it's not a conscious choice, it can look really wrong.

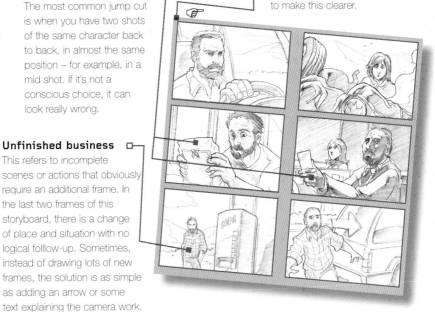

Too many cuts

The problem of having too many cuts can't always be solved simply by cutting out unnecessary frames. In the process of eliminating frames, you usually discover that the original sequence needs to be reworked – so you're not only cutting out frames, but also restaging the action and, therefore, drawing new frames. Sometimes you'll be asked to combine two or more frames into one. For example, if a man is jumping over a wall and making a phone call, you may be asked to combine the two actions in the same shot to save time. Working with the storyboard as an animatic (see pages 86–91) makes it evident what scenes need to go.

Unfinished business

This refers to incomplete scenes or actions that obviously require an additional frame. In the last two frames of this storyboard, there is a change of place and situation with no logical folllow-up. Sometimes, instead of drawing lots of new frames, the solution is as simple as adding an arrow or some text explaining the camera work.

UNIT 8:
GOING PROFESSIONAL

films

TV

advertisements

games

animation

Becoming a professional storyboard artist doesn't just mean having a talent for drawing. You do need talent, but you shouldn't rely on your artistic capabilities alone. There are a number of aspects to consider: the capacity to be organized, the ability to communicate well, a certain self-confidence, and the ability to promote your own work. Not everyone is fortunate enough to have an agent representing them. And discipline, as in most other professions, is crucial. All this put together represents professionalism.

As a storyboard artist you'll be working to tight deadlines, juggling several projects at once and driving your own business. You must be organized.

Effective working space

It sounds pedantic and boring, but setting up an efficient system early on will give you more time to be creative in the end. Artists are notoriously lazy. Sometimes the laziness is caused by lack of organization: first you have to take out the paper, then grope around for those markers, then search for that reference book. It all takes time away from being creative. A messy desk never helps any artist get in the mood.

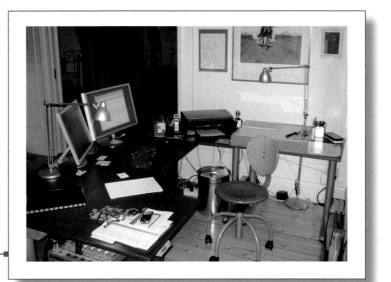

ORGANIZATION

A dedicated workspace

The best solution is to have a separate dedicated studio, but if that's not possible, section off a corner of your apartment for this purpose. It is important to have a desk or a workspace where you can leave work in progress, without having to put everything away at the end of each day. Nothing encourages procrastination like having to set up your workspace every time you start work.

Ideally, you should always aim to finish short assignments such as advertisements or music videos by the end of the day. This isn't always possible, especially when you're just starting out. In the beginning, even smaller jobs will take a few days, and you might have more than one job lying on your desk. So you need a system that allows you to move easily from working on one storyboard to working on another.

Accessibility

Have your references accessible. Sometimes, just getting up to look in a reference book is enough to break your flow and concentration. One tip is to have a bulletin board in front of your desk where you can pin up useful reference pictures and photographs (see page 174). Having a computer close at hand is also useful for Internet reference, digital photos, and any reference material that the agency or production company may send via email.

Also make sure that all the materials you need are at hand when you start work. Have a little extra of everything in store, so you don't have to interrupt your work when you run out of ink or paper. Print out a variety of frame templates so that when you sit down at your desk you can just start drawing.

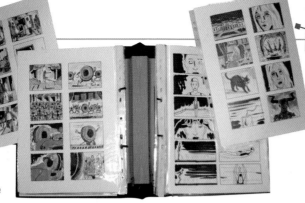

Working on the computer

Nowadays, everyone relies on email rather than fax machines, so you need to be able to scan your work directly into the computer. Draw two strips on each page to reduce scanning time.

Modern scanners are pretty fast, so the amount of time you spend scanning isn't really a problem when you're working on ads or music videos, which might only be a few pages. When it comes to a feature film, however, you really will spend a lot of time on the computer and scanner. (For animation, you'll have to deliver the originals. The studio needs them for their archives and to ensure distribution of up-to-date copies.)

As for your computer, get in the habit of regularly making back-ups – not only of your work, but also of your mail. There are a lot of viruses out there, and your client list is something you base all of your work on. You don't want to lose those contacts. Print out all data (name, address, phone numbers, and email) every time you make a new contact.

Filing systems

Everyone has a personal way to store information. Just find the one that best suits you. Avoid duplicates and multiple folders. One method is to simply have one folder entitled "Storyboards", inside which you have a separate file for each agency; then, in each agency file, put your individual job files.

Always catalogue your old boards so that when you get called back for a follow-up job you know exactly where to find them. Sometimes revisions can come up when you've completely forgotten about a job. Use ring-binders and plastic folders to organize your work. Binders are great for organizing old jobs and reference material and for keeping track of invoices.

Invoicing

As a freelancer, you'll be in charge of your own invoices. Keep track of each job you do, noting the date, contact person, company, hours and, of course, your fee. Make a note of when you send in the invoice and when it's due. Send the invoice as soon as the job is completed. You'll be working on several jobs at once and it's easy to forget.

Negotiate your fee in advance to avoid any misunderstanding. If you're working for a foreign company, find out what the invoicing procedure is in that particular country. It varies. In Italy, for example, the standard due time on an invoice is three to six months!

Invoice Number: 608
Date: 12 10 06

Customer Address: Media Communications Ltd.
Reference: G. Cristiano

Terms of Payment: 15 days
Order number: 45

Art No.	Name		Amount
StoryB	Storyboard		1,000.00 USD
		Sum:	1,000.00 USD
		Freight:	00 USD
		Expenses	00 USD
		VAT	00 USD
		Total:	1,000.00 USD

Bank details: (Include details of your bank and requested payment method here)

Address: (Always include your address and contact details)

With thanks

Files and folders

These days, the storyboard artist usually keeps the original artworks since most work is sent by email to the agency. File everything – not just for your personal archive but also because you might need to use references from an old board, for example, packshots, products, car models or even an update or follow up to a script you have already been working on.

Time zones

New York am Sydney pm Tokyo pm

When working with people in other countries, be sure to keep track of the time difference between your location and theirs. Otherwise you might accidentally wake someone up – or, worse still, find that your seven o'clock deadline actually passed six hours ago! Of course, there are also potential benefits, as you may find that the time difference gives you a few extra hours leeway to finish your job before your colleagues have even made it to the office.

Invoice

Remember to include your address and contact details on your invoice. Also an invoice number is important in case you have to track the progress of the payment with the accounts department.

PROMOTION

films

TV

advertisements

games

animation

Now you've learned the basics and you need to put yourself on the market. Where should you begin? It's not difficult to build up a showcase of your work – drawings you've done, samples, exercises and so forth – but in the beginning no one even knows you exist, so you have to get out there and start knocking on doors.

In order to do that, you need to know what doors you want to knock on – in other words, whether your area of interest lies in animation, advertising, live-action films or computer games. If you haven't yet decided which area you want to pursue, then you need to do some research.

A little organization is also important to begin the job hunt. First, organize your studio and know your possibilities – and, of course, your limitations. You don't want to take on jobs you won't be able to fulfill. You also need a lot of self-confidence, especially during meetings. If you feel frightened and insecure, don't let the people you're meeting see it. Just show what you know. After all, in this profession you learn something new every day.

Professional portfolio
A portfolio with a few good pages works better than a very large one with lots of illustrations and samples. Meetings usually have to be kept to a short time frame so it is important to keep your presentation of work to the essentials.

Promotional tools

There are many ways to promote yourself, but let's start with the good old classic – the portfolio.

At the very minimum, you'll need an up-to-date collection of relevant work and finished illustrations that represents your style and ability. The portfolio is traditionally housed in a zip-up briefcase. A4-size format is preferable, since it is easy to carry and copy. For more information on building a portfolio, turn to page 170.

Make copies of your work that you can leave behind at meetings, along with your contact information. Make a print copy of your portfolio: it will impress any future employer and give you a professional edge.

Business cards are always good to hand out, and these days, with a computer and a printer, they're also easy to make yourself. There are plenty of other artists out there, and even more business cards – so be creative. Your card needs to make an impression so that people remember you next time they have a job.

You might even like to print a small publication or sketchbook to hand out to agencies. It's definitely more expensive than a traditional business card, but if you invest the money you make from one or two jobs in marketing yourself, then it might lead to many more jobs in return.

Be contactable

Make it easy for people to get a hold of you. Have a mobile phone and a reliable email, but don't hand out your home phone number. A lot of storyboard artists

who are just starting out in the business need to work from home for economic reasons. Don't mix your private life with your work life more than you have to. You should be able to get away from the job when you need to.

Set up your own website

The Internet is a fantastic promotional and resource tool, both for showcasing your work and for contacting companies all around the world without leaving your studio. It's easy, affordable and makes you look professional. Think of it as your global office, open 24/7.

Keep your site as simple as possible. Avoid long, animated intros or jazzy interfaces. They're only interesting the first time around, if then. Remember, your potential employers are working to tight deadlines. They're not looking to be entertained. What they want to know is if you're the artist for the job. So give them what they need to know in an easy, accessible way – your contact information and a sample gallery of your work, that's all. Don't give details of pricing on your site.

Web page
Nowadays, given the huge number of sites available on the Internet, a simple navigation page is a must in order to enable visitors to find their way around the site.

There are some standard fees, but each job is unique, and it's best find out more about the individual job before deciding on a fee. For more information on setting up your own website, turn to page 172.

Making contacts

You may also want to attend conventions and related festivals to network and promote yourself. Come equipped with promotional material to give away such as a sample portfolio, small flyers or business cards.

One of the most straightforward marketing approaches is to simply contact agencies and production companies and set up meetings. They're usually very happy to increase their contact list, because it can be difficult to find a storyboard artist at the last minute.

The first thing you need to do is to locate the production companies and agencies in your area. Advertising agencies tend to be located downtown in big cities. They need to be in the centre of town, close to amenities such as typographers, courier services, banks, hotels and restaurants. Very often they need to host meetings with directors and clients from out of town, so they also need to be easy to get to. Film production companies are usually located in more suburban areas, as they need more space for equipment and crew.

You can get address information from your local telephone directory or the Internet. The easiest way, however, is to get hold of a local industry resource book or Internet site that lists the advertising agencies, production companies or animation studios in your area, along with addresses, contact people, and appropriate email and phone numbers. Make a list of the companies and relevant contact information, then simply start calling.

Your first contact should be by phone, since you can never be sure if your email has arrived safely. Make the calls and try to set up meetings. Always introduce yourself

Sample sheets to leave with client
One sheet of paper with your contact information and a few representative samples of your work are more than enough to leave behind with a client. Don't forget to leave your business card as well.

professionally over the phone. Remember, this is the first impression prospective employers will have of you, so make it a good one.

Meeting a potential client

When you meet a potential client, always bring your portfolio and, preferably, a copy of sample work and contact information that you can leave behind.

ATTITUDE

films

TV

advertisements

games

animation

Your attitude is crucial, both at initial meetings and on the job. It plays a big part in making an agency or production company feel comfortable about working with you.

So what are they interested in? Above and beyond your skill as a storyboard artist, they want to be assured that you're reliable and will respect deadlines.

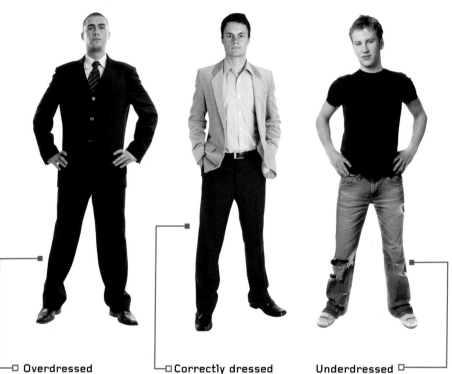

Overdressed
A suit and tie is not appropriate for a first impression in this industry. You want to look creative, not uptight!

Correctly dressed
A casual but smart attire is the best approach for an initial meeting with a new client.

Underdressed
Ripped jeans and scuffed sneakers are too casual for a first meeting. You want to give the impression that you are organized.

Assess your capabilities

If you are unable to do an assignment, then it's much better to make that assessment quickly and let them know as soon as possible, ideally at the initial meeting. Of course, you can't tell them flat out that you aren't capable of doing the job – but you might perhaps suggest that you need more time, because you're busy with other jobs at the moment. Having more time might actually make it possible for you to do the job. If the agency really does need the job to be done immediately, they'll probably decide to find someone else. This doesn't necessarily mean that

you're out of the picture for good: you still give the impression of being a busy professional, whereas if you take on a job that you are incapable of handling, you could damage your reputation.

In the beginning, you will be still unsure of your capabilities, which can make it difficult to assess a job. Some jobs are easy and some can be very complicated, so take time to "measure" your skill.

Be available

The agency or production company needs to be able to get hold of you easily to see

if you're available to do a job or not. Considering the tight turnaround of some jobs, being hard to reach can cost you a job. Sometimes agencies tend to rely too heavily on email contact, assuming that you are always on line. Email is a useful tool, but sometimes you simply don't have access to an Internet connection, so mobile phone is still the most reliable way to reach someone.

Dealing with deadlines

In advertising, you'll continually be told that a job is needed "as soon as possible". Sometimes a job really is urgent, but at other times the person in charge simply has their hands full and has underestimated the time it will take, so when they contact you they're stressed and demanding. Don't let yourself fall into the trap of working all hours to deliver a job as soon as possible, because the job may not actually be that urgent.

Try to keep your weekends free. If you don't, people will start taking it for granted that you work weekends. By working over the weekend, you're really saving their day. If you are willing to work weekends, you should at least add a little to your fee when you're asked to do a last-minute job. Most agencies have no problem with this.

If you finish a job earlier than estimated, it can be a good idea to send it in right away as it makes you look efficient. Sometimes, however, you might want to hold onto it for a little while. Revisions and changes are part of the job, but the longer the agency has to examine and scrutinize every detail of your work, the more changes you'll have to do. It's just human nature.

As soon as possible!

Dealing with rejection

One of the situations you will definitely have to get used to as a storyboard artist is being refused for a job. It happens to everyone, even the professionals, so don't worry: it's completely normal.

There are many reasons why you may be turned down for a job, and often they have nothing to do with your capabilities.

For example, a director might already have a trusted storyboard artist that he or she wants to work with, but the production company is not aware of this and has let you believe, initially, that the job is yours.

Or perhaps the production house felt that your style wasn't "right". Before sending in your applications, research the studios you want to work for. Often you'll find specifications in their ads, describing exactly what they are looking for.

If it's clear that the director really doesn't like your work, then that's just too bad. You can't always be lucky. Don't get demoralized.

Don't get demoralized!

Spread your options

To avoid investing too much time on a project with the risk of not being chosen for the job, contact lots of different production houses. When you have been offered a job, get into the habit of immediately applying for more.

If you're aiming for the world of cinema, don't ignore other sectors such as advertising. Learn to take on any job you're offered, even if it's a simple illustration. In this way you are ensuring some economic stability for yourself.

Do not do illustrations for free in return for a verbal promise that you will be working on the storyboard later. More often than not, this doesn't happen. In fact, try contacting the production house later on and you'll probably find that the person who made that promise to you no longer works there.

Rejection letters
Keep a record of any rejection letters or emails you receive but don't be disheartened by them. Situations can always change.

Dear Storyboard Artist

Thank you for your letter/mail to us regarding storyboards. Sorry but at the moment we don't need the kind of job/service that you can provide. We will keep your letter/mail if the situation changes.

Kind regards
Jane Green

Dear Storyboard Artist

We received your email, and we do occasionally need a storyboarder and/or illustrationist. I've passed your information around here, and we'll call when the right opportunity arises. Thanks.
Marsha Porter

BUILDING A PORTFOLIO

films

TV

advertisements

games

animation

It's essential to have a good portfolio to show potential clients. Thanks to the many print shops who offer "print on demand" services, nowadays it's possible to print a small book at little cost. It's a good idea, and a good investment, to print a portfolio book to leave as reference with agencies and potential clients.

Your portfolio is your business card. It illustrates your artistic talent and shows how organized you are. It has to reassure clients and make them feel that they are in good hands. You should also consider having more than one portfolio available, tailored to suit different sectors of the industry, to avoid showing clients material that is not relevant to their needs. For example, a portfolio pitched at an animation studio should contain material very different from what you would show an advertising agency.

Whatever field you're aiming at, it's good practice to include relevant copies and business cards to hand out at the end of the meeting.

Never stop researching. Knowing your market is essential. With experience, you'll be able to understand at first glance what an agency is looking for, and consequently what you need to show them.

Practicalities

The portfolio has to be concise, practical and, above all, easy to peruse. Use good folders (you can find them in any art suppliers) as they are easy to handle and look elegant. Alternatively, use the kind of document binders you find on news-stands and in stationery shops.

Tailor your portfolio to suit the client

If you are creating your first portfolio, the most important thing to consider is the market you choose to go into. Whatever area you're interested in, tailor the contents of your portfolio accordingly.

An advertising agency will be interested in seeing realistic drawings of everyday life, and clear, easy-to-understand illustrations. Animation studios will want to see your skills in drawing figures, characters, and sequential art and motion. If you're meeting with a film production company, include some high-quality illustrations that show off your ability to draw set and costume design, mood pictures, and more finished illustrations. If you're interested in computer games, include more finished design illustrations and some action storyboard samples.

Portfolio for the film industry

If your target is the film industry, you will need to create storyboards in a different format, more widescreen. The style is also different from that used in advertising. You'll have to create hundreds of illustrations and you'll have to demonstrate you can work in two very different styles – a "quick" one, and a more elaborate one which takes a longer time to complete. (During meetings, it's important to point out the difference between the two, and the time you'll need for each one.)

Include in your portfolio various sketches and anything that can suggest your capacity for design. If you're good at painting, include examples of art that could be considered as conceptual art. Always remember that you're dealing with the world of cinema, so don't include any still life.

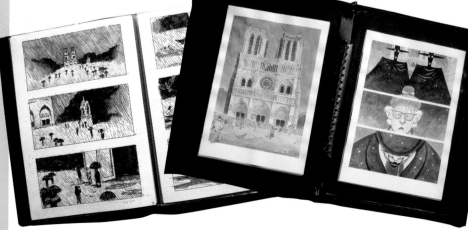

Portfolio for the film industry
Different styles need to be shown to potential clients.

Portfolio for advertising

To get an idea of the kind of imagery you should include in your portfolio, look at the ads shown on television. Generally, advertising is about showing everyday situations – people drinking coffee, reading the paper, driving a car and so on. You need to be able to draw the human form and different vehicles, and most importantly, clothes, shoes and other objects. It might seem strange, but it's not always easy to draw from memory something that we see every day. Find some magazines and start copying photos. Even better, take photos with a digital camera and draw from them. For vehicles, there are many specialized magazines that you can use as reference. Once you feel confident in drawing these subjects, try to recreate a scene that can be summarized in 4 to 8 frames.

Having done this, imagine you have to draw a sketch for a poster to advertise, say, a drink. Create a number of sketches and choose the ones you feel have the most possibilities. (Ask your friends and family to help you choose.) Pick one image and draw a further two or three examples of it using different techniques – for example, one in black and white plus grey, one in colour, and one computer coloured. If you are at the beginning of your career, you will have only a few samples to show. As you work your way through your professional life, substitute different samples and add more of the work that best represents you.

Portfolio for animation

With animation, things are more complex – mainly because there are so many different kinds of production. You need to have a good knowledge of both classic and computer-generated animation. Your portfolio should include classic material that shows your drawing skills (so put in different types of sketches – anatomy and movement studies, animal illustrations and so on). You should also include drawings that conform to the style of the studio you wish to contact.

When you work on a production, you need to be able to adapt your style, so your portfolio needs to demonstrate that you can easily change from one style to another. But be careful not to present drawings that are copies of the company's previous productions, as you risk being considered a novice. Generally, as a professional artist, your portfolio needs to have samples of work that you have produced for agencies and production companies, along with some personal projects – but not exercises or things that you have studied.

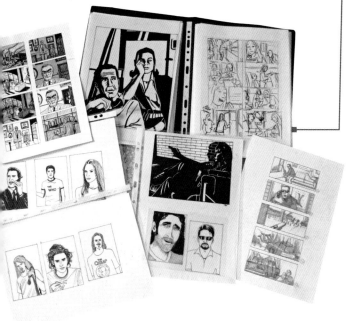

Portfolio for advertising

As well as examples of finished storyboards you should also include examples of everyday situations – perfect for the advertising world.

Portfolio for animation

Research your market and include examples of styles that will appeal to potential clients.

CREATING A WEBSITE

films

TV

advertisements

games

animation

Having your own website is like having an office with a door open onto the world. Just think of the opportunities: rental expenses near zero, an office open all year round, a chance to always be available, and, clearly, the chance to show your work to anyone passing through your "virtual studio".

Creating your own website is not very difficult and, with the help of programs with good interfaces, you can be up and running in days.

You need a certain amount of creativity and graphics awareness – but as you're a storyboard artist, it's safe to assume that you already have these skills. Don't forget to have a look at websites of other artists – both at your favourites and at the "competition".

Getting started

First you'll need a name, and then you'll have to register your "domain". A number of companies on the Web offer deals at competitive prices. It takes only a few minutes to register a website, with necessary emails. Check out websites such as **www.domaindirect.com**. From these websites you can also see if the domain name you have chosen is still available. Opt for names that are short and easy to remember.

Designing your website

The first step in designing your website is to do so on paper, even if just to set down what your "pages" will be. This will make life easier for you. In a sense, you will be creating the storyboard for the website.

Software

Website design software can be divided into four categories:
- Programs for graphic art (drawing and touch-up).
- HTML editor. HTML (Hyper Text Markup Language) is the document format used on the Web. It defines the page layout, typefaces and all graphic elements.

- Specialized programs for the application of special effects, such as animation.
- Internet browser.

The most famous, and most used, programs are Microsoft FrontPage, Macromedia Flash, and Macromedia DreamWeaver. On the Internet, there are also many sites that allow you to download (for free) pre-designed web templates; all you have to do is add your own content.

If you want to create your website in HTML, the first thing to do is to draw the graphics side of it. If, instead, you want to use Macromedia Flash, the graphic art development will happen at the same time as the rest of the website. The whole process is kept in the hard disk of your computer and only at a later date will it be transferred online. During the development phase, however, you will need to test the site at times, so a basic knowledge of how the Internet works is essential.

Keep it simple

Websites that are too complicated, with many pages and a lot of text, are not popular among surfers. Avoid long introductions or animations; they're cute

Homepage Contact information

the first time around, but people might not want to see them again and again. And update your site regularly – at least the information section and art gallery.

Clients have very little time to waste looking for the right artist, so your phone number is the most important element in the contacts section. It's good to have a great gallery section that includes examples not only of your style but also of the various standards – storyboard examples in black and white, grey scale, colour. Anyone looking at your site then immediately has a clear idea of your capabilities. Don't worry about including your price list; this will be requested and discussed over the phone.

Home/biography pages
You don't need to include your resumé or details of your education; you can always send these on if the client requests it. It's important not to have too much text on your website: it's pictures that your future clients will want to see.

Keep your biography short – and relevant. It should hint at what your main storyboarding interests are, as well as giving a little information on what you are like personally. You could mention, for example, that you have previous work experience in advertising, or the fact that you have an interest in photography.

Art gallery
The art gallery has to be easy to navigate; it is an online portfolio. If you wish, you can add a downloadable version of your portfolio to your website, maybe in PDF format, as this can be opened by both a PC and a Mac. If you work in different styles, you may want to create more than one gallery. These gallery pages can then be sub-divided into the different types of media in which you are interested – for example, animation, film, conceptual art, and so on. Remember not to add high-resolution images. There's nothing more irritating than a slow-moving website.

Client list page
A list of the clients for whom you work is becoming ever more important for a freelancer, but if you are just starting out you may not be able to include one on your site. Make sure, however, that you can easily add this feature to your website later on, without having to redo the whole layout.

Contact information
The contact information page is important, so as well as your email, home or work address, phone and fax numbers, don't forget to include your mobile phone number.

Client log-in
It's a good idea to add a client log-in, so that clients can access your site to see work in progress and to download the files related to the job you are working on. This is really useful for long-term jobs, like the storyboard for a film.

CHECKLIST

Ensure that your website has pages for the following:

- Main (home) page
- Biography page
- Art gallery page(s)
- Client list page
- Contact information page
- Work in progress/Client log-in page

Log-in page

Gallery page I

Gallery page II

USING REFERENCE MATERIAL

films

TV

advertisements

games

animation

As a storyboard artist, you'll be asked to draw a wide range of subject matter. A general interest and knowledge of history, art, architecture and film is invaluable, but you'll also be using specific images for inspiration. An agency or production company will usually provide you with reference material that they've compiled, but most often you'll supplement this with reference material of your own.

You can be creative here: use whatever works for you. Models of any kind, picture books, magazines and comics are all useful. The Internet is also a fantastic resource, allowing you easy access to all kinds of material. Locations, logotypes, products, costumes, animals, vehicles: just type whatever you're looking for into a search engine such as Google, and it's all there in a matter of seconds.

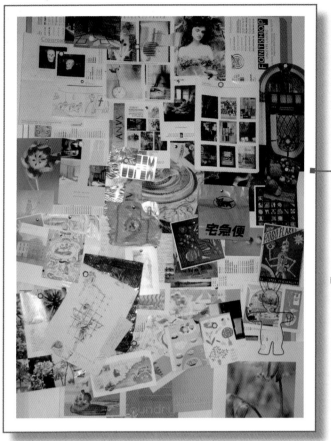

Bulletin board
Create your own reference board in your studio. Pin up anything that inspires you – from postcards to sweet wrappers!

Books and magazines
Film reference books are great sources of information about classic films – both old and modern. A subscription to a film magazine may also be worth the investment.

Polaroids are also useful for quick reference shots.

Digital camera
If you can, always have a digital camera with you to take reference shots from daily life.

Classic shots

It's good to have some of the best known films on your shelves for easy reference when people talk about classic shots or sequences. It's very common – especially when working with advertisements – for agencies and production companies to refer to certain classic scenes. There are some that always come up, such as *Taxi Driver* for the driving scenes, nightlife, photographic style and 1970s style, or *The Graduate* for composition and framing. Hong Kong films are great for action scenes. *Saturday Night Fever* is a classic for some costume clichés and the whole "disco thing". As for television series, *Hill Street Blues* is often mentioned in relation to morning meetings and conferences. That's just to name a few. It tends to be the better-known films that are picked as examples and reference, because they've become part of the language of film. A good knowledge of film history and films in general is necessary – so watch as many as you can!

Save it!

It's a good idea to save and catalogue your reference material, because you never know when it will come in handy on a future job. Every artist has his or her proverbial Achilles heel, that thing that's particularly hard to draw. Whatever it may be, just be aware of it – and make sure you have plenty of references on hand.

Useful tools

A digital camera is a fantastic reference tool. You can use it to take snapshots of locations, people, architecture and costumes. You can record product information and reference material presented at a meeting. You can use it to record a rough action sequence that you'll later draw from. You can even do the entire board by taking preliminary photos of friends or models, printing out the sequence, and then tracing it on a light table.

You don't need a camera with super-high resolution. It's good enough if you can view the image on a computer screen. Remember that you'll be sending and receiving reference photos via email, so the resolution needs to be low enough to send over the Internet. Size is also important. Look for a camera that's small and easy to carry in your pocket.

Stills from films
Some scenes from films are iconic. You should be familiar with as many as possible as agencies often refer to certain scenes in briefing meetings.

films

TV

animation

OVER THE SHOULDER

Name: Ray Kosarin
Occupation: Director of animated television series and films
Recent work: Supervising director of the hit series Daria, director for the television series Beavis and Butt-head, sequence director for the Paramount feature film Beavis and Butt-head do America

ADVICE FROM A PROFESSIONAL

Q How do you work with the storyboard?

A It varies, depending on the nature of the production, but whenever possible, my favourite way to work with the board is from the very beginning – as a visual scriptwriting tool. Because film is, in essence, a visual language, a written script is by nature hobbled in ways that a storyboard is not. The best filmmakers have always understood this, and consider storyboarding and scriptwriting to be inseparable parts of the process. Animation, in particular, lends itself to storyboarding in this way, because its inherent potential for visual expression is bound by the imagination.

Q How do you personally approach the process of storyboarding?

A At the outset, I like to draw as quickly and as loosely as possible. Structuring shots and cuts, and especially pacing them, is a fundamentally visceral exercise, and intuition will almost always be your smartest, most reliable guide to fleshing out a sequence. The intellect is also essential, but largely as a check and balance – never the sole arbiter of what will move or entertain an audience. I prefer to leave the finer points of design, such as the details of an interior or a character's costume, for much later: fussing with them too early is almost like choosing the upholstery for a car without knowing which kind of car you are buying. Once the cuts and shots are working well, you'll be better equipped to make design decisions that develop and reinforce your message.

Q Is the process different for television series?

A On an animated TV series, there is seldom the opportunity to use the board in the scripting stage. Most of the time, you are asked to board and direct a script that has been signed off by creators, producers, and networks. Your work is to tell your story in the best possible way: staying true to the characters, making plot points clearly and naturally, and standing the jokes "on their feet" so that they play funny for the audience.

Q Do you think one person should be responsible for storyboarding an entire episode?

A Yes, whenever possible. If the schedule or other reasons prevent this, the director, or an artist working closely with the director, should rough out as many key sequences as possible for the other artists – especially recurring situations which develop throughout the episode – so that there is a shapely visual structure from start to finish.

Q What's the starting point for storyboarding a TV show?

A I find the best way to storyboard a show is almost never to start with the first page of script and move forwards. There are key moments in any good story – often turning points of character or plot – that will define the visual relationships between characters, characters and setting, or characters and the frame, and the cutting language. Starting with, for example, the scene where a main character meets an adversary for the first time will – if you're awake – almost force you to find the best staging for the characters. Storyboarding those scenes honestly will then largely set the visual balance for the rest of the episode. This will especially help refine those expository sequences early in a story. Anytime anyone looking at a board or a show thinks, "What a cool shot!" instead of thinking about the story, the shot is almost certainly wrong!

This method also helps to uncover any weakness in the script – and in even the best screenplay there is nearly always some clunkiness or unfinished business – and remedy it. A good storyboard will make judicious use of composition, cutting and pacing either to shore up a plot point in danger of being lost or, in other cases, to help play down an overworked section of dialogue or exposition.

Q What do you look for in a storyboard artist?

A Above all, I look for an extremely good storyteller. The artist must draw well enough to illustrate the characters and shots clearly and correctly – but I will always choose an average artist who solves the story well over the greatest draughtsman in the world who doesn't.

Q How do you assess an artist's portfolio?

A When I look at a portfolio, I look for boards that read like a film, where the basic intention of each shot is clear even before I look at the captions. That said, I also look for captions that are understandable and fully express any information that is not explained by the pictures alone. I look for drawing that's expressive but not indulgent – drawing that invites me to think not about the artist, but about the characters. I look for drawings without a lot of lines or fuss, because we will need to be able to think and work quickly.

Q What qualities does a good storyboard artist need, beyond the ability to draw well?

A A good storyboard artist is a smart reader – of both scripts and films. He or she lives and breathes film language and intuitively senses each "beat" in a story and, for each one, when a long shot or a close-up is called for.

A good storyboard artist is also a good entertainer, who appreciates the value of each comic or dramatic turn in a story and works to harvest from it the best, most faithful, visual sequence possible. He or she has a natural sense of timing, and can read a paragraph of dialogue and sense how many words belong with each panel or shot to feel both natural and right for the moment. He knows how to place a cut when it needs to be noticed versus when it shouldn't.

A good board artist knows what's important to spend his limited time solving and plans his work accordingly. This means considering all the people who will use the board, and what information they will need from it.

Not least, a good board artist is a team player, who is able to balance his or her convictions about what is best for the story with the reality of working for a client, producer and director who will sometimes have other ideas. Devotion to doing your best work – the exact same quality that makes you good at what you do – can at times make it very difficult to let go of an idea you have poured your heart and soul into, but this is an essential part of our profession. Under the best circumstances, a natural chemistry and trust will develop between you and the director, and whoever's idea wins, or even who had which idea to begin with, will become almost the furthest thing from anyone's mind.

If you are such a person, and you are lucky enough to belong to a team that recognizes your strengths, then you are well on your way to creating work that audiences will enjoy and of which you will be proud.

FILM FESTIVALS

A good storyboard artist should be well informed about what goes on in the film world. Film festivals often offer the opportunity to meet producers and directors who work for the smaller production companies. Contacting representatives of the major studios at film festivals is more difficult since their representatives are there to sell the films to distributors and not to find storyboard artists. However you can always collect their business cards for future reference.

Independent companies are more approachable and they are usually very interested in making new contacts.

Don't forget to pick up the festival catalogue. As well as listing the films in the programmes and showing inspiring pictures, they usually also contain addresses of the production companies and contact names.

Here is a list of important film festivals around the globe and throughout the calendar year:

January/February

INTERNATIONAL FILMFESTSPIELE BERLIN
www.berlinale.de
Berlin, Germany
Email: info@berlinale.de

SUNDANCE FILM FESTIVAL
www.sundance.org
Park City, Utah, USA
Email: institute@sundance.org

FUTURE FILM FESTIVAL
www.futurefilmfestival.org
Bologna, Italy
Email: ffinfo@futurefilmfestival.org

KIDFILM FESTIVAL
www.usafilmfestival.com
Dallas, Texas, USA
Email: usafilmfestival@aol.com

TRIESTE FILM FESTIVAL
www.triestefilmfestival.it
Trieste, Italy
Email: info@alpeadriacinema.it

PREMIERS PLANS – FESTIVAL D'ANGERS
www.premiersplans.org
Angers, France
Email: angers@premiersplans.org

INTERNATIONAL FILM FESTIVAL – ROTTERDAM
www.filmfestivalrotterdam.com
Rotterdam, Netherlands
Email: tiger@filmfestivalrotterdam.com

FESTIVAL INTERNATIONAL DU COURT METRAGE – CLERMONT-FERRAND
www.clermont-filmfest.com
Clermont-Ferrand, France
Email: info@clermont-filmfest.com

GOTEBORG INTERNATIONAL FILM FESTIVAL
www.goteborg.filmfestival.org
Gothenburg, Sweden
Email: info@filmfestival.org

FANTASTIC ARTS – FESTIVAL DU FILM FANTASTIQUE GERARDMER
www.gerardmer-fantasticart.com
Gérardmer, France
Email: info@gerardmer-fantasticart.com

ANIMATED EXETER
www.animatedexeter.co.uk
Exeter, UK
Email: animatedexeter@exeter.gov.uk

ANIMA
www.awn.com/folioscope
Brussels, Belgium
Email: info@folioscope.be

FANTASPORTO – FESTIVAL INTERNACIONAL DE CINEMA DO PORTO
www.fantasporto.online.pt
Oporto, Portugal
Email: info@fantasporto.online.pt

March

ALBA INTERNATIONAL FILM FESTIVAL
www.albafilmfestival.com
Alba, Italy
Email: info@albafilmfestival.com

N.I.C.E.
www.nicefestival.org
Amsterdam, Netherlands
St. Petersburg/Moscow, Russia
Email: info@nicefestival.org

TAMPERE INTERNATIONAL SHORT FILM FESTIVAL
www.tamperefilmfestival.fi
Tampere, Finland
Email: office@tamperefilmfestival.fi

F.I.F.A. – FESTIVAL INTERNATIONAL DU FILM SUR L'ART
www.artfifa.com
Montréal, Canada
Email: info@artfifa.com

FESTIVAL INTERNATIONAL DE FILMS DE FEMMES
www.filmsdefemmes.com
Créteil, France
Email: filmsfemmes@wanadoo.fr

BRUSSELS INTERNATIONAL FESTIVAL OF FANTASTIC FILM
www.bifff.org
Brussels, Belgium
Email: peymey@bifff.org

BERGAMO FILM MEETING
www.bergamofilmmeeting.it
Bergamo, Italy
Email: info@bergamofilmmeeting.it

SEATTLE JEWISH FILM FESTIVAL
www.ajcseattle.org
Seattle, Washington, USA
Email: seattle@ajc.org

FESTIVAL INTERNATIONAL DE FILMS DE FRIBOURG
www.fiff.ch
Fribourg, Switzerland
Email: info@fiff.ch

FESTIVAL DU CINEMA NORDIQUE
www.festival-cinema-nordique.asso.fr
Rouen, France
Email: festival.cinema.nordique@wanadoo.fr

SAN FRANCISCO INTERNATIONAL ASIAN-AMERICAN FILM FESTIVAL
www.naatanet.org/festival
San Francisco, California, USA
Email: festival@naatanet.org

FESTIVAL DEL CINEMA AFRICANO, D'ASIA E AMERICA LATINA
www.festivalcinemaafricano.org
Milan, Italy
Email: festival@coeweb.org

FESTIVAL INTERNATIONAL DES ECOLES DE CINEMA
www.rihl.org
Poitiers, France
Email: festival.rihl@letheatre-poitiers.com

ANN ARBOR FILM FESTIVAL
www.aafilmfest.org
Ann Arbor, Michigan, USA
Email: info@aafilmfest.org

April

SAMSUNG KOREA FILM FEST
www.koreafilmfest.com
Florence, Italy
Email: info@
koreafilmfest.com

PANAFRICANA – LE MILLE AFRICHE DEL CINEMA
www.panafricana.it
Rome, Italy
Email: panafricana@
gmail.com

FESTIVAL DU FILM POLICIER DE COGNAC
www.festival.cognac.fr
Cognac, France
Email: sbataille@le-public-systeme.fr

SINGAPORE INTERNATIONAL FILM FESTIVAL
www.filmfest.org.sg
Singapore, Singapore
Email: filmfest@pacific.net.sg

EUROPACINEMA
www.europacinema.it
Viareggio, Italy
Email: evspett@tin.it

USA FILM FESTIVAL
www.usafilmfestival.com
Dallas, Texas, USA
Email: usafilmfestival@
aol.com

SAN FRANCISCO INTERNATIONAL FILM FESTIVAL
www.sffs.org
San Francisco, California, USA
Email: frontdesk@sffs.org

FAR EAST FILM
www.fareastfilm.com
Udine, Italy
Email: fareastfilm@
cecudine.org

MINNEAPOLIS – ST. PAUL INTERNATIONAL FILM FESTIVAL
www.mnfilmarts.org
Minneapolis, Minnesota, USA
Email: info@mnfilmarts.org

VISIONS DU REEL – FESTIVAL INTERNATIONAL DE CINEMA
www.visionsdureel.ch
Nyon, Switzerland
Email: docnyon@
visionsdureel.ch

CORTOONS
www.cortoons.it
Rome, Italy
Email: info@cortoons.it

LINEA D'OMBRA – SALERNO FILM FESTIVAL
www.shadowline.it
Salerno, Italy
Email: info@shadowline.it

TRENTO FILM FESTIVAL
www.trentofestival.it
Trento, Italy
Email: mail@trentofestival.it

May

MAGGIO ITALIANO – CINEMA D'AUTORE
www.maggiofesteggiante.it
Teramo, Italy
Email: spaziotre.spaziotre@
tin.it

INTERNATIONALES DOKUMENTAR FILMFESTIVAL MUNCHEN
www.dokfest-muenchen.de
Munich, Germany
Email: info@dokfest-muenchen.de

B.F.B – BOOK FILM BRIDGE
http://bfb.fieralibro.it
Torino, Italy
Email: bfb@fieralibro.it

INTERNATIONALE KURZFILMTAGE OBERHAUSEN
www.kurzfilmtage.de
Oberhausen, Germany
Email: info@kurzfilmtage.de

BLACK INTERNATIONAL CINEMA (BERLIN)
www.black-international-cinema.com
Berlin, Germany
Email: bicdance@aol.com

TORONTO JEWISH FILM FESTIVAL
www.tjff.com
Toronto, Canada
Email: tjff@tjff.ca

FESTIVAL DE CANNES
www.festival-cannes.org
Cannes, France
Email: festival@festival-cannes.org

YORKTON SHORT FILM & VIDEO FESTIVAL
www.yorktonshortfilm.org
Yorkton, Canada
Email: director@
yorktonshortfilm.org

S.I.F.F – SEATTLE INTERNATIONAL FILM FESTIVAL
www.seattlefilm.org
Seattle, Washington
Email: info@seattlefilm.org

MOUNTAINFILM IN TELLURIDE
www.mountainfilm.org
Telluride, Colorado, USA
mountainfilm.org

INTERNATIONAL FILM FESTIVAL FOR CHILDREN AND YOUTH
www.zlinfest.cz
Zlin, Czech Republic
Email: festival@zlinfest.cz

KRAKOW FILM FESTIVAL
www.cracowfilmfestival.pl
Krakow, Poland
Email: festiwal@apollofilm.pl

June

MOSTRA INTERNATIONAL FESTIVAL OF NEW CINEMA
www.pesarofilmfest.it
Pesaro, Italy
Email: info@pesarofilmfest.it

PALM SPRINGS FILM NOIR FESTIVAL
www.palmspringsfilmnoir.com
Palm Springs, California, USA
Email: kittyteeth@aol.com

ARCIPELAGO
www.arcipelagofilmfestival.org
Rome, Italy
Email: info@
arcipelagofilmfestival.org

FESTROIA INTERNATIONAL FILM FESTIVAL
www.festroia.pt
Setùbal, Portugal
Email: geral@festroia.pt

NAPOLI FILM FESTIVAL
www.napolifilmfestival.com
Naples, Italy
Email: segreteria@
napolifilmfestival.com

INTERNATIONAL ANIMATED FILM FESTIVAL
www.annecy.org
Annecy, France
Email: info@annecy.org

NEWPORT INTERNATIONAL FILM FESTIVAL
www.newportfilmfestival.com
Newport, Rhode Island, USA
Email: info@
newportfilmfestival.com

SYDNEY FILM FESTIVAL
www.sydneyfilmfestival.org
Sydney, Australia
Email: info@
sydneyfilmfestival.org

MIDNIGHT SUN FILM FESTIVAL

www.msfilmfestival.fi

Sodankyla, Finland

Email: office@msfilmfestival.fi

NEW YORK ASIAN FILM FESTIVAL

www.subwaycinema.com

New York, New York, USA

Email: info@subwaycinema.com

ART FILM FESTIVAL

www.artfilm.sk

Trencianske Teplice, Slovakia

Trencin, Slovakia

Email: artfilm@artfilm.sk

GENOVA FILM FESTIVAL

www.genovafilmfestival.it

Genova, Italy

Email: segreteria@genovafilmfestival.it

July/August

GALLIO FESTIVAL OF ITALIAN CINEMA

www.cineghel.it

Gallio, Italy

Email: info@cineghel.it

UMBRIA FILM FESTIVAL

www.umbriafilmfestival.com

Montone, Italy

Email: info@umbriafilmfestival.com

IL CINEMA RITROVATO

www.cinetecadibologna.it

Bologna, Italy

Email: cinetecamanifestazioni1@comune.bologna.it

LE VIE DEL CINEMA

Terni, Italy

Email: leviedelcinema@comune.narni.tr.it

JERUSALEM FILM FESTIVAL

www.jff.org.il

Jerusalem, Israel

Email: daniel@jff.org.il

AUCKLAND INTERNATIONAL FILM FESTIVAL

www.nzff.co.nz

Auckland, New Zealand

Email: festival@nzff.co.nz

FILMFEST MUNCHEN

www.filmfest-muenchen.de

Munich, Germany

Email: info@filmfest-muenchen.de

MELBOURNE INTERNATIONAL FILM FESTIVAL

www.melbournefilmfestival.com.au

Melbourne, Australia

Email: miff@melbournefilmfestival.com.au

LOCARNO INTERNATIONAL FILM FESTIVAL

www.pardo.ch

Locarno, Switzerland

Email: info@pardo.ch

EDINBURGH INTERNATIONAL FILM FESTIVAL

www.edfilmfest.org.uk

Edinburgh, Scotland

Email: info@edfilmfest.org.uk

September

VENICE FILM FESTIVAL

www.labiennale.org

Venice, Italy

Email: cinema@labiennale.org

DEAUVILLE AMERICAN FILM FESTIVAL

www.festival-deauville.com

Deauville, France

Email: jlasserre@le-public-systeme.fr

TORONTO INTERNATIONAL FILM FESTIVAL

www.bell.ca/filmfest/

Toronto, Canada

Email: tiffg@tiffg.ca

MILAN FILM FESTIVAL

www.milanofilmfestival.it

Milan, Italy

Email: info@milanofilmfestival.it

OTTAWA INTERNATIONAL ANIMATION FESTIVAL

www.awn.com/ottawa

Ottawa, Canada

Email: info@animationfestival.ca

FANTASTISK FILM FESTIVAL

www.fff.se

Lund-Malmo, Sweden

Email: info@fff.se

DONASTIA – SAN SEBASTIAN INTERNATIONAL FILM FESTIVAL

www.sansebastianfestival.com

San Sebastian, Spain

Email: ssiff@sansebastianfestival.com

COPENHAGEN INTERNATIONAL FILM FESTIVAL

www.copenhagenfilmfestival.com

Copenhagen, Denmark

Email: info@copenhagenfilmfestival.com

PRIX ITALIA

www.prixitalia.rai.it

Venice, Italy

Email: prixitalia@rai.it

NETHERLANDS FILM FESTIVAL

www.filmfestival.nl

Utrecht, Netherlands

Email: info@filmfestival.nl

VANCOUVER INTERNATIONAL FILM FESTIVAL

www.viff.org

Vancouver, Canada

Email: viff@viff.org

NAMUR INTERNATIONAL FRANCOPHONE FILM FESTIVAL

www.fiff.be

Namur, Belgium

Email: info@fiff.be

October

ROME FILM FESTIVAL

www.romacinemafest.org

Rome, Italy

Email: info@romacinemafest.org

PORDENONE SILENT FILM FESTIVAL

www.cinetecadelfriuli.org/gcm

Sacile, Italy

Email: info.gcm@cinetecadelfriuli.org

HAMBURG FILM FESTIVAL

www.filmfesthamburg.de

Hamburg, Germany

Email: info@filmfesthamburg.de

FRANCE CINEMA

www.francecinema.it

Florence, Italy

Email: france.cinema@dada.it

FILMS FROM THE SOUTH

www.filmfrasor.no

Oslo, Norway

Email: info@filmfrasor.no

CHICAGO INTERNATIONAL FILM FESTIVAL

www.chicagofilmfestival.com

Chicago, Illinois, USA

Email: info@chicagofilmfestival.com

WARSAW INTERNATIONAL FILM FESTIVAL
www.wff.pl
Warsaw, Poland
Email: kontakty@wff.pl

INTERNATIONAL FESTIVAL OF CINEMA AND RELIGION
www.religionfilm.com
Trento, Italy
Email: segreteria@religionfilm.com

INTERNATIONAL FESTIVAL OF CINEMA AND TELEVISION
www.eurovisioni.it
Rome, Italy
Email: eurovisioni2@tiscali.it

FESTIVAL OF LATIN AMERICAN CINEMA
www.cinelatinotrieste.org
Trieste, Italy
Email: festivalatino@gmail.com

CINEKID
www.cinekid.nl
Amsterdam, Netherlands
Email: info@cinekid.nl

MEDITERRANEAN FILM FESTIVAL
www.mediterraneofilmfestival.com
Cagliari, Italy
Email: umanitaria.carbonia@tiscali.it

INTERNATIONAL LEIPZIG FESTIVAL FOR DOCUMENTARY AND ANIMATED FILM
www.dokfestival-leipzig.de
Leipzig, Germany
Email: info@dok-leipzig.de

November

TORINO FILM FESTIVAL
www.torinofilmfest.org
Torino, Italy
Email: info@torinofilmfest.org

SULMONACINEMA FILM FESTIVAL
www.sulmonacinema.it
Sulmona, Italy
Email: info@sulmonacinema.it

MEDFILM FESTIVAL
www.medfilmfestival.org
Rome, Italy
Email: info@medfilmfestival.org

N.I.C.E. USA
www.nicefestival.org
New York/San Francisco,, USA
Email: info@nicefestival.org

LATIN AMERICAN FILM FESTIVAL
www.latinamericanfilmfestival.com
London, UK
Email: info@latinamericanfestival.com

AMIENS INTERNATIONAL FILM FESTIVAL
www.filmfestamiens.org
Amiens, France
Email: contact@filmfestamiens.org

INTERNATIONAL FILM FESTIVAL MANNHEIM-HEIDELBERG
www.mannheim-filmfestival.com/en/homepage/
Mannheim/Heidelberg, Germany
Email: ifmh@mannheim-filmfestival.com

TOKYO FILMEX
www.filmex.net
Tokyo, Japan
Email: info@filmex.net

SALERNO INTERNATIONAL FILM FESTIVAL
www.cinefestivalsalerno.it
Salerno, Italy
Email: cinefestivalsalerno@yahoo.it

OFFICINEMA
www.cinetecadibologna.it
Bologna, Italy
Email: cinetecamanifestazioni1@comune.bologna.it

TALLINN BLACK NIGHTS FILM FESTIVAL
www.poff.ee
Tallinn, Estonia
Email: poff@poff.ee

CAMERIMAGE – INTERNATIONAL FILM FESTIVAL OF THE ART OF CINEMATOGRAPHY
www.camerimage.pl
Lodz, Poland
Email: office@camerimage.pl

December

DESERT NIGHTS: TALES FROM THE DESERT
www.desertnightsfestival.org
Rome, Italy
Email: info@desertnightsfestival.org

COURMAYEUR NOIR IN FESTIVAL
www.noirfest.com
Courmayeur, Italy
Email: noir@noirfest.com

FESTIVAL DEI POPOLI
www.festivaldeipopoli.org
Florence, Italy
Email: festivaldeipopoli@festivaldeipopoli.191.it

INTERNATIONAL FILM FESTIVAL BRATISLAVA
www.iffbratislava.sk
Bratislava, Slovakia
Email: iffbratislava@ba.sunnet.sk

ANCHORAGE INTERNATIONAL FILM FESTIVAL
www.anchoragefilmfestival.com
Anchorage, Alaska
Email: aliza@anchoragefilmfestival.com

INTERNATIONAL SHORT FILM FESTIVAL LEUVEN
www.shortfilmfestival.org
Leuven, Belgium
Email: info@shortfilmfestival.org

FESTIVAL TOUS COURTS
www.aix-film-festival.com
Aix-en-Provence, France
Email: aixfilms@club-internet.fr

INTERNATIONAL FESTIVAL OF LATIN AMERICAN NEW CINEMA
www.habanafilmfestival.com
L'Avana, Cuba
Email: festival@festival.icaic.cu

SANTA FE FILM FESTIVAL
www.santafefilmfestival.com
Santa Fe, New Mexico, USA
Email: info@santafefilmfestival.com

KATHMANDU INTERNATIONAL MOUNTAIN FILM FESTIVAL
www.himalassociation.org/kimff
Katmandu, Nepal
Email: kimff@himalassociation.org

CAPRI, HOLLYWOOD – INTERNATIONAL FILM FESTIVAL
www.caprihollywood.com
Capri, Italy
Email: caprinelmondo@tin.it

Further Reading

Practical Art Books

All how-to-draw books are useful to have on the shelves of your studio. There are plenty on the market to choose from, visit your local art supply store where you'll find a good selection. This is not a complete list, but it is a good place to start.

Animals In Motion, Eadweard Muybridge (Dover Publications, 1957)

Bridgman's Life Drawings, George B. Bridgeman (Dover Publications, 1971)

Drawing: You Can Do It!, Greg Albert (North Light Books, 1992)

Dynamic Anatomy, Burne Hogarth (Watson-Guptill Publications, 1971)

Keys To Drawing, Bert Dodson (North Light Books, 1985)

The Fantasy Figure Artist's Reference File, Peter Evans (Barron's Educational Series, 2006)

The Human Figure In Motion, Eadweard Muybridge (Dover Publications, 1955)

Perspective For Artists, Rex Cole, (Dover Books, 1971)

Practical Film Books

These books will be useful for further insights into the filming process and the role of the storyboard.

Every Frame A Rembrandt, Andrew Laszlo (Focal Press, 2000)

Film Directing Shot By Shot: Visualizing From Concept To Screen, Steven D. Katz (Michael Wiese Productions, 1991)

From Word To Image, Marcie Begleiter (Michael Wiese Productions, 2001)

Filmmaking Course, Chris Patmore (Barron's Educational Series, 2005)

Setting Up Your Shot, Jeremy Vineyard (Michael Wiese Productions, 2000)

For Inspiration

Here are some of the books that I've found inspirational during my career.

Chaos, Jean "Moebius" Giraud (Marvel Entertainment Group)

Comics And Sequential Art, Will Eisner (Poorhouse Press, 1985)

Film Architecture – From Metropolis to Blade Runner, Dietrich Neumann (Prestel, 1999)

From Star Wars To Indiana Jones – The Best Of The LucasFilm Archives, Mark Cotta and Shinji Hata (Chronicle Books, 1995)

Hitchcock At Work, Bill Krohn (Phaidon, 2003)

Industrial Light & Magic – The Art Of Special Effects, Thomas G. Smith (Ballantine Books, 1986)

Mythology: The DC Comics Art Of Alex Ross, Alex Ross (Pantheon, 2005)

Norman Rockwell Adventures, Norman Rockwell (Harry N. Abrams, 1995)

Norman Rockwell's America, Christopher Finch (Harry N. Abrams, 1985)

Oblagon – Concepts Of Syd Mead, Minami Hiramatsu, (Oblagon, 1996)

Production Design & Art Direction – Screencraft, Peter Ettedgui (Focal Press, 1999)

The Animator's Survival Kit, Richard Williams (Faber and Faber, 2002)

The Art Of Production Design, Gabriele Lucci (Electa & Accademia dell'Immagine, 2004)

The Art Of Robots, Amid Amidi and William Joyce (Chronicle Books, 2004)

The Art Of Star Wars, Carol Titelman (Ballantine Books, 1979)

The Art Of The Incredibles, Mark Cotta Vaz (Chronicle Books, 2004)

The Bill Sienkiewicz Sketchbook, Bill Sienkiewicz (Fantagraphics Books)

The Film Posters Of Drew Struzan, Drew Struzan (Running Press, 2004)

The Norman Rockwell Treasury, Thomas S. Buechner (Galahad, 2004)

The Stanley Kubrick Archives, Alison Castle (Taschen, 2005)

Toy Story: The Art And Making Of The Animated Film, John Lasseter, Steve Daly (Disney Editions, 1996)

Walt Disney Magic Moments, (Random House Value Publishing, 1988)

1001 Films You Must See Before You Die, Steven Jay Schneider (Cassell Illustrated, 2003)

Magazines and Periodicals

I find film and animation magazines very helpful in keeping me up to date with what's going on in the industry.

American Cinematographer
www.ascmag.com
The premier journal for cinematography

Animation Magazine
www.animationmagazine.net
A monthly magazine with news on animations in production, reviews, and events.

Cinefex
www.cinefex.com
Published only four times per year but a good research tool for special effects. Each issue reveals in detail the newest F/X for the biggest films on current release.

Daily Variety
www.dailyvariety.com
Published once a week and full of trade information.

Empire
www.empireonline.com
Published monthly and focusing on mainstream releases.

Hollywood Reporter
www.hollywoodreporter.com
The industry's daily trade paper. You'll find listings of features in production and preproduction and the people working on them.

Premiere
www.premiere.com
Film and DVD reviews and news from film premieres around the world.

Total Film
www.totalfilm.com
More news and reviews.

Further Viewing

When I purchase DVDs I try to choose the special edition versions as these often include interesting documentaries and storyboard and production designs in the bonus material.

However, you shouldn't build up your film library based only on this. There are plenty of films that are considered classics and they are often picked up as references for productions from TV advertisements to feature films. Sometimes it might just be for the particular style of photography or sceneography of the film, other times for the technique or the storytelling. A good storyboard artist should watch a lot of films and have a good knowledge of many different genres of film. Below is my recommended list of classics.

The Rope (A. Hitchcock)
North By NorthWest (A. Hitchcock)
Psycho (A. Hitchcock)
Rear Window (A. Hitchcock)
Vertigo (A. Hitchcock)
Citizen Kane (O. Welles)
M (F. Lang)
The Shining (S. Kubrick)
2001: A Space Odyssey (S. Kubrick)
Barry Lyndon (S. Kubrick)
A Clockwork Orange (S. Kubrick)
Taxi Driver (M. Scorsese)
Raging Bull (M. Scorsese)
The Godfather Trilogy (F. F. Coppola)
Apocalypse Now (F. F. Coppola)
Brazil (T. Gilliam)
Duel (S. Spielberg)
Jaws (S. Spielberg)
The Good, The Bad And The Ugly (S. Leone)
Star Wars (G. Lucas)
La Dolce Vita (F. Fellini)
Ladri di Biciclette (L. Visconti)
Umberto D. (L. Visconti)
Blow Up (M. Antonioni)
À Bout De Souffle (J. L. Godard)
Les Quatre Cents Coups (F. Truffaut)
Ran (A. Kurosawa)

The Duellists (R. Scott)
Alien (R. Scott)
Blade Runner (R. Scott)

I also believe that any of the films on the link below are necessary viewing for someone interested in working with films.
http://www.imdb.com/chart/top

Websites

Today it is very simple to find any kind of reference that you need simply by looking on the Internet. When working with commercials the agency usually provides Internet links for the product or the client. Costumes, locations, music etc – everything you need is just a few clicks away.

Here are some useful resources to keep in your bookmarks.

www.awn.com
Animation World Network – browse the jobs postings and upload your resumé.

www.deepdiscount.com
Site selling region 1 DVDs in the U.S.A.

www.imagebanksearch.com
Huge photo database – pictures of all sorts.

www.imdb.com
Internet Film Database – the most complete source of information about films.

www.mandy.com
International TV and film production resources.

www.sendit.com
Site selling region 2 DVDs in the UK

www.youtube.com
On this website you'll be able to find anything from old advertisements to music videos.

Further Study

www.storyboardschool.com
A website designed to be a home study in
storyboards.

The American Film Institute
http://www.afi.com/
P.O. Box 27999/2021
North Western Avenue
Los Angeles, CA, USA
90027

California Institute of the Arts
http://www.calarts.edu/
24700 McBean Parkway
Valencia, CA, USA
91355

Columbia University School of the Arts
http://www.columbia.edu/
New York, NY, USA
10027

The North Carolina School of the Arts
www.ncarts.edu/film
School of Filmmaking
1533 South Main Street
Winston-Salem, NC, USA
27127-2188

New York University
http://www.nyu.edu/tisch/filmtv.html
70 Washington Square South
New York, NY, USA
10012

San Francisco State University
http://www.cinema.sfsu.edu
Cinema Department
1600 Holloway Avenue
San Francisco, CA, USA
94132

University of California
http://www.filmtv.ucla.edu
Department of Film and Television
102 East Meinitz Building
Box 951622
Los Angeles, CA, USA
90095-1622

University of Texas at Austin
http://www.utexas.edu/coc/rtf/
College of Communication
Department of Radio-TV-Film
Austin, TX, USA
78712

Bristol School of Animation
www.uwe.ac.uk/amd/bristolanimation
University of the West of England
Bower Ashton Campus
Kennel Lodge Road
Bristol
BS3 2JT
UK

London Film Academy
www.londonfilmacademy.com
The Old Church
52a Walham Grove
London
SW6 1QR
UK

*École Internationale de Création
Audiovisuelle et de Réalisation*
http://www.eicar.fr
50 Avenue du Président Wilson,
Bâtiment 136–BP 12,
93214 La Plaine Saint-Denis
Paris
France

Huston School of Film and Digital Media
http://www.filmschool.ie/
National University of Ireland
University Road
Galway
Ireland

*Melbourne University's Summer School in
Filmmaking*
www.summerfilmschool.com
Parkville Campus
The University of Melbourne
Victoria 3010
Australia

Vancouver Film School
http://www.vfs.com
VFS Administration and Admissions Office
2nd Floor
198 West Hastings Street
Vancouver, BC
V6B 1H2
Canada

GLOSSARY

Words or phrases in *italics* refer to other entries in the glossary.

A

Action match cut
A cut made between two different angles of the same action, using the subject's movement as the transition.

Aerial shot
A shot taken from far overhead, usually via plane or helicopter, to give a bird's eye perspective. Also called *Fly over* or *Bird's eye view*.

Angle
The perspective from which a camera shows the subject. Every shot can include some kind of angle, which breaks up the monotony of shooting with the camera straight on to the subject.

Angle of view
The size of the field of view covered by a lens measured in degrees.

Animation
The illusion of movement through individual drawings or cels drawn and filmed in sequence. See also *Cel animation*

Aspect ratio
The relationship between the height and width of the frame size. The Academy Standard ratio is 1.33:1, while widescreen is 1.85:1.

Axis of action
See *Line of action.*

B

Background (BG)
Series of elements that are furthest from the camera in the visual field.

Backlighting
Lighting a subject from behind.

Beat
A smaller dramatic unit within a scene; a scene within a scene; a change in direction of scene content.

Bird's eye view (BEV)
See *Aerial shot.*

Blue screen (sometimes green screen)
A process in which actors are filmed against a blue or green screen. In postproduction, the screen is replaced with different backgrounds, creating the illusion that the actors have physically been in that location.

Bridge shot
A shot used to cover a jump in time or place, or other discontinuity.

C

Camera angle
The position and orientation of the camera in relation to its subject.

Canted angle shot
A tilt, either to the left or to the right, which makes objects within the frame look as if they are slanted. The horizontal frame line is not parallel to the horizon.

Cel animation
A form of animation that uses a series of drawings on pieces of celluloid, called cels for short. Slight changes between the drawings combine to create an illusion of movement.

Cinematography
The art of motion-picture photography, which involves cameras and lighting.

Climax
The highest point of tension in a drama, at which complication reaches a maximum and the forces in opposition confront each other in an ultimate physical or emotional conflict.

Close-up (CU)
A shot that shows a small object or details of a larger object.

Complementary shot
A shot compositionally designed to *Intercut* with another.

Composition
The combination of objects, light and movement that points the audience's attention in a certain direction within a frame.

Cover shot
See *Master shot.*

Crane
Large camera trolley with the camera mounted on the end of a boom, usually with accommodation for one or more camera operators.

Crane shot
A shot taken from a crane. Generally, these shots give an overhead view of a scene.

Crosscutting
Cutting between two separate sequences or scenes as they unfold, in order to show a parallel relationship between them.

Cross dissolve
A scene or shot transition that fades out one scene while another fades in.

Cut
A transition or change from one shot to another.

Cutaway
A quick shot that temporarily redirects the audience's attention away from the main action in order to provide commentary or to hint at a coming change.

D

Deep focus
A photographic technique, which permits all planes to remain clearly in focus, from close-up to infinity.

Depth of field
The distance from the camera within which objects remain in focus.

Detail shot
A tighter, more highly magnified version of the *Close-up*, used to show a fragment of a whole subject or a small object in its total size.

Distant shot
A scene photographed to give the effect of the camera being at a great distance from the action being photographed. Also called *Long shot.*

185

GLOSSARY

Dolly
A low platform, which supports the camera and operator, mounted on steerable wheels, enabling it to move in any direction.

Dolly shot
A shot taken from a dolly.

Dynamic composition
Pictorial composition as it changes within a moving shot.

Editing
The process of arranging shots into scenes, sequences and, ultimately, a film.

Establishing shot (ES)
An opening shot of a scene, most often long, that establishes place and time.

Exterior (EXT.)
A scene filmed outdoors.

Extreme close-up (ECU)
A shot that isolates the details of an object, such as an eye on a human face.

Extreme long shot (ELS)
A shot, taken at quite a distance, wherein the setting overwhelms the subject.

Eye-level shot
A shot taken with a camera placed at approximately the same eye level as the film subject, not the equipment operator. This type of shot places the viewer on the same level as the subject.

Eyeline match
A *Cut* obeying the *Axis of action* principle, in which the first shot shows a person looking off in one direction and the second shows a nearby space containing what he or she sees. If the person looks to the left, the following shot should imply that the looker is off-screen right.

Fade
A term that denotes the gradual appearance or disappearance of an image. An image that appears out of a black or white frame is a *fade in*, while an image that gradually disappears from a black or white frame is a *fade out*.

Final cut
A film in its finished form. Having "final cut" on a film assures the filmmaker or producer that the film will not be tampered with after their final approval.

Fisheye lens
A lens constructed to give the maximum possible field of view.

Flashback
A scene or sequence that temporarily breaks the chronological continuity of a film by moving backward in time.

Fly over
See *Aerial shot*.

Focus pull
See *Rack focus*.

Follow shot
A tracking shot, pan or zoom-in motion that follows a moving subject.

Foreground (FG)
Elements in the frame placed in the visual plane nearest the camera.

Frame
A single film image. 24 frames make up one second of screen time.

Full shot
A type of long shot that includes the human body in full view, with the head near the top of the frame and the feet near the bottom.

Genre
A French term meaning subject or category. It refers to a group of films with similar characteristics such as plots, themes or styles.

Hand-held shot
A shot taken with a camera held in the operator's hand, usually resulting in a wobbly or unsteady effect. Popular in investigative reporting or documentary style.

Headroom
Compositional space left above heads.

High angle (HA)
A shot taken from above the subject, usually from overhead.

Insert shot
Normally a *Close-up*, showing an important detail of a scene.

Intercut
An editing technique that moves between two different scenes. See also *Crosscutting*.

Interior (INT.)
A scene filmed indoors.

Jump cut
A sequence of shots in a scene in which the appearance of real continuous time has been interrupted by omission. In certain situations, jump cuts are an accepted convention for compressing time. The new trend in music videos and advertisements uses the staccato jump cut purely for rhythmic effect.

Juxtaposition
The positioning of two objects or images in proximity or sequence in order to create a relationship between them.

Letterboxing
An *Aspect ratio* for television and home video that emulates widescreen format, with black bars at the top and bottom of the screen.

Lighting
The art of manipulating light and shadow in a film frame.

Line of action
An imaginary line that separates the

camera from the action before it. To ensure continuity in editing and avoid disorienting the audience, the camera should not cross this line. Also referred to as *Axis of action*.

Long shot (LS)
A shot that shows its subject at a distance.

Long take
A shot that runs for an extended duration.

Loose
Refers to the composition of a shot. Loose framing includes a great amount of space around an element.

Low angle (LA)
A shot taken from below while tilting the camera upward, resulting in the effect of looking up at the subject.

Low-key lighting
A type of lighting that uses more shadows and lower illumination to create a grey or dark effect.

 Mainstream
A Hollywood-made film with big stars, big budget and big hype appealing to the masses.

Master shot
The viewpoint of a scene in which the relationships between subjects are clear and the entire dramatic action could be understood if no other shots were used.

Match cut
A transition that cuts on common "matched" elements that connect two scenes.

Matte shot
A type of special effect in which a portion of the film image is painted or created digitally and combined with live-action footage in postproduction.

Medium close-up (MCU)
A shot that includes a person's upper torso and head.

Medium long shot (MLS)
The subject or main object fills the entire frame. Also referred to as a *Three-quarters shot*.

Medium shot (MS)
A shot that frames characters from the waist up.

Mise-en-scène
The elements in frame, including lighting, movement, setting and costuming.

Mockumentary
A fiction film that parodies the style of documentary films.

Montage
A series of short shots edited together, usually without dialogue, to create a certain emotional effect or portray a passage of time.

Motif
An image, object, spoken phrase or stylistic device that appears and reappears in a certain pattern throughout a film. It gains significance with each repetition.

Moving shot
A shot in which the camera is moved to follow a moving element.

 Narrative
The storyline in a film.

Normal lens
A lens that best captures what the eye normally would see.

 Omniscient point of view
A point of view in which the narrator knows everything occurring in a story, including character thoughts, conversations and events.

180 degree rule
A filming style that dictates a camera must remain on one side of the *Axis of action*, while the action remains on the other. This system helps eliminate the possibility of disorienting the audience during cuts within a scene.

Off camera (OC)
A sound that originates from outside the frame but is still identifiable as occurring within the narrative space. Also referred to as *Off screen* (OS).

Open forms
Used primarily by realist film directors, these techniques are likely to be subtle and unobtrusive, with an emphasis on informal compositions and apparently haphazard designs. The frame generally is exploited to suggest a temporary masking, which arbitrarily cuts off part of the action.

Overlap
In sound, to carry dialogue or music from one scene to another.

Over-the-shoulder shot (OTS)
A shot where we see a subject who is facing us, with the back of the head and the shoulder of another subject in the extreme foreground as a framing device.

 Pack shot
A shot that shows off the product being advertised. Often the client uses the same pack shot for every commercial they make.

Pan
A shot in which the camera rotates on its vertical axis from left to right or right to left.

Parallel editing
A type of editing that cuts between two sequences taking place at different locations and possibly at different times.

Plan sequence
A scene handled in a single shot, usually a *Long take*.

Plot
A series of events that creates the film's narrative.

Point of view (POV)
The perspective from which a story is told.

Point of view shot
A shot that shows us what a character sees.

GLOSSARY

Practical lighting
A lighting style that imitates how lighting in a scene would appear in real life.

Production
Umbrella term encompassing both the procedure and crew involved in the principal photography of a film. Can also be used to refer to the entire film project.

Progression
The traditional rising action of dramatic tension. Increasingly close camera angles represent camera progression.

Property
Commonly known as *prop*, refers to any object an actor touches or uses on set.

Protagonist
The hero of a story; the character with whom the audience is directed to identify.

Pull-back shot
A *Dolly shot* or *Zoom* effect that starts in close-up on an element and slowly widens to include more of the area surrounding the element.

Rack focus
To shift focus from one character or element to another within a shot, such as from foreground to background. Also known as *Focus pull.*

Reaction shot
In a dialogue scene, a shot of a character listening while the other character is talking off camera. Most often done in *Close-up.*

Realism
A movement in film that attempts to capture or represent reality as closely as possible.

Rear projection
A technique combining a *Foreground* action with a *Background* filmed earlier. The live-action foreground is filmed in a studio, against a screen which has background imagery projected onto it from behind.

Re-enactment
A production that re-creates an actual event as closely as possible.

Re-establishing shot
A shot that repeats an *Establishing shot* near the end of a sequence.

Reframing
Using short *Pan* or *Tilt* movements of the camera to keep figures on screen or centred.

Representation
How films assign meaning to what they depict, such as social groups.

Retracking
Backward movement of the camera mounted on a *Dolly* along a path that it has already covered in the same shot or in a previous shot within the same scene. Normally the dolly is moving on tracks.

Reverse angle
A shot that is turned approximately 180 degrees in relation to the preceding shot.

Rising action
The plot developments, including complication and rising conflict, that lead to a plot's *Climax.*

Rhythm
In visual composition, the pleasing repetition of images. In drama, the repetition of phrases, actions or musical themes for increased dramatic effect.

Rough cut
An early draft of a film with the storyline in place but without any finishing editing touches.

Scene
A shot or series of shots linked by location and time.

Screen direction
The right-to-left relationships in a scene that are set up in a *Master shot* and determined by the position of characters and objects in the frame, the direction of

movement and the characters' eye lines. *Continuity editing* attempts to keep screen direction consistent between shots. See also *Axis of action, Eyeline match, 180 degree rule.*

Sequence
A series of *Shots* linked by time, place, and action that form a coherent unit of narrative with a specific start, middle and end.

Set-up
The choice of *Camera angle*, shot size, and staging. It is normally described by the number of players in a shot. A *Two-shot, Over-the-shoulder shot* and *Close-up* are all typical set-ups.

Setting
The time and place in which a film's action occurs.

Shallow focus
A shot wherein a small frame area is in focus while the rest of it is blurry.

Shot
One uninterrupted run of the camera.

Shooting script
The final script.

Single
A shot with only one subject in the frame.

Slow motion
The effect of slowed action created by exposing frames in the camera at greater-than-normal speed and then projecting that footage at normal speed (24 frames per second).

Special effects (F/X)
A general term for various photographic and digital manipulations in the film, such as *Superimposition, Matte shots* and *Rear projection.*

Split screen
Two or more scenes on screen simultaneously.

Static camera
Any shot where the camera is not in motion.

Steadicam
The invention of cameraman Garrett Brown (developed in conjunction with Cinema Products, Inc.), this is a system which permits hand-held filming with an image steadiness comparable to tracking shots. A harness redistributes the weight of the camera to the hips of the cameraman; a spring-loaded arm minimizes the motion of the camera; a video monitor substitutes for the camera's eyepiece.

Style
A director's personal pattern of treating material, including staging of camera and performers, script elements and music.

Storyboard
A series of drawings that suggest how a scene or film might look once filmed.

Subjective camera
A technique that presents the viewpoint of a character in a scene. See also *Point of view*.

Subjective point of view
A point of view that is limited; the narrator is unaware of some things occurring in the narrative.

Superimposition
The exposure of more than one image on the same film strip.

Swish pan
A panning shot in which the intervening scene moves past too quickly to be observed. It approximates the action of the human eye as it moves from one subject to another. Also called *Whip pan* or *Zip pan*.

Take
One continuous recording of a shot.

Talking heads
Medium shots of people talking. Little action occurs in such shots.

Telephoto lens
A lens that can act like a telescope. Often used in sports, news, and documentary film work.

Testimony
Statements made by people witnessing an event or going through an experience themselves.

Theme
A dominant idea given expression through its representation by the characters, action and imagery of the film.

Three-quarters shot
A shot showing a character from the knees up.

Three shot
A *Medium shot* that contains three people.

Tight framing
Usually in close shots. The mise-en-scène is so carefully balanced and harmonized that the subject photographed has little or no freedom of movement.

Tilt
The upward and downward movement of the camera.

Timing
The control of objective and subjective time.

Tracking shot
A shot taken while the camera moves on a wheeled platform.

Travelling shot
Any shot that requires the camera to move from one location to another. The *Crane shot* and *Tracking shot* are both travelling shots. A *Pan shot,* however, is not a travelling shot since the camera stays in one location.

Two-shot
A *Medium shot* with two people in it.

Underlighting
Illumination from a point below the figures in the scene.

Visualization
The mental visual image of an event in a single shot. Also known as *Conceptualization*.

Whip pan
See *Swish pan*.

Wide-angle lens
A type of lens that exaggerates the disparity between the foreground and background within a film frame. Objects in the foreground become disproportionately larger, while those in the background become disproportionately smaller.

Widescreen
Any image with an aspect ratio greater than Academy Standard of 1.33:1. The most common widescreen aspect ratio is 1.85:1.

Wipe
A visual effect in which one image replaces another by seemingly pushing it off the screen.

Zip pan
See *Swish pan*.

Zoom
An optical effect that increases or decreases the magnification of an object in the frame, making it appear larger or smaller. The effect is achieved through changing the focal length of a lens, not by moving the camera.

INDEX

CREDITS

Author acknowledgments

I would like to thank Inga Helgesson and Francesca Rao for the translation. Special thanks go to Alessandra Orlacchio, Pia and Melanie Berglund, Per Carlsson, Tomas Grahl, Esbjörn Jorsäter, Alessandro Aiello and most of all to my family. I would also like to thank all the production companies, agencies, directors, producers and creatives that I have had the pleasure to work with in all these years.

www.storyboardagency.com
www.iradidio.com

Picture credits

Quarto would like to thank and acknowledge the following for supplying illustrations and photographs reproduced in this book

Key = a above, b below, l left, r right
Tim Burgard 18b, 19ar, 20b, 75al, 75cr; Marco Letizia www.storyboardagency.com 22bl, 29a, 29br, 46a, 46b, 53, 69a, 81br, 83bl, 136r, 154, 171l; Amitai Plasse www.amiplasse.com 158, 159; Bill Plympton www.plymptoons.com 26a; Maxime Rebière www.maximerebiere.com 19l, 21, 133l; Carlos Ruiz Brussain www.carlosruizbrussain.com 9, 156al, 156ar, 157bl, 157br, 166, 170b, 171r; Simon Valderama www.edlav.com 95b

Quarto would also like to thank the following companies for the use of their images:
6 SNAP/Rex Features; 8a Gene Lester/Getty Images; 8b John Meek/The Art Archive; 12b EON/Ronald Grant Archive; 16b Acne Film www.acne.se; 18a Constantin Film Produktion GmbH/Ronald Grant Archive; 19br Everett Collection/Rex Features; 23ar Andrew Drysdale/Rex Features; 24b Bettmann/CORBIS; 26b, 27bl Louis Quail/Corbis; 27br Rune Hellestad/Corbis; 30b Stack Studios www.stack-studios.com; 34r Dannyphoto80/Dreamstime.com; 35al Kirsty Pargeter/Dreamstime.com; 35br James Fraser/Rex Features; 43bl NU/Shutterstock, Inc.; 51al Images.com/Corbis; 51cl c.SND/Everett/Rex Features; 51bl Kjeld Duits www.ikjeld.com; 52ar Dave Bartruff/CORBIS; 59bl Feng Yu/Dreamstime.com; 67c NorthGeorgiaMedia/Shutterstock, Inc.; 67bl Dimitrije Paunovic/Shutterstock, Inc.; 75bl Dukane Corp AV Division www.dukcorp.com/av; 98b RPC/The Kobal Collection; 99al Titanus/SNPC/The Kobal Collection; 99br Columbia/Tri-Star/The Kobal Collection; 100ar Paramount/The Kobal Collection; 100bl Columbia/The Kobal Collection; 101br Warner Bros./The Kobal Collection; 104ar Paramount/The Kobal Collection; 104bl P.E.A./The Kobal Collection; 111bl SNAP/Rex Features; 111br Jimmy Jib "TRIANGLE" Camera Crane www.jimmyjib.com Photo: Kelly J. Richardson, Atomic Dolly & Crane Rentals, www.dollyrental.com; 126al Marija Calic/Dreamstime.com; 126ar Suprijono Suharjoto/Dreamstime.com; 126bl Daniela Spyropoulou/Dreamstime.com; 126br Jason Stitt/Dreamstime.com; 127al Christopher Howey/Dreamstime.com; 127cl Rfoxphoto/Dreamstime.com; 127bl David Davis/Dreamstime.com; 133br Peter Albrektsen/Dreamstime.com; 135l EuToch/Shutterstock, Inc.; 135r Peter Guess/Shutterstock, Inc.; 139ar James Thew/Fotolia.com; 139bl Ron Downey/Fotolia.com; 139br Nataliya Peregudova/Dreamstime.com; 144bl Jason Stitt/Shutterstock, Inc.; 155 iofoto/Shutterstock, Inc.; 165br Doug Stevens/Shutterstock, Inc.; 168l Gabriel Moisa/Shutterstock, Inc.; 168c Sean Nel/Shutterstock, Inc.; 168r EML/Shutterstock, Inc.; 175al kd2/Shutterstock, Inc.; 175ar jocicalek/Shutterstock, Inc.; 175c Paramount/The Kobal Collection; 175br Columbia/The Kobal Collection; 176 Ray Kosarin

All other images are the copyright of Quarto Publishing plc. While every effort has been made to credit contributors, Quarto would like to apologize should there have been any omissions or errors—and would be pleased to make the appropriate correction for future editions of the book.